Perfect

Waves

The Endless Allure of the Ocean

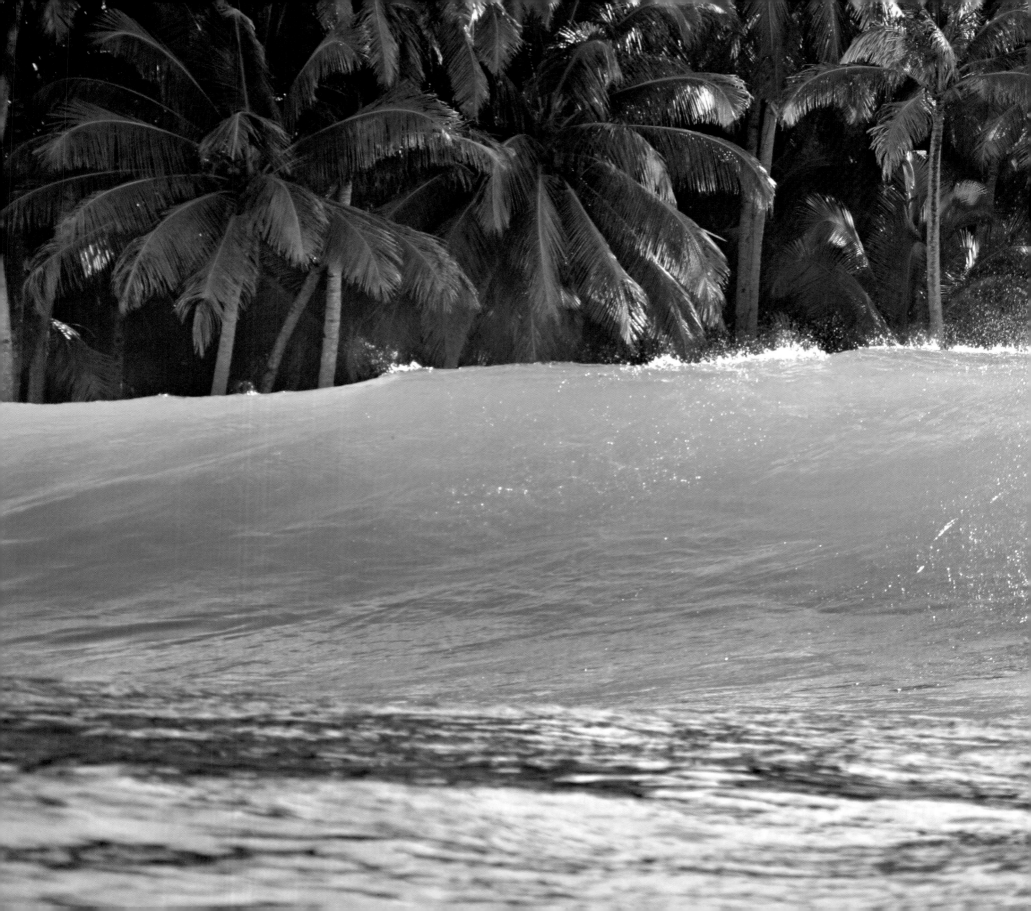

Photographs by Sylvain Cazenave, Éric Chauché, and Tim McKenna
Essays by Guillaume Dufau, Alexandre Hurel, and Pierre Nouqueret

Perfect
Waves

The Endless Allure of the Ocean

Abrams, New York

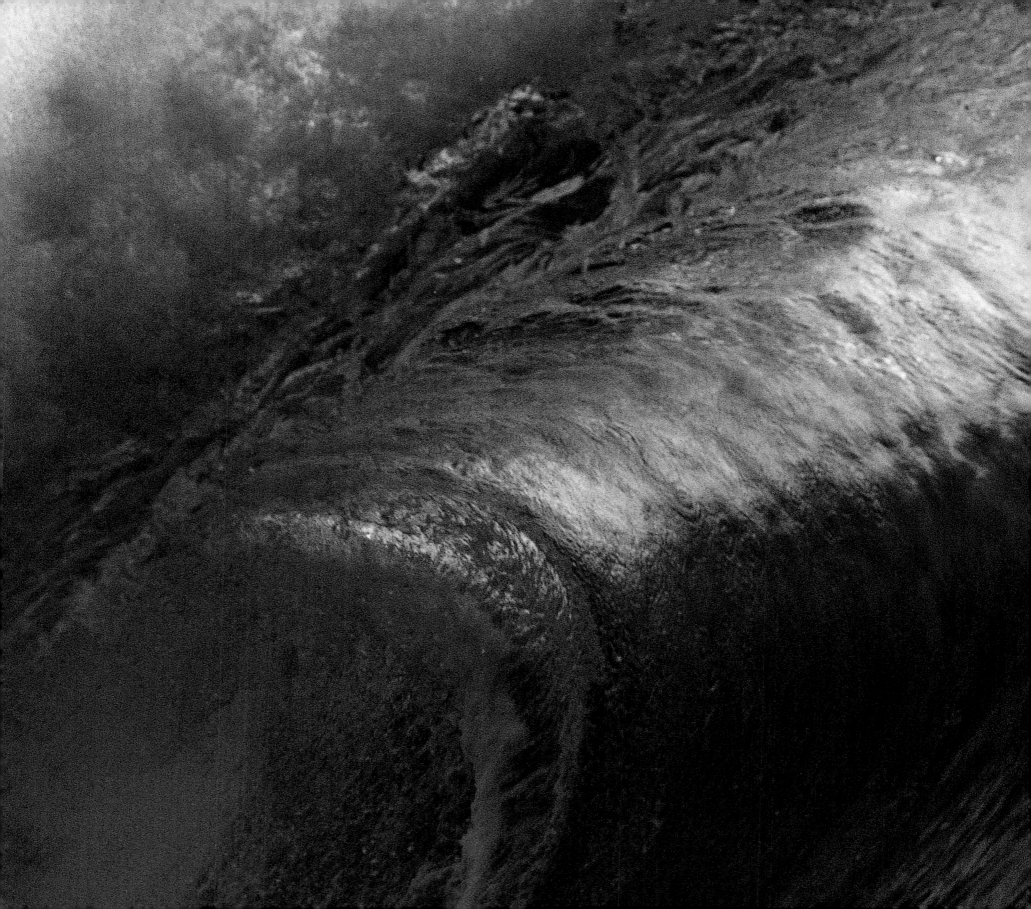

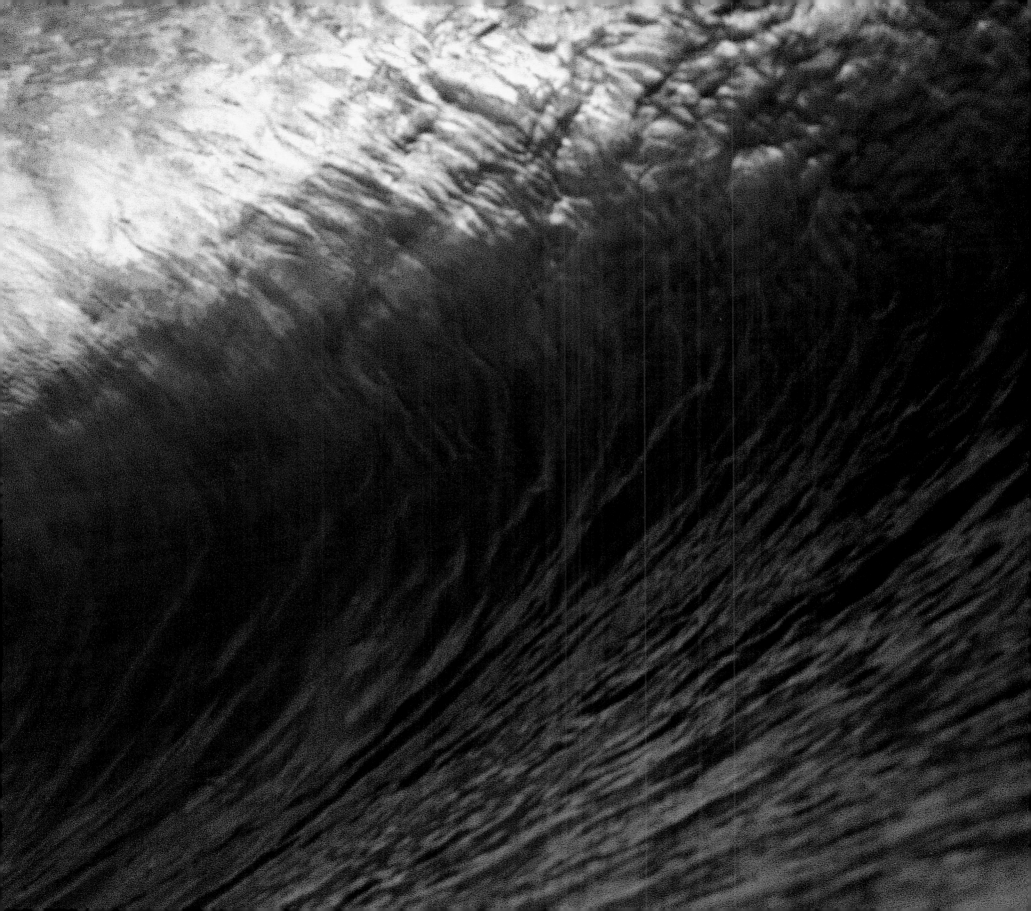

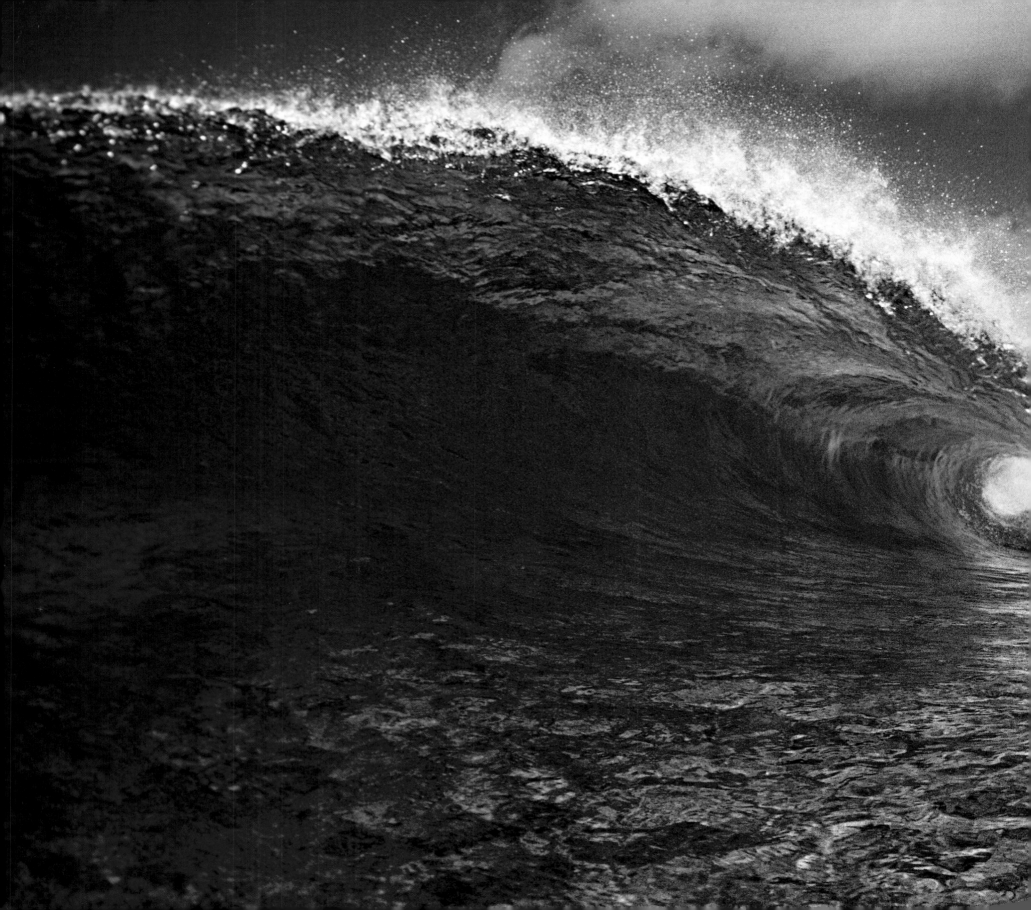

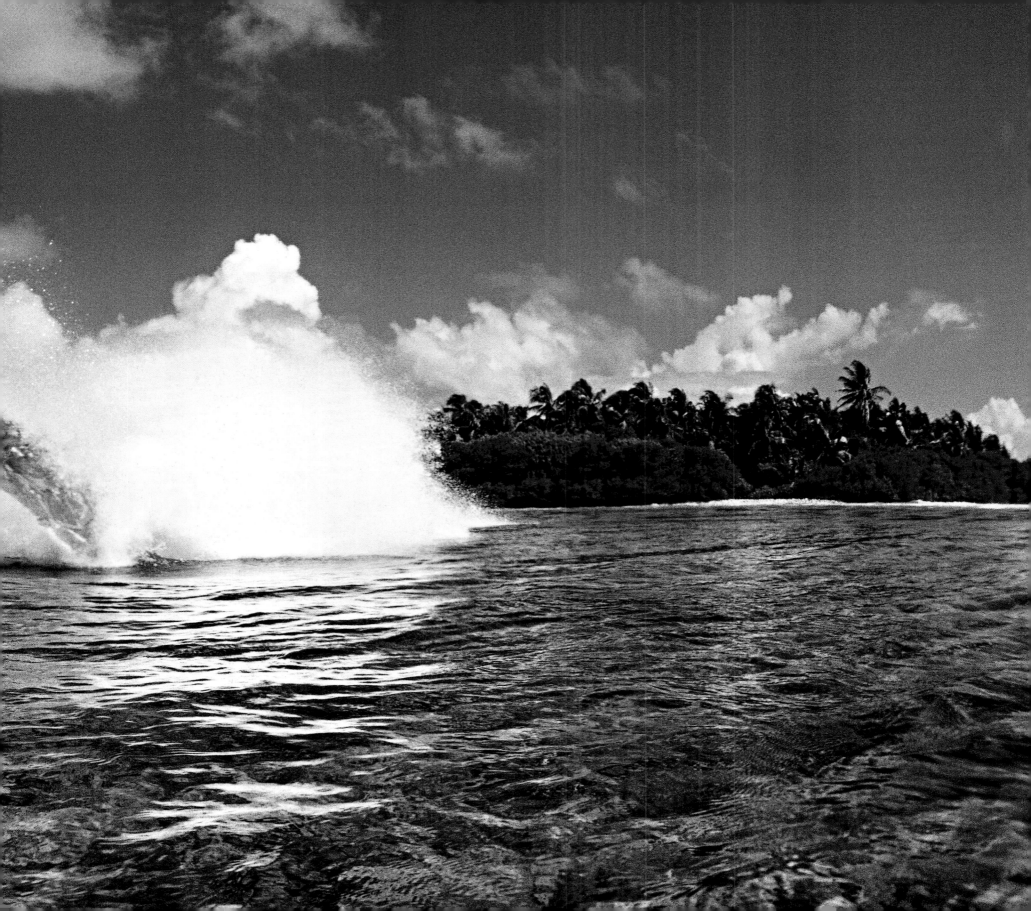

Contents

Mystique of the Wave 96

by Alexandre Hurel

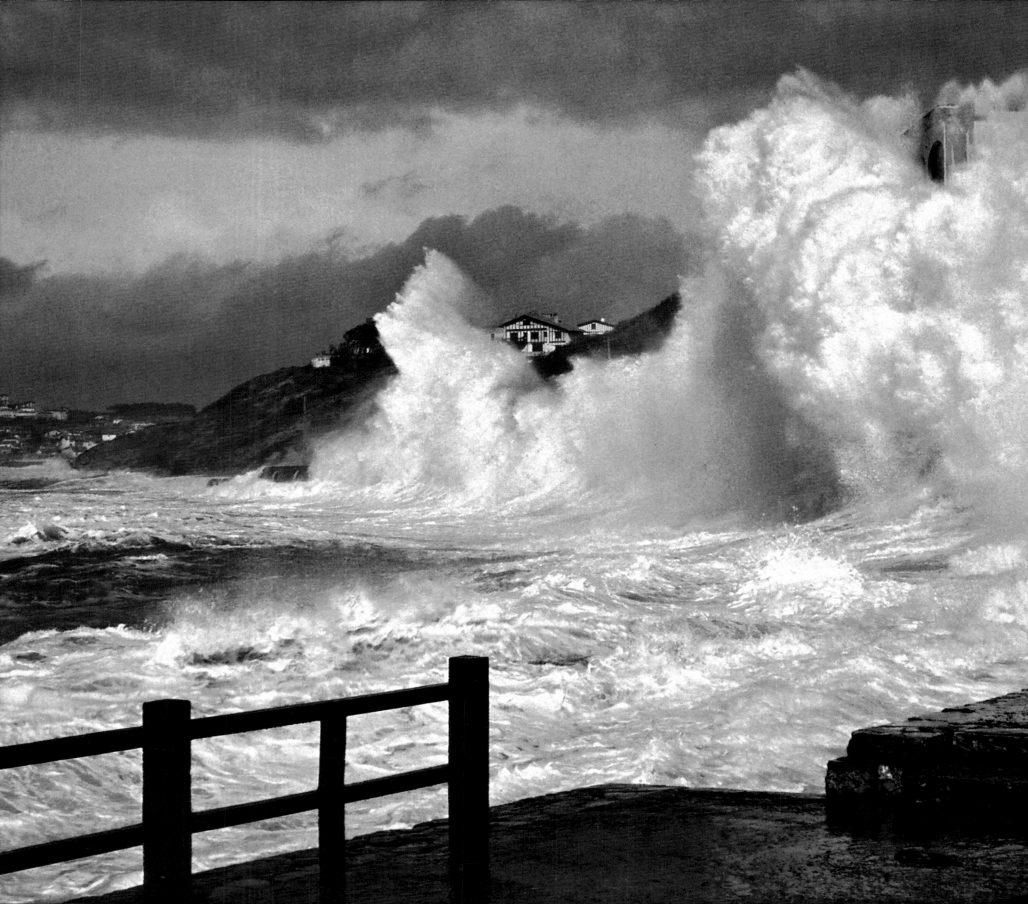

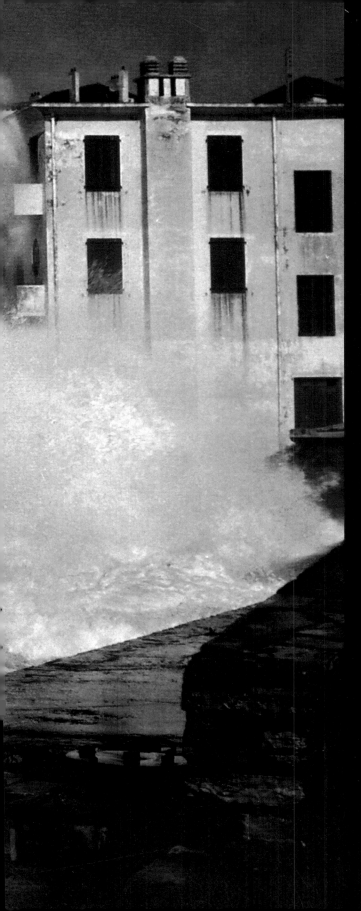

The Wave

I can still see myself as a kid, hanging out in the Guéthary photo shop run by Mr. Dubertrand. While he and my Dad rambled about their upcoming hikes in the Pyrenees, I stood with my dog, Bat, and gazed for the hundredth time at the blowups Mr. Dubertrand had posted of his best photos. My eyes moved from the green Basque mountains to the red houses in the surrounding villages, skimmed over the wild coat of a Pottok (Basque pony) standing deep among the ferns, and came to a halt on the blue hulls of fishing boats in Saint-Jean-de-Luz. Despite the fact that it was in black and white, one image stood out from all the photos in the little shop's window. It was a picture of a wave.

How big was it? Had it destroyed the building? Had the building's inhabitants survived? How had the photographer made it out alive?

Jean Dubertrand referred to this picture as "The Wave." In February 1962, while a terrible storm battered the small Basque coastal village of Guéthary, Dubertrand snapped a picture of this terrifying white-water ground swell as it swept over the local casino.

Storms and waves made for breathtaking photos.

Today, it is my exceptional privilege and pleasure to spread hundreds of photos by Sylvain, Eric, and Tim over my living room table and spend hours poring over them. Stimulated by this treasure trove of magical images, I lift my eyes to the wall, to gaze at a print of —"The Wave."

Naturally.

Pierre Nouqueret

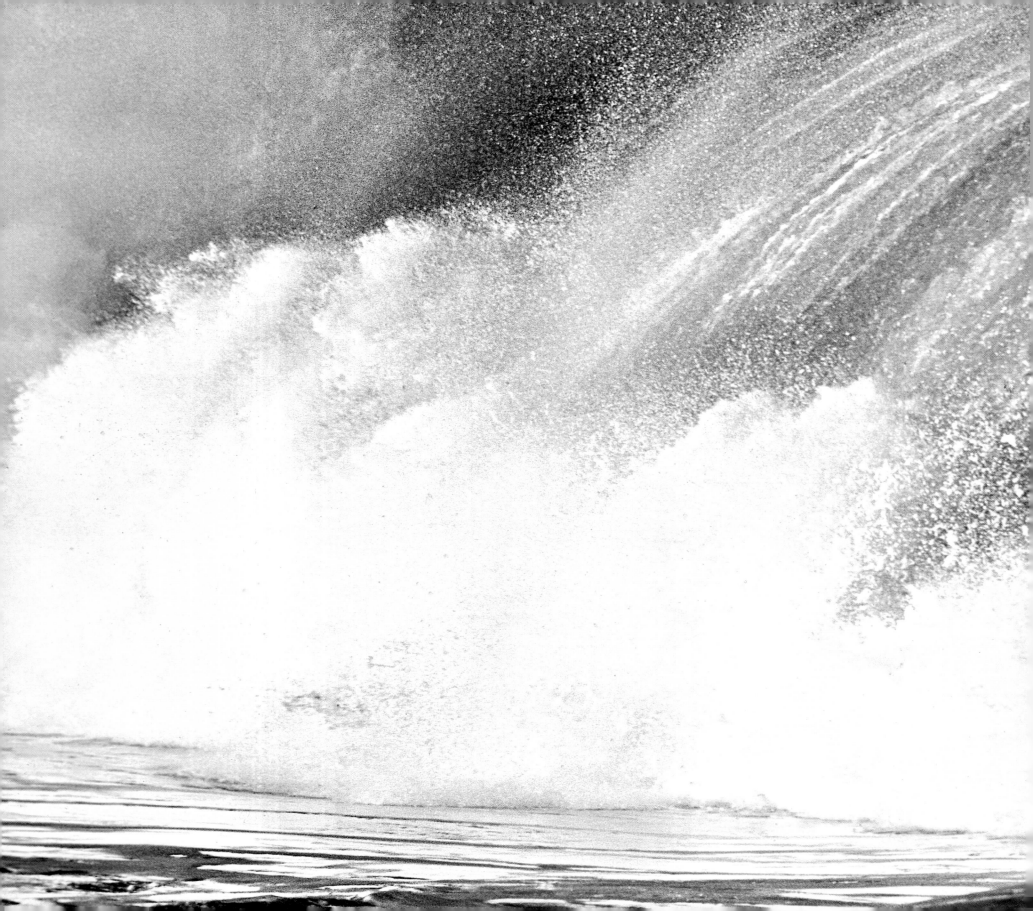

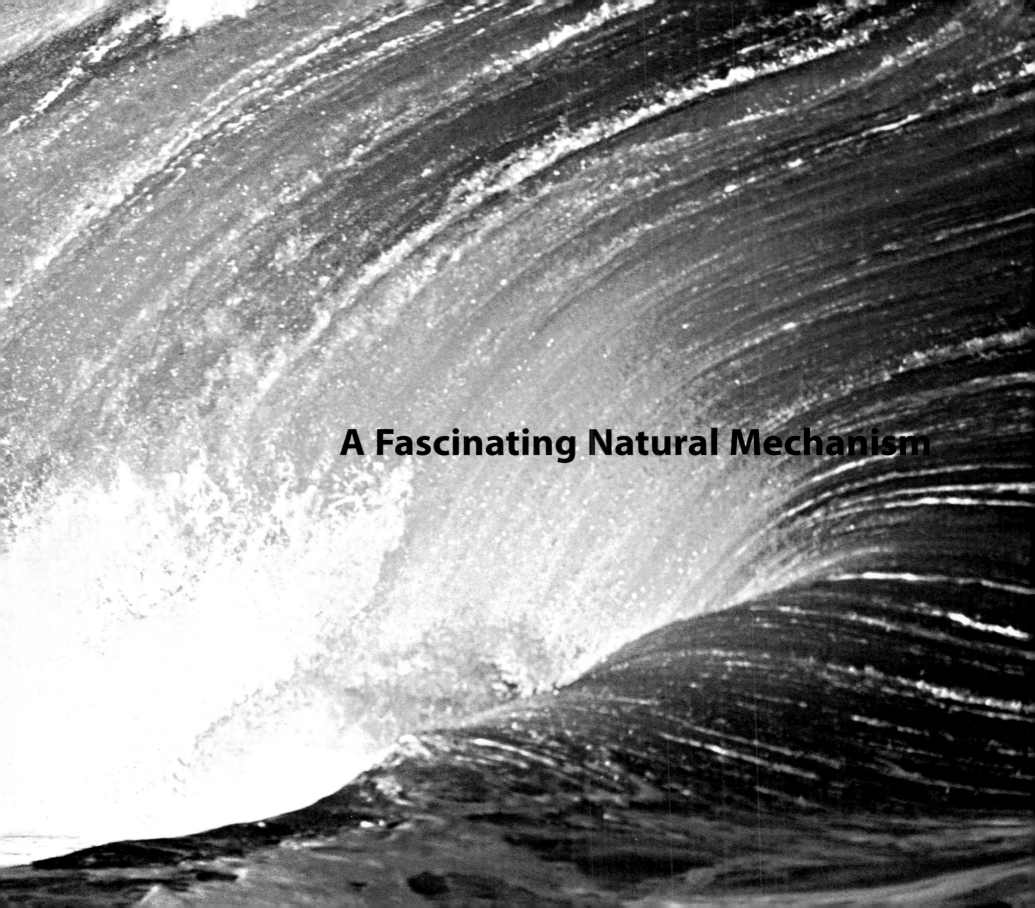

A Fascinating Natural Mechanism

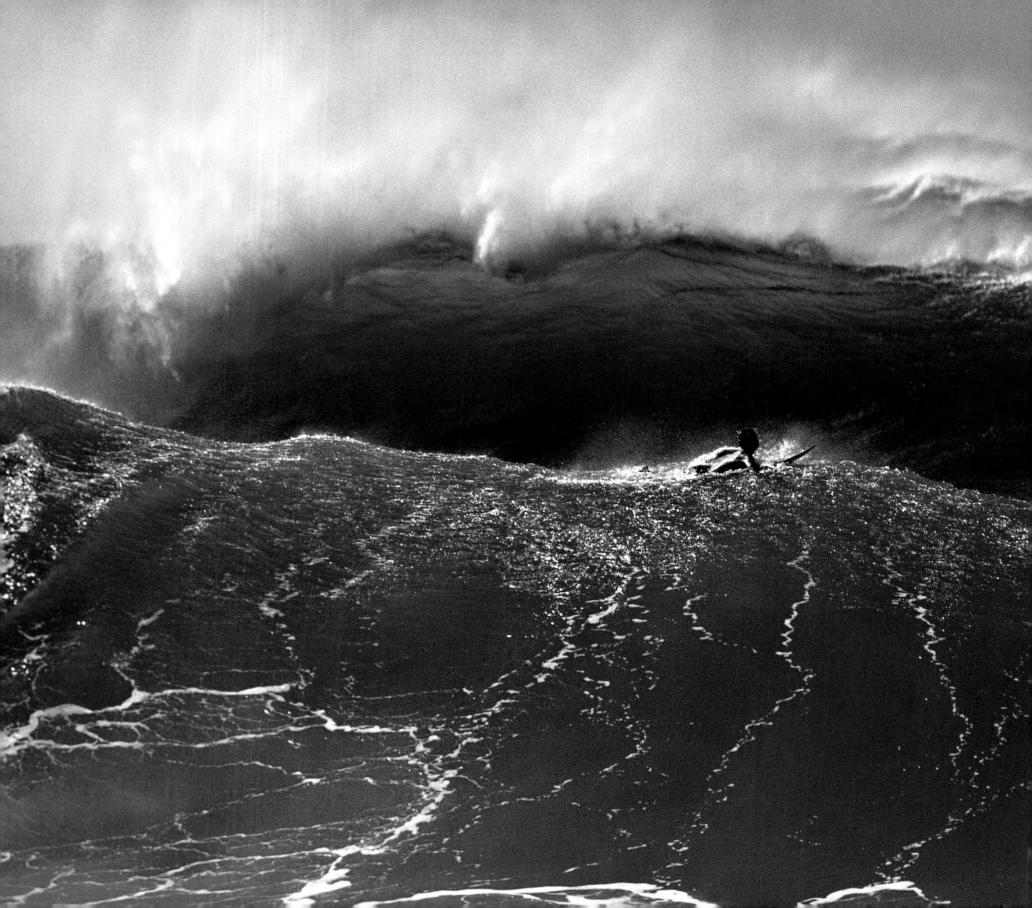

Allegory of the Wave

From the moment it begins to rise until it breaks on the shore, a wave is the result of a complex set of interactions between different natural forces. Once the wave comes into being, it begins to move, to change, to fall into a pattern, to travel, and to change yet again as it approaches land. Born out of the chaos of a storm, it moves toward the coast in silence, then ends its journey with a brutal crash. Though it follows the rules of physics and is mathematically propagated, the sinuous wave remains impenetrably mysterious, as unpredictable as it is unique.

The wave is frequently considered too complex or too unpredictable to be included in books and studies. It has long been considered dangerous, treacherous, destructive and, especially, useless. Is it still possible to rehabilitate it?

In the entire history of man, only a few civilizations, such as those of Polynesia and Hawaii, have taken an interest in waves. The Polynesian's and Hawaiian's interest may not be much of a surprise, given that they lived cheek by jowl with some of the world's most beautiful waves. They learned long before we did to derive pleasure from the wave, and to view it as an essential social reference. In return for the oceanic treasures they were fully conscious of receiving, the islanders elevated waves to the level of divinities.

Many centuries later, with the development of surfing and other board sports, local populations began to discover unsuspected riches along their coastlines. Would California be any better off than Florida if it didn't have its waves? What would the village of Mundaka, Spain, be like if it didn't have those long sinuous lines rolling into the estuary of Urdai Bai? How would Australia cool off without the sea spray from the huge waves tirelessly battering its beaches? And don't get me started on Hawaii!

Waves are always specific to the place from which they spring. They are crucial to making a landscape feel whole. Beyond that, they are increasingly recognized as precious aspects of the coastal heritage, natural monuments that are the pride and joy of the communities that live beside them.

Given society's rapid transformations, the wave's most essential function could spring from its role as an ultimate example of mobility, and as a perfect balance of the most unstable elements. The wave could represent a contemporary model for us to aspire to.

There is little doubt that the wave's diversity and universality, its turbulence and power, and its constant metamorphoses and steady, regular breaking can help us better understand the complex patterns of our world. Let us run, dive, and play in the wave, let us be carried away by it. We will never become aquatic, but we may become more human.

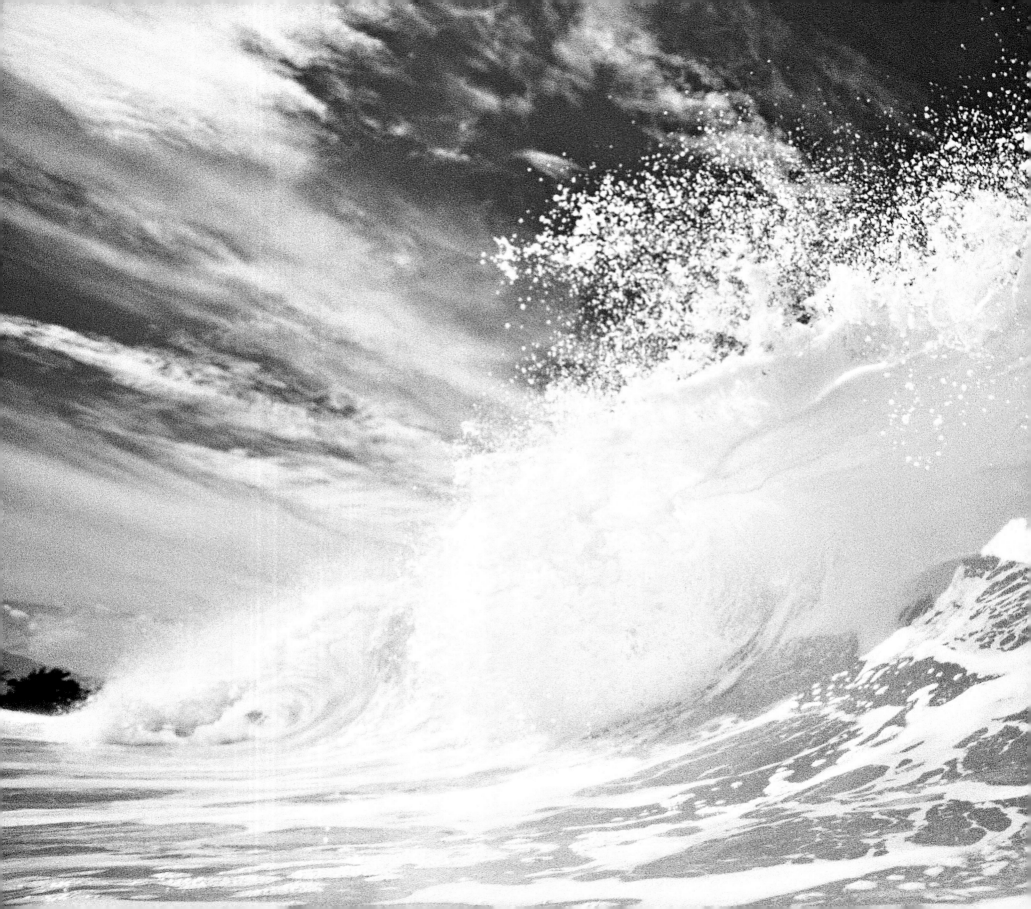

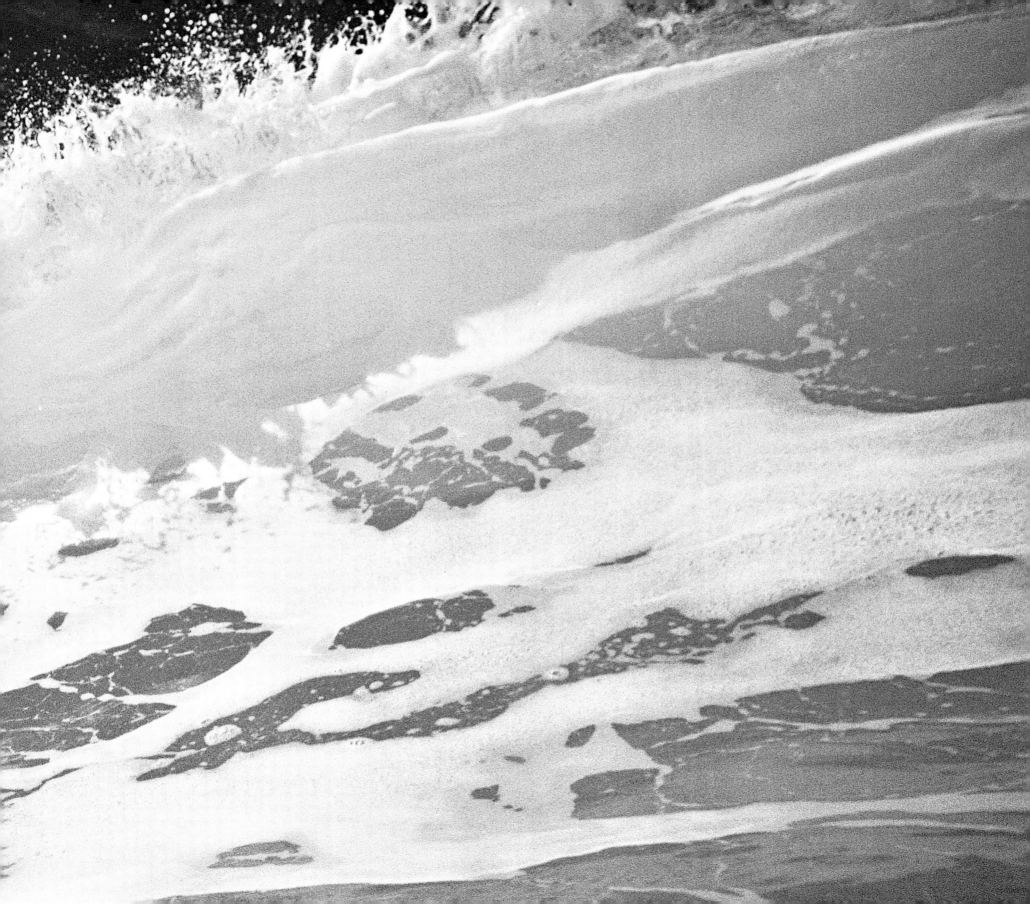

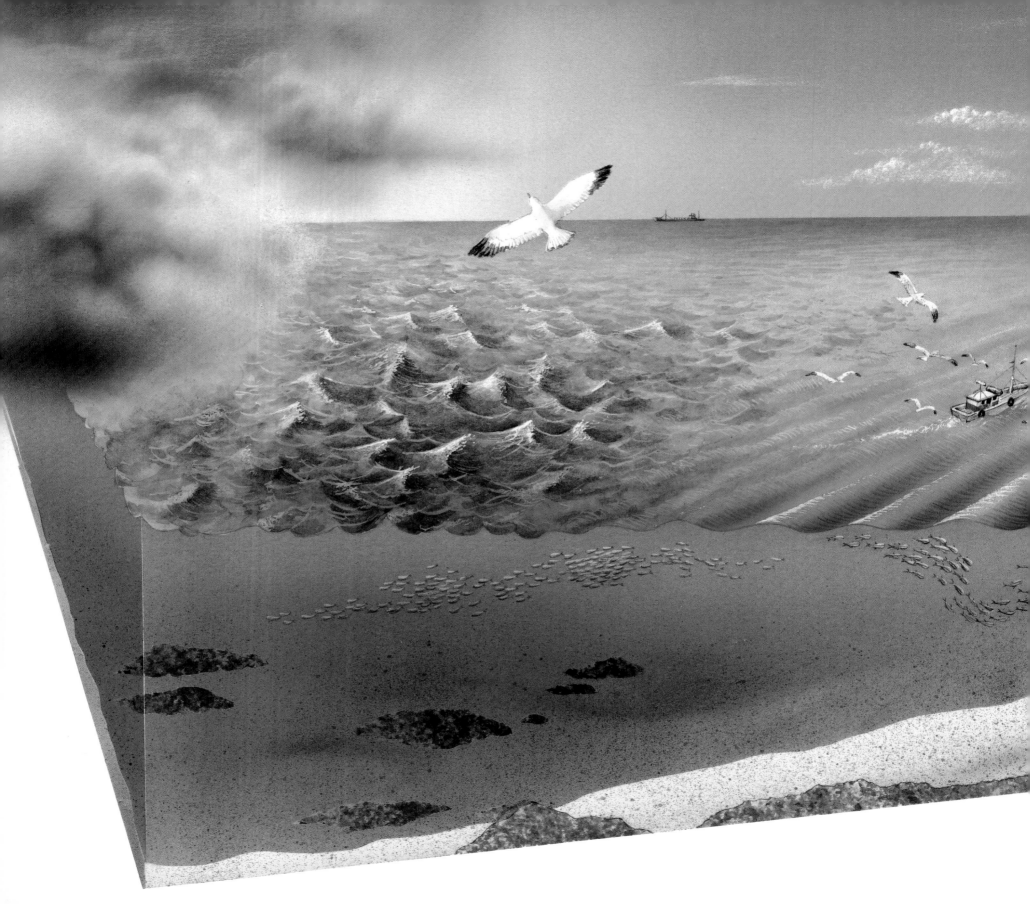

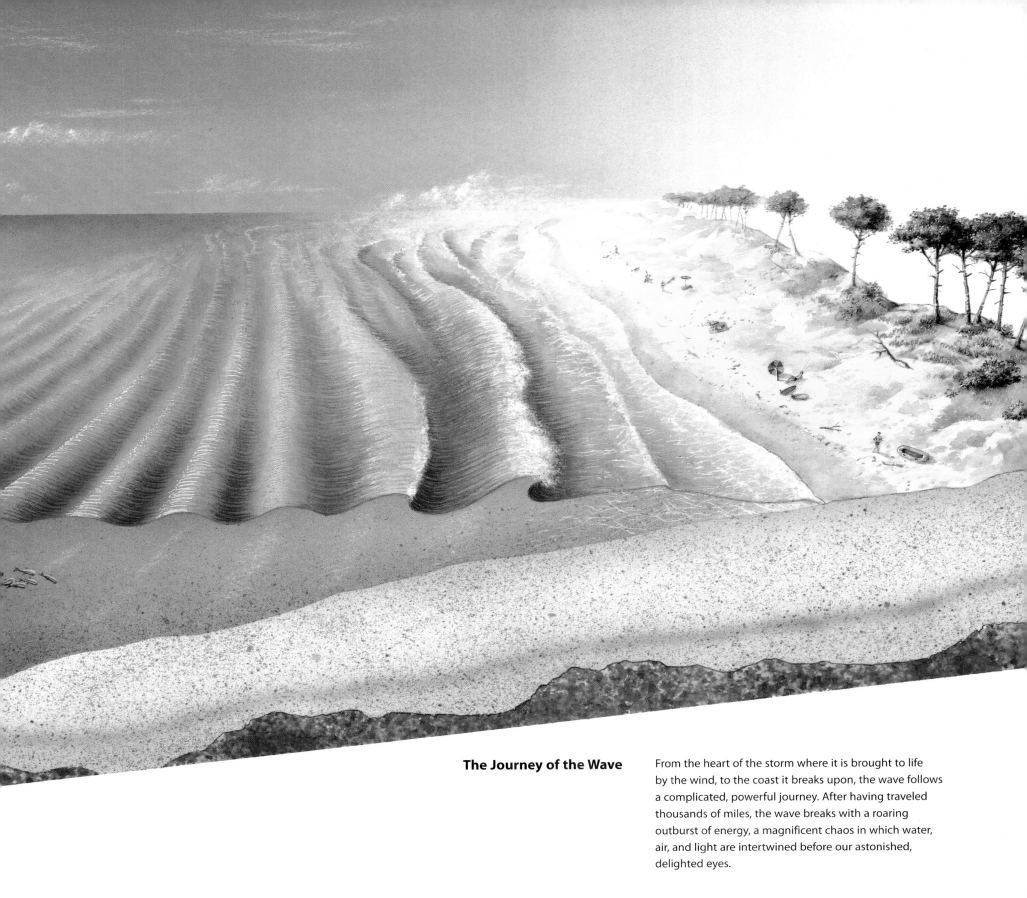

The Journey of the Wave

From the heart of the storm where it is brought to life by the wind, to the coast it breaks upon, the wave follows a complicated, powerful journey. After having traveled thousands of miles, the wave breaks with a roaring outburst of energy, a magnificent chaos in which water, air, and light are intertwined before our astonished, delighted eyes.

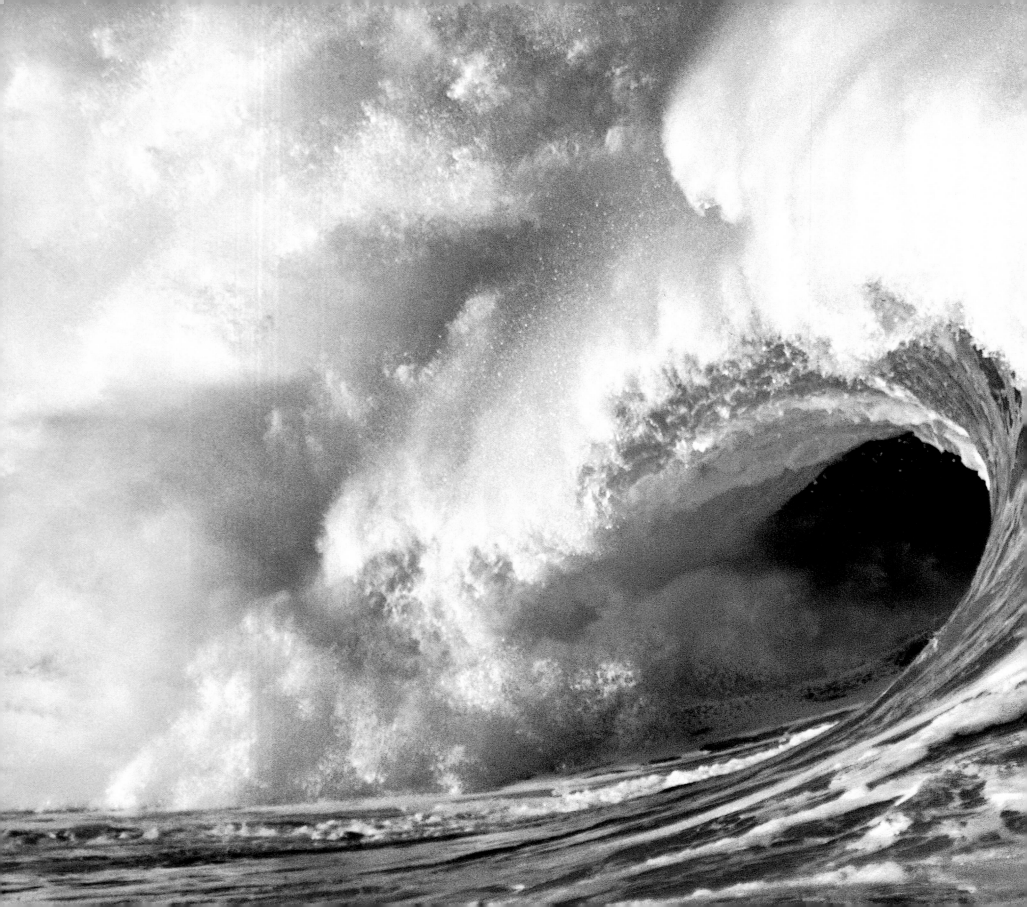

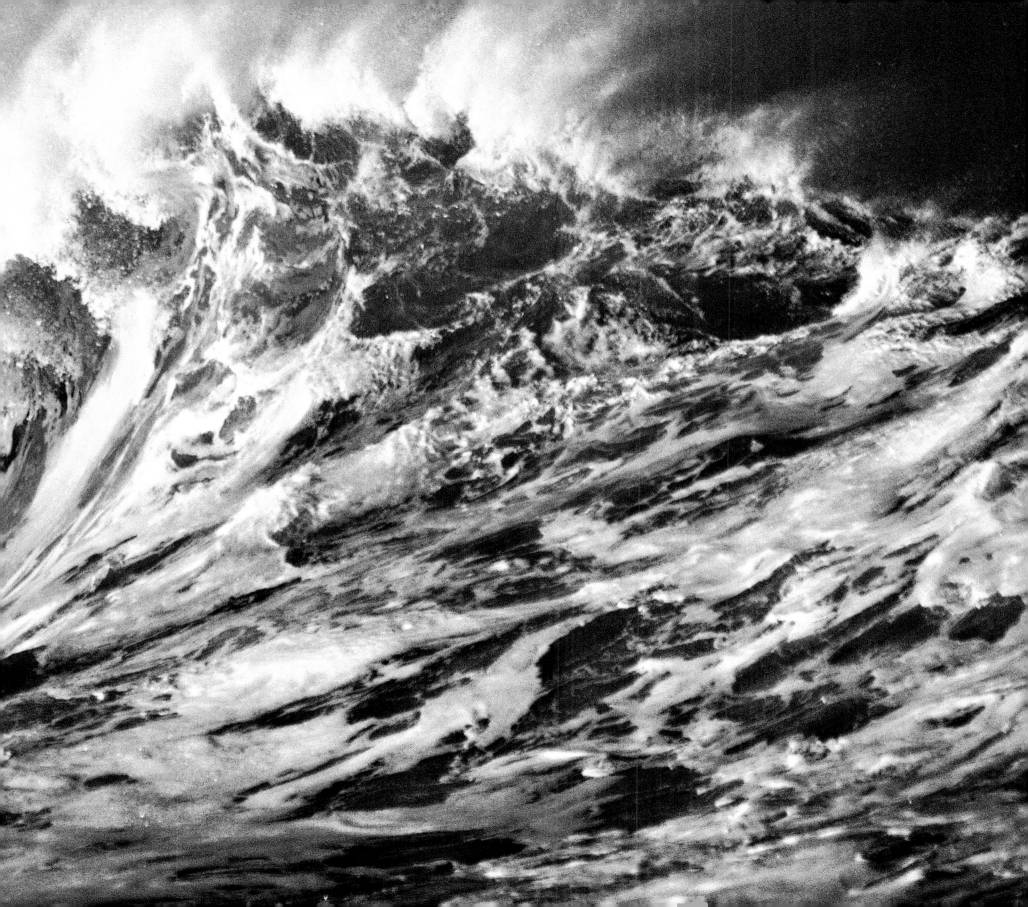

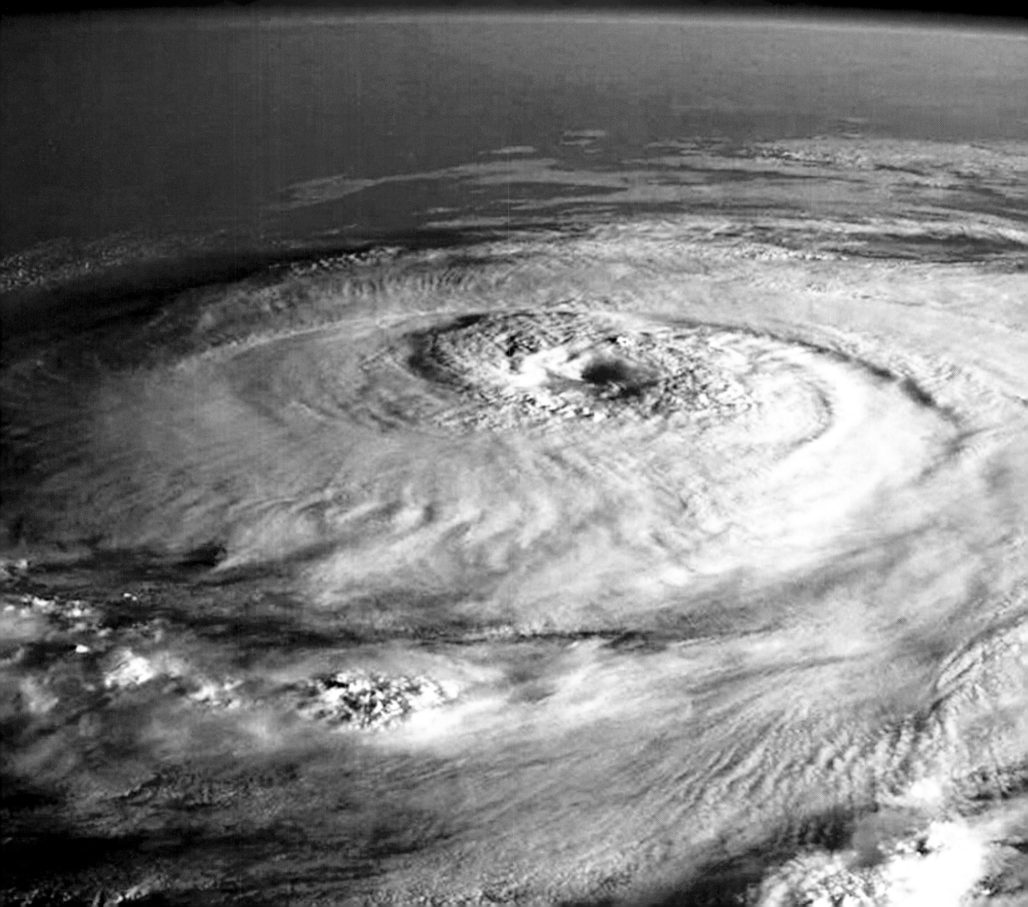

The Sea of Wind

Atmospheric collisions of air masses of varying temperatures create high-pressure zones (anticyclones) and low-pressure zones (depressions). The Coriolis effect, which is a result of the earth's rotation, deflects these masses of air and causes winds. A new wind blows over a calm sea, agitating the surface of the water and creating small undulations. If the wind dies down quickly, the water surface returns to its glassy state. However, if the wind continues, the undulations begin to grow in stature.

Three factors govern the growth of the undulations: the force of the wind, the amount of time it blows, and, finally, the surface area of the section of the ocean over which it blows. This wind-agitated surface, known as the fetch area, will generate the swell. The greater the above parameters (wind force, wind duration, size of the fetch) are, the greater the size of the swell generated. For example, a 25-miles-per-hour wind blowing over a 125-mile surface for 15 hours generates 8-foot swells.

During this growth period, the sea takes on a particularly chaotic aspect. Undulations of various heights, lengths, and directions clash and double over one another. Once certain parameters of intensity and duration have been reached (the exact nature of which are still unknown), the small waves are amplified by a resonance mechanism. The energy thus transmitted to the waves by the wind combines with gravitational forces to compel the waves to travel.

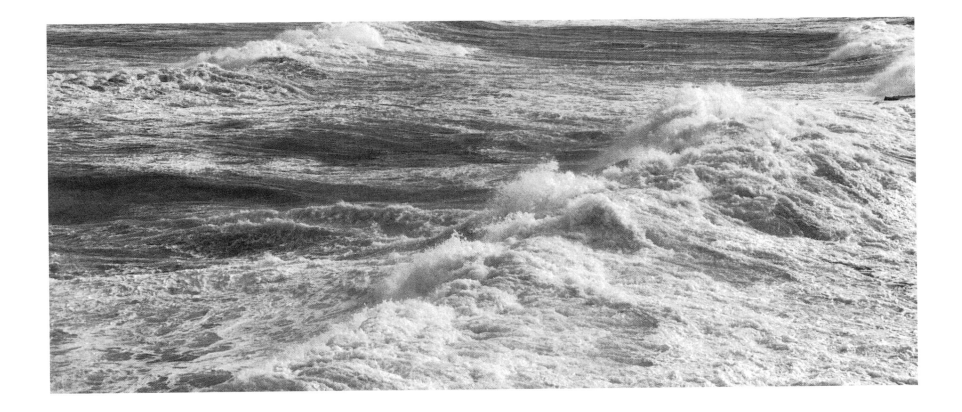

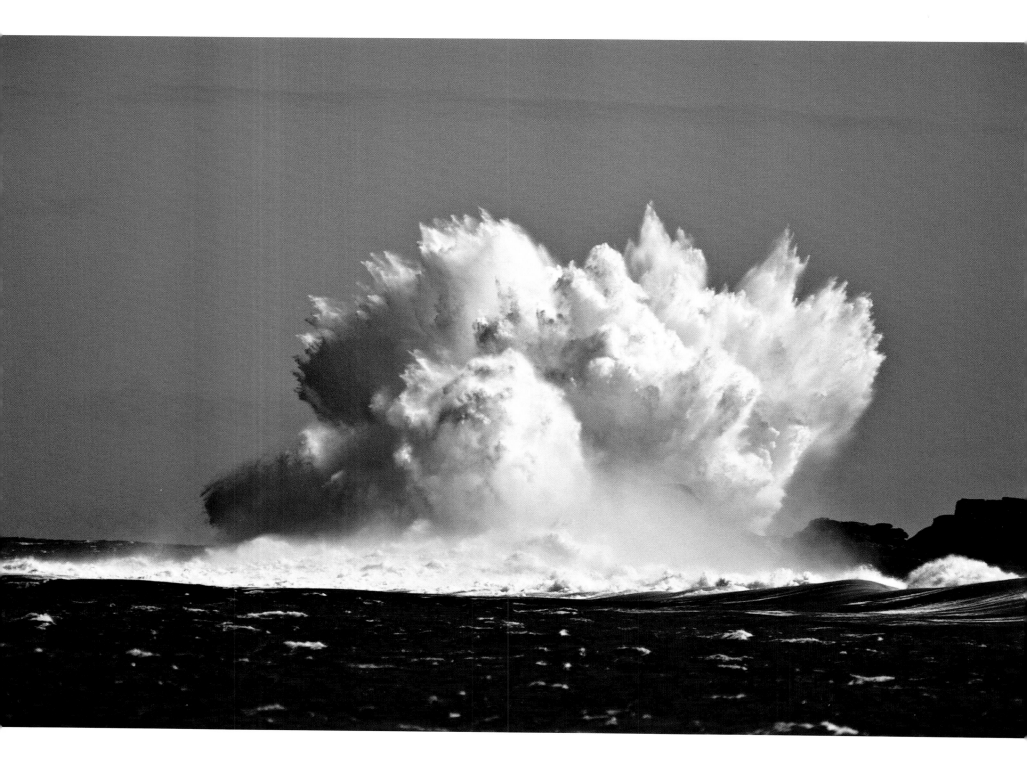

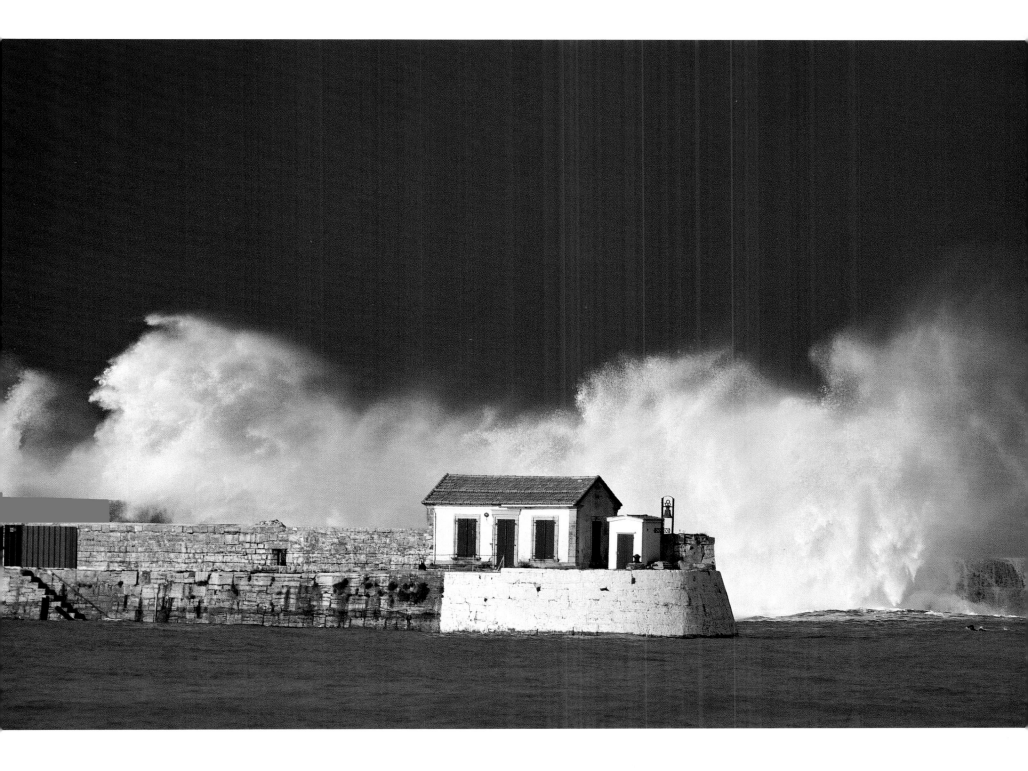

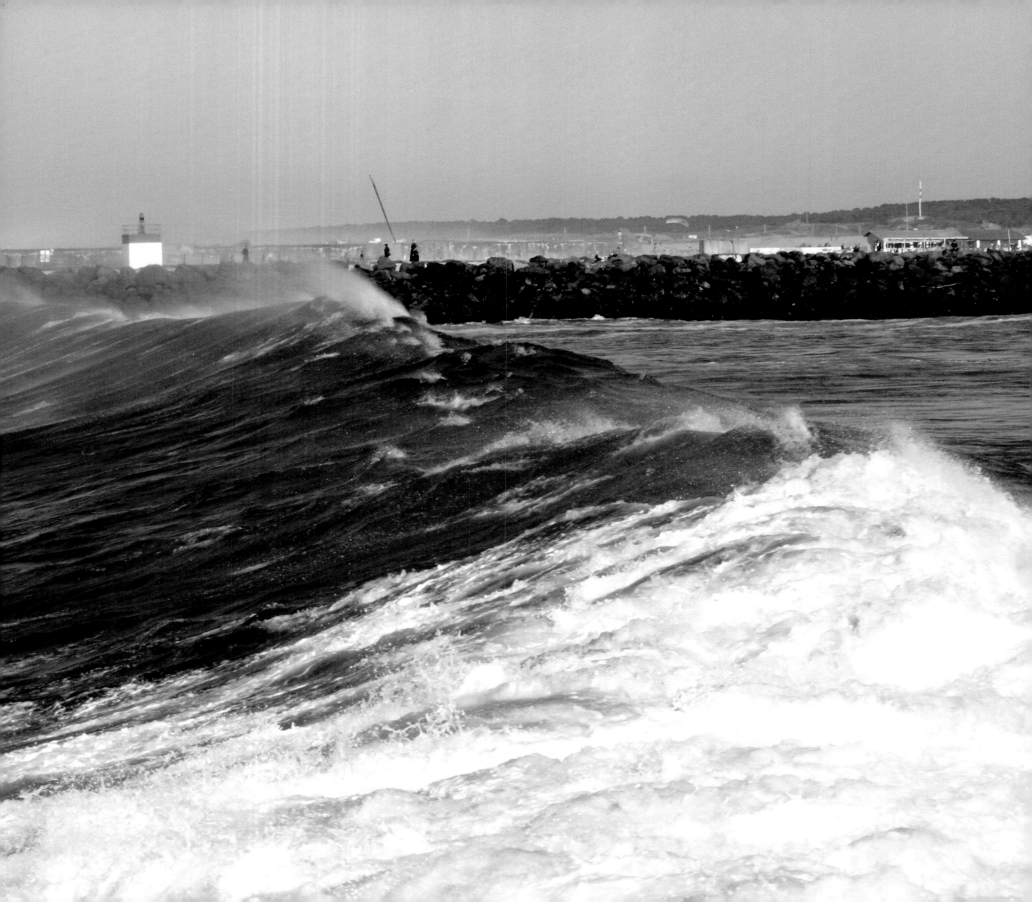

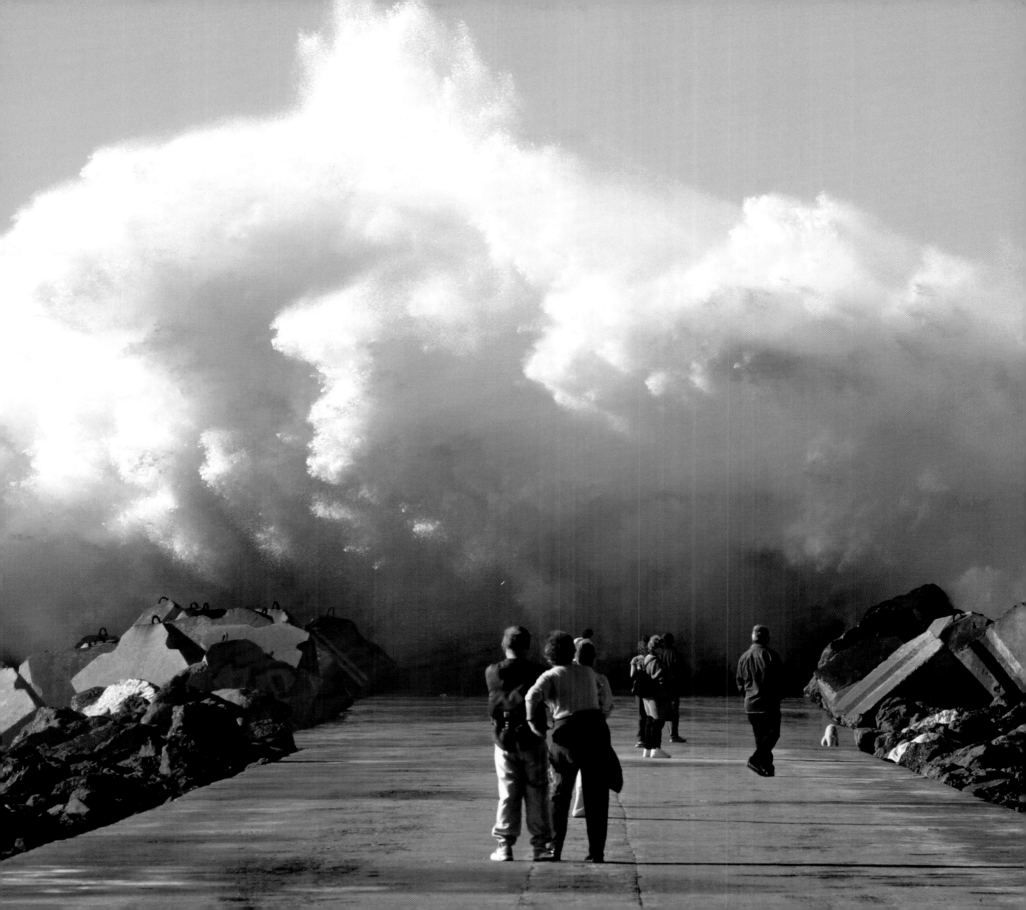

The Swell's Long Voyage

When the wind stops blowing, or when the moving undulations leave the area of the storm, the surface of the sea becomes less and less chaotic. The waves launched from the heart of the depression in the direction of the wind that generated them now change status. They are no longer simply wind-driven waves; they have become authentic swells. The swells now move autonomously and begin a voyage which, for the largest among them, will end on the coast, even if it is several thousand miles away. As the swells are set in motion, a swell filtering phenomenon begins to occur.

Once in motion, the waves making up the swell tend to diminish in size and to spread out. The main swell grows increasingly long as the waves spread out. The distance between the crests of the waves, which is referred to as the wavelength, increases. This phenomenon is known as circumference dispersion.

Though they differ in height, speed, and wavelength, the waves generated by the storm fall into place and go through a sorting process. First, the shortest undulations disappear. The longer undulations slowly begin to dominate through wave interactions and their greater speed. This process is known as radial dispersion, or swell filtering.

As an example of natural selection, swell filtering selects the largest and fastest waves. The lesser undulations gradually disappear. This is how the chaotic sea of wind, provoked by a depression off the coast of Ireland, can generate a long, regular swell reaching the Canary Islands several days later.

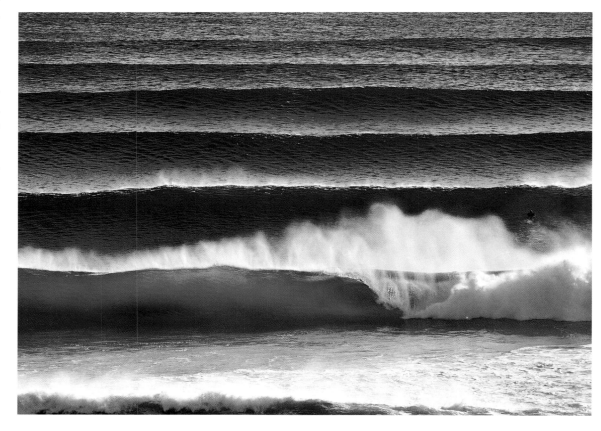

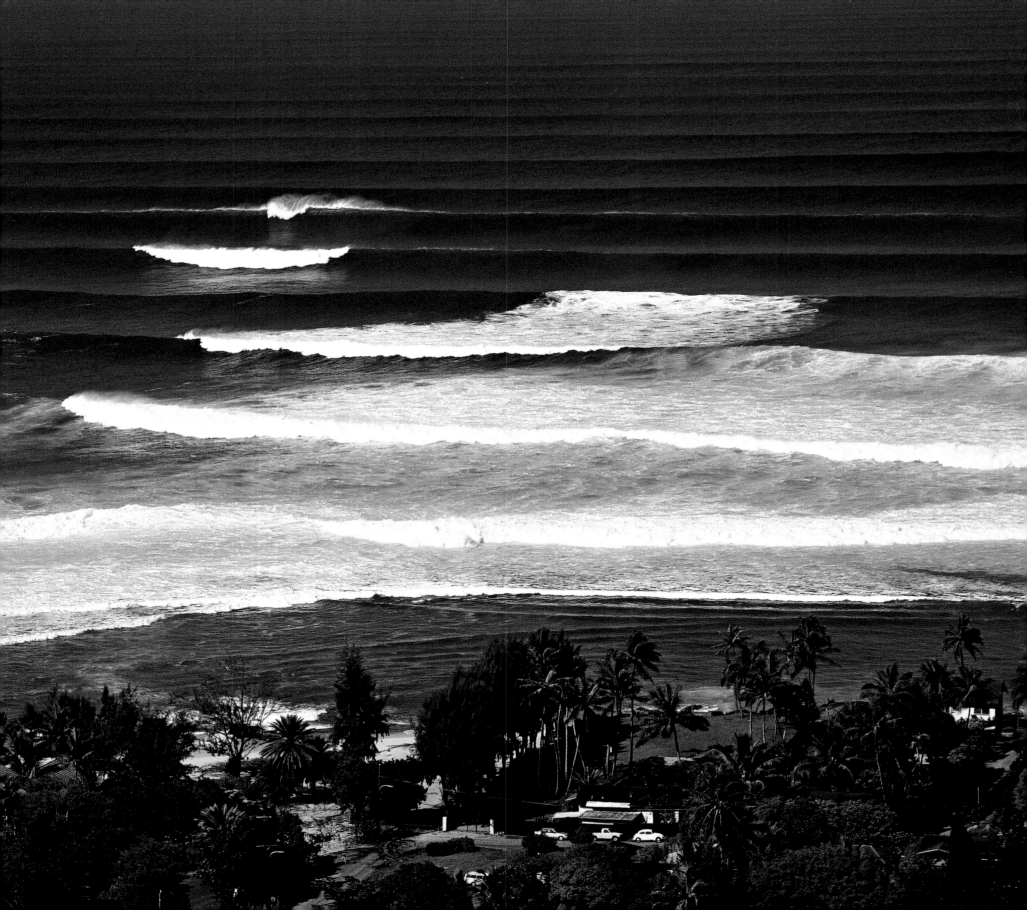

The Marine Wave

In deep water, the swell is similar to a wave. A wave moves according to a sinusoidal law. It is described by various physical measurements: the period, length, and amplitude.

The period of a wave is the amount of time a complete cycle lasts. The wavelength corresponds to the distance between two crests. The amplitude refers to the wave's height.

The swell does not carry water as it moves. If you were to leave a buoy in the ocean, it would rise and fall with the passage of the crests of the waves, but it would not move. In fact, the swell is a wave which carries energy, but does not carry matter. Therefore, floating trash and oil slicks, caused by degassing or oil spills, are not propelled by waves, but by surface currents directly related to the wind over a particular area.

More specifically, when a wave passes, water particles enter a circular motion pattern, then resume their original position.

The higher the wavelength, the faster the motion of the swell. So long as it does not encounter any obstacles, the swell can maintain its speed for hundreds, even thousands of miles. Waves generated in Antarctica can reach Alaska after having covered about 9,320 miles in fifteen days.

A swell can, however, encounter various obstacles over the course of its voyage. It can be subjected to another storm, run into a head wind, or cross another swell's path. When the swell is battered, crossed, or doubled over by another wave, or crushed by the wind, it is deformed.

If you stand on any beach for a while, you'll notice that the arrival of a series of waves alternates with periods of calm. This is because waves have a tendency to gather in individual series of two, three, or even ten waves over the course of their journey. These series are divided by patches of calm water, or by smaller waves. The further the swell travels, the more series will form. These groupings are due to the interference between waves of different wavelengths. The appearance of rows of waves successively rolling onto shore is a result of this phenomenon.

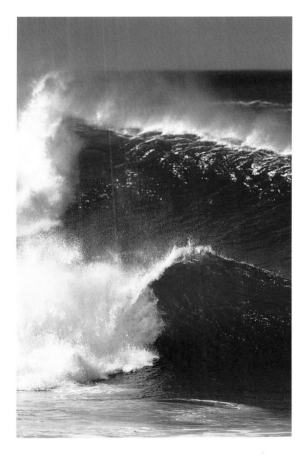

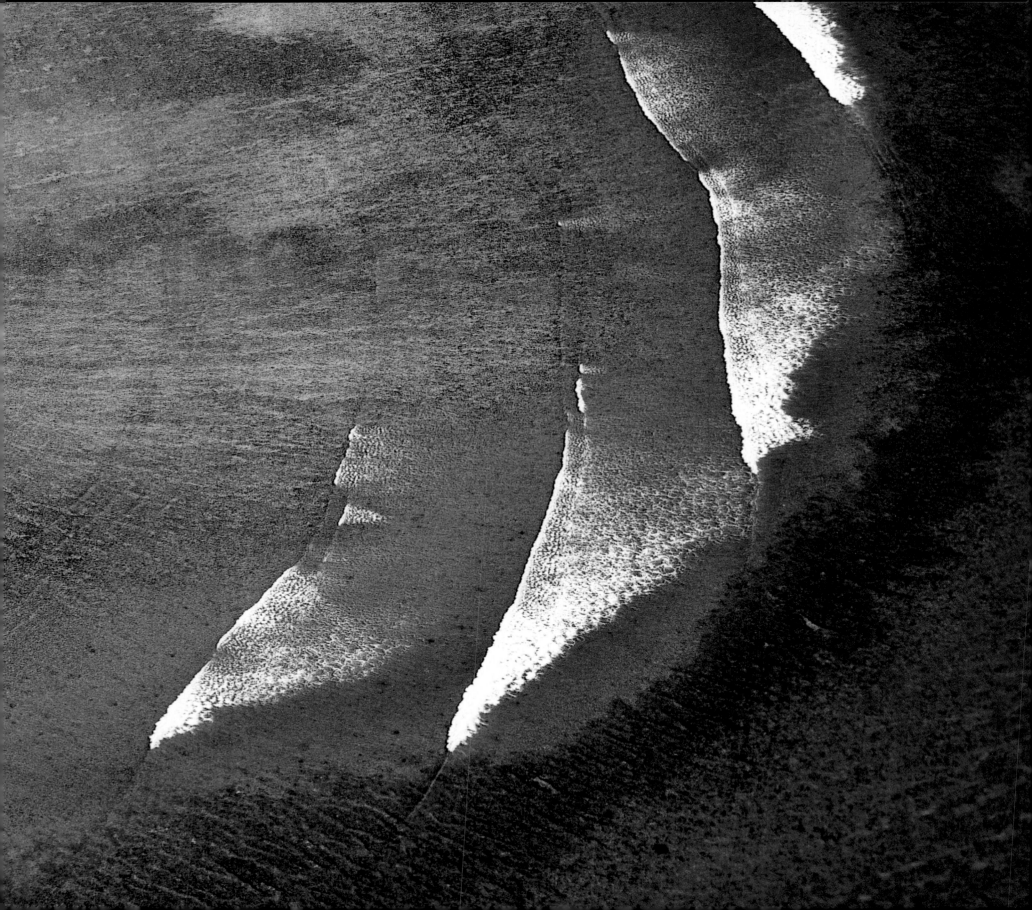

Various Distortions

When the swell approaches the shore, the coast's morphology influences its trajectory as it heads into land and breaks. Just like a sound wave or a light wave, the swell is subject to phenomena of reflection, diffraction, and refraction.

Reflection

When a wave comes up against a hard obstacle, the obstacle reflects part of the wave and sends it back in the opposite direction. Wave reflection occurs along sea walls, and also during low tide on beaches with particularly steep inclines. As it moves back toward the open sea, the reflected wave hits the next inbound wave with full force, sometimes sending great sprays of water into the air. Surfers refer to this reflection phenomenon as backwash.

Diffraction

When the swell encounters a sudden change of water depth, it is diffracted. This phenomenon occurs in ports, where the crests of the waves arch around the extremities of the jetties. In fact, in the area behind a dike, the broken swell loses much of its power creating a sort of energy shadow.

Refraction

Given that the speed of swells diminishes in direct correlation to the reduction of water depth, any part of a wave which encounters a rocky outcropping, a sandbank, or a coral reef slows down. The part of the wave that is not affected by this "braking and breaking" process continues its trajectory, moving through the bay's deeper waters at a steady speed. This process, which is known as concave refraction, alters the swell's trajectory. In a bay, or along a beach with landmasses projecting into the water on both its sides, the waves are subjected to a double refraction effect, which leads them to take on the shape of the bay. This is known as convex refraction.

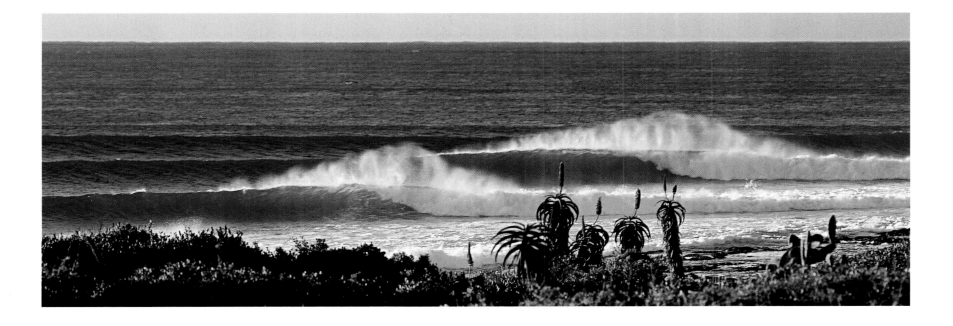

The Refraction Phenomenon

The waves wrap around the rocky outcropping, which is responsible for slowing down the swell and forcing it to break. Meanwhile, the shoulder of the wave continues its path through the bay without slowing down. The wave therefore breaks progressively from left to right, or from right to left, depending on the exact direction it is moving. If it does break left to right, the wave will be called a right-hander, and vice versa. The wall of water erected along the surface of the breaking zone is referred to as the wave's shoulder, and is where surfers wait for waves. Often surfers discover they are sharing a wave's shoulder with dolphins.

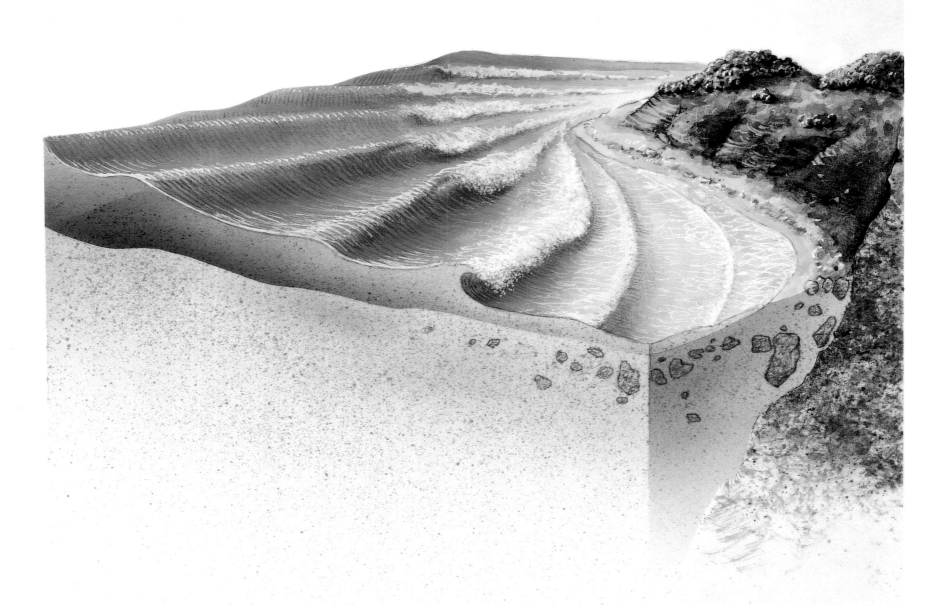

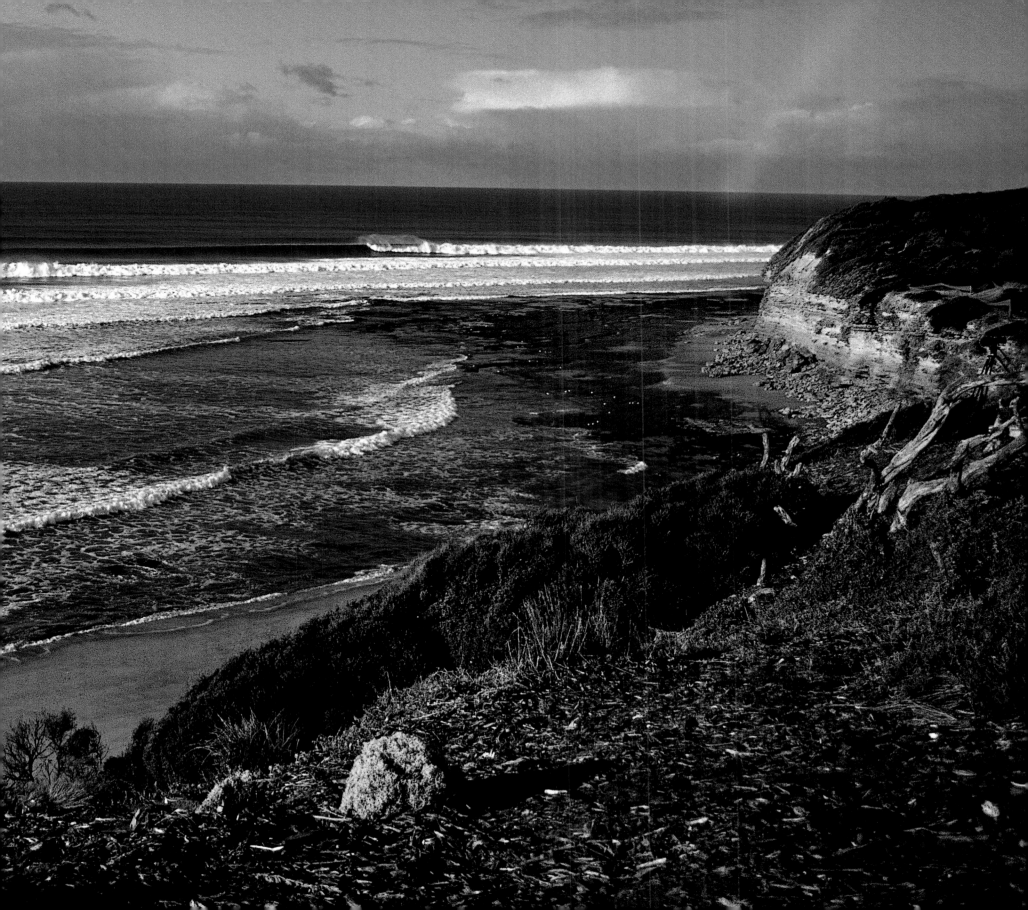

The Chaos of Breaking Waves

When the swell approaches the coast, and particularly the continental plate, its speed diminishes with the decreasing water depth. At this stage, the swell loses its sinusoidal shape and water particles no longer have the room to move in the complete circles described above. The wave's innate energy flow compensates by causing an increase in its height. This phenomenon is known as shoaling. The height of the wave increases until it reaches a critical height, at which point the combination of the constant slowing of the wave's trough by the sea bottom, and the now excessive tilt of the wave's arch makes the wave unstable. When the crest of the wave plunges forward, the wave breaks. According to calculations, a wave breaks when it encounters a water depth less than 1.3 times its height.

As can be seen from any beach, waves have different ways of breaking. The way the wave breaks principally depends on the nature of the sea bottom and the wave's open-sea wavelength, along with wind conditions along the shore. There are three types of breakers.

1. Plunging breakers are the most spectacular. These generally occur with medium to long, fast swells, on beaches with steeper inclines. The wave's loss of balance is so extreme that the crest of the wave is projected forward and smashes into the trough. This creates the "tube," so sought after by surfers. Offshore winds delay the point of instability by holding up the wave's erect wall, thereby accentuating the tube effect. Plunging breakers bring significant masses of water crashing down on the water surface, the beach, or surfers. After all, a mere 35 cubic feet of water weighs close to one ton.

2. Spilling breakers are principally seen on beaches with minor inclines. The wave's loss of balance is slow, and its crest spills and slides progressively along the incline as it breaks. The shorter the swell on the open sea, the more likely it will generate spilling breakers. An onshore wind pushes the crests of the waves forward, causing them to collapse into foam before the point of imbalance has been reached.

3. Surging breakers occur when the beach's incline is very steep. In these cases, the wave collapses on itself. Contrary to the other two types of breakers, surging breakers are very rarely seen on the French Atlantic coast, and are more frequently encountered on the Mediterranean. Surging breakers are also observed along the shores of a river, or in a boat's wake.

The foam produced by breakers is a mixture of water and turbulent, unstable air, which accompanies the sudden release of much of the wave's energy as it breaks. The sound of a wave breaking, of moving water as it hits the water surface, can be incredibly loud. This is why we often hear the sound of the ocean deep inland. Having braved the elements, crossed the oceans, and broken on sandbanks or rocks, the wave dies on the beach or the shore, sapped of all its energy.

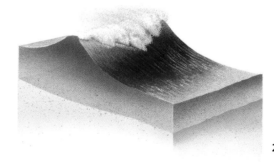

1

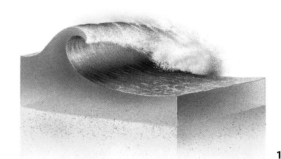

2

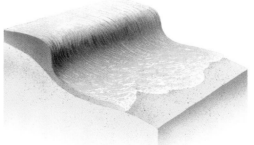

3

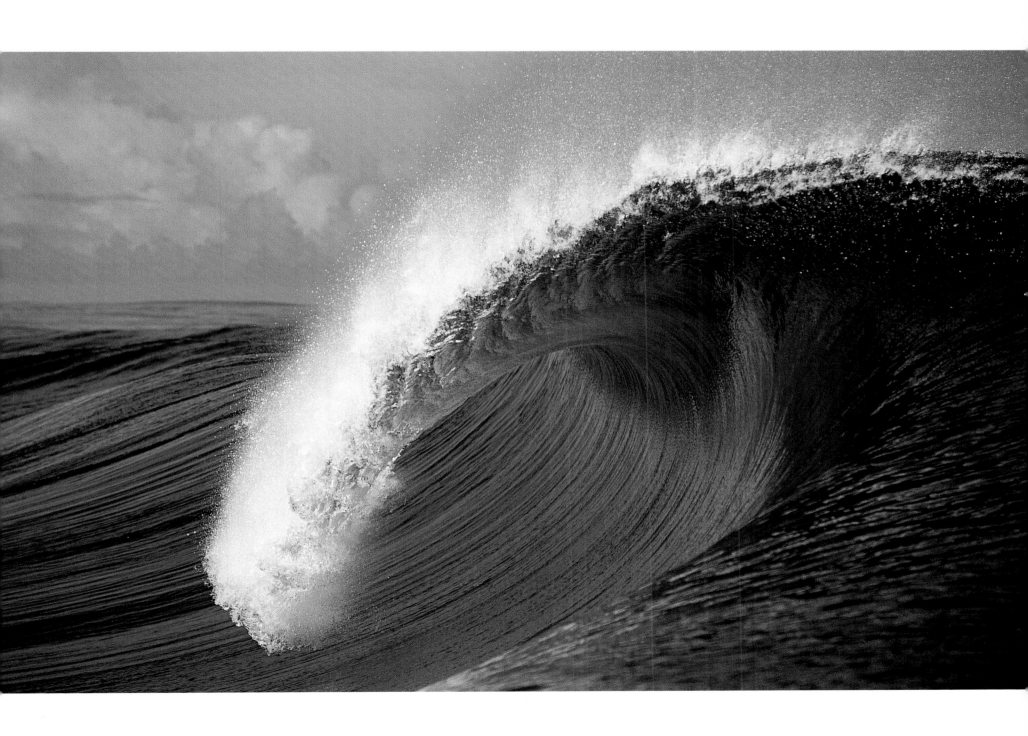

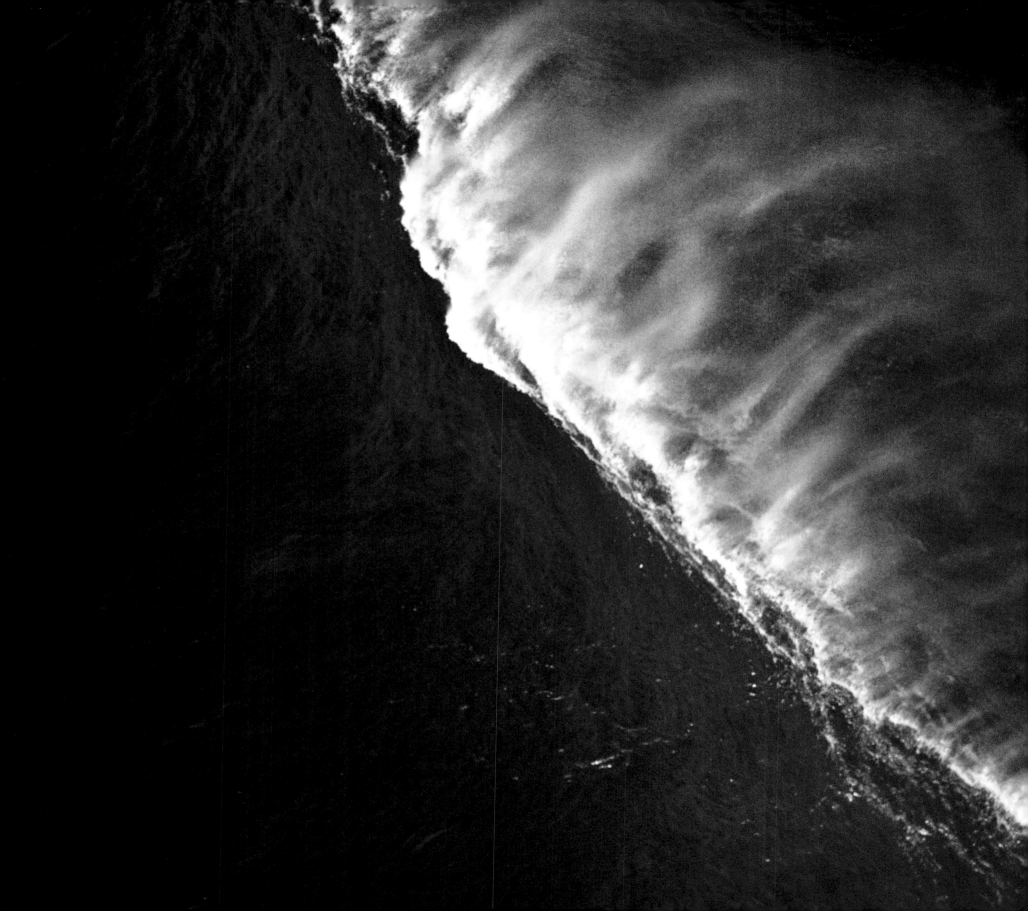

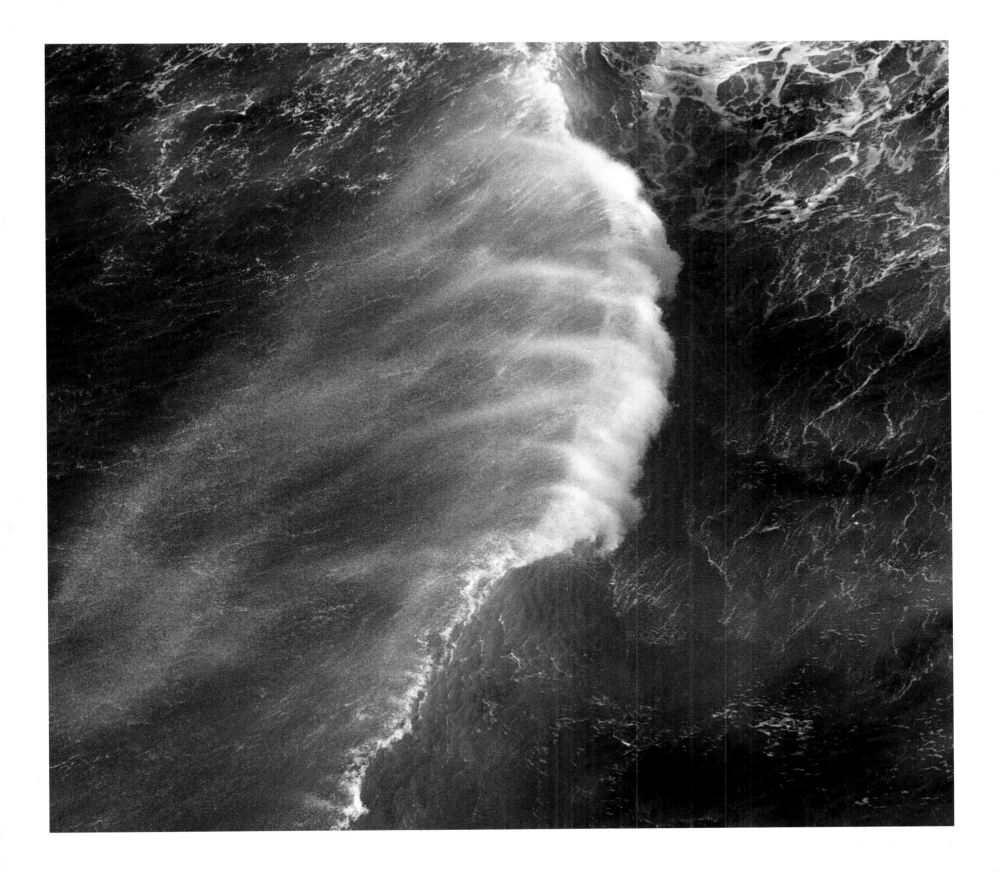

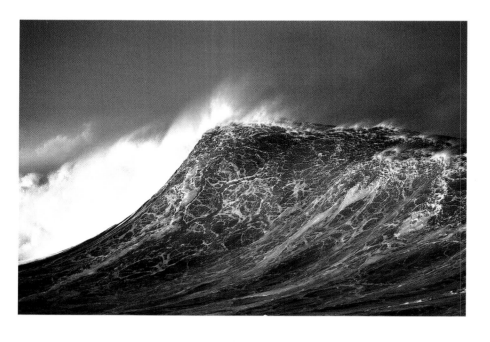
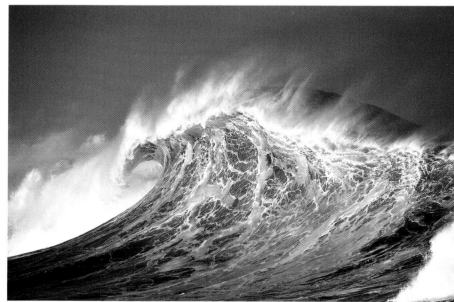
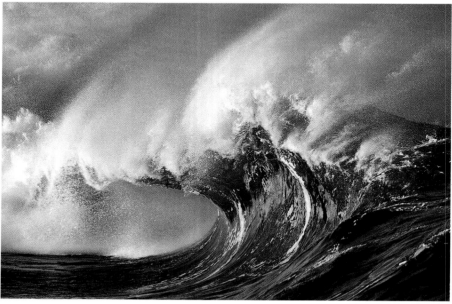
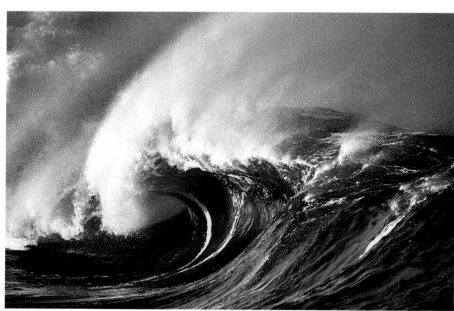

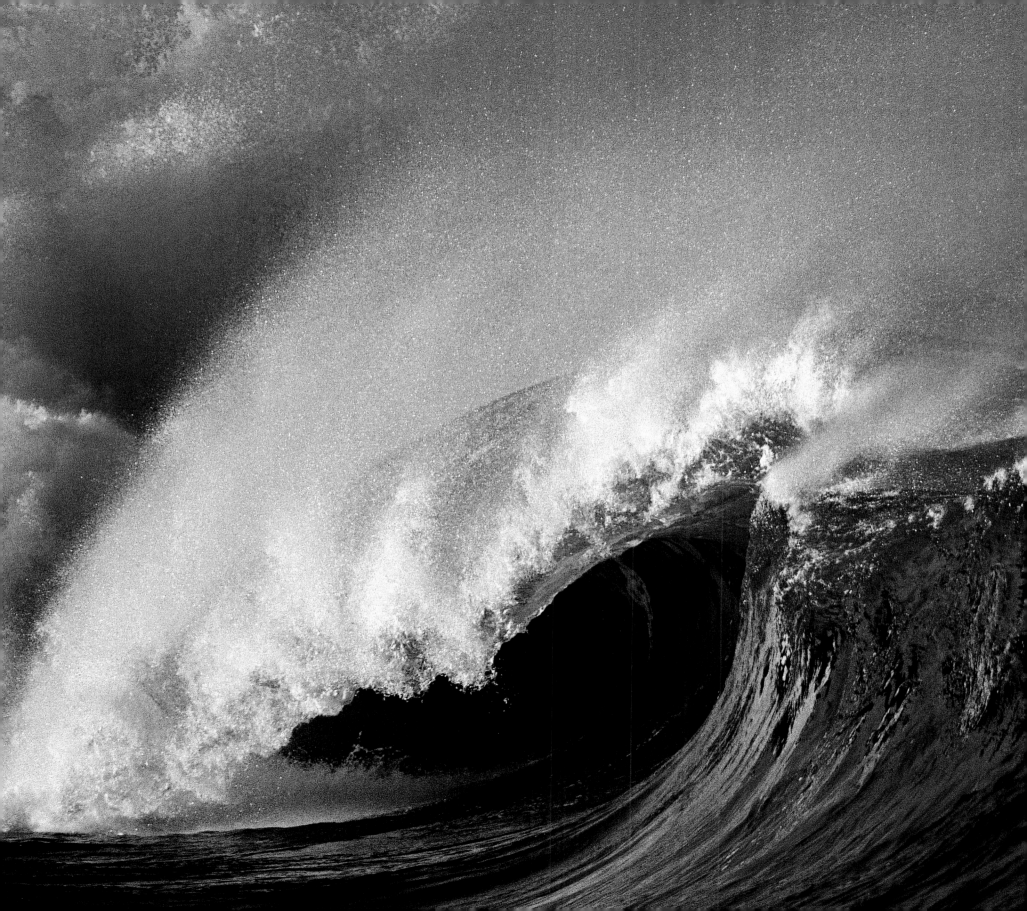

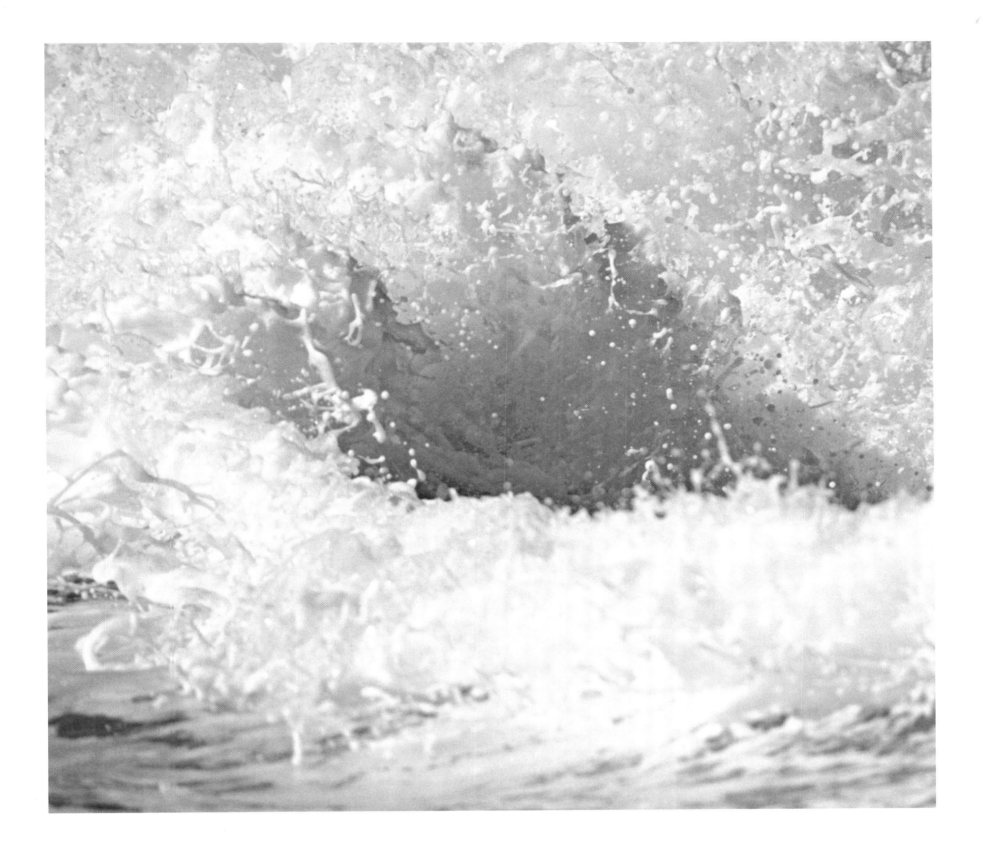

Tomorrow There Will Be Waves

Forecasting (and commenting on) the weather is an age-old, universal human activity. Though significant resources and apparatus have long been deployed around the planet and even into space, the prediction of coastal waves is a relatively new, developing field. In fact, the existence of coastal waves was long considered insignificant, for man had wisely chosen to settle in coastal areas protected from the waves, such as inlets, bays, or landlocked bodies of water.

Nevertheless, beginning at the end of the last century, an ever-increasing number of surfers started taking an interest in wave forecasting. After all, good surfing days are not so common. Forecasting has consequently become an essential factor for optimizing an upcoming session, anticipating a dawn surfing outing, or planning a weekend. Surfers have learned to read isobaric weather maps. Newspaper weather maps promising, for example, depressions off the coast of Ireland were long the surfer's best tool to prepare for great swells. But in the last few years, the development of communication technologies such as mobile telephony and the Internet have pushed wave forecasting forward. Anti-cyclone movements and the formation of atmospheric depressions around the globe are constantly followed and analyzed. Innumerable sensors placed throughout the seas and oceans record wind speed, air and water temperatures, and the direction and height of swells. Mathematical models digest all this data and generate 24-hour, 48-hour, and 72-hour forecast maps on a continuous basis. Strategically placed buoys provide real-time indications of the swell's inexorable advance. We have reached the point where any surfer can acquire information by picking up a cell phone or clicking a few buttons: long-term forecasts, a daily photo update of a favorite beach, or a direct video feed of the best surfing spots in the world. Someone in a midtown-Manhattan skyscraper can now lean over to a colleague and enthusias-tically whisper, "The wind's coming in from the west in Sydney!"

Even better, the best tow-in surf teams in the world now eagerly watch the Web for the exceptionally hellish conditions generated by a potential hurricane. Permanently connected to all the relevant sites, they patiently await the arrival of the giant swell they consider their very own Holy Grail. These surfers are ready to jump in a plane at a moment's notice, to fly anywhere on earth, just to have their shot at the biggest wave ever surfed—the 100-footer. For them, knowing everything in advance is essential to keeping their date with history.

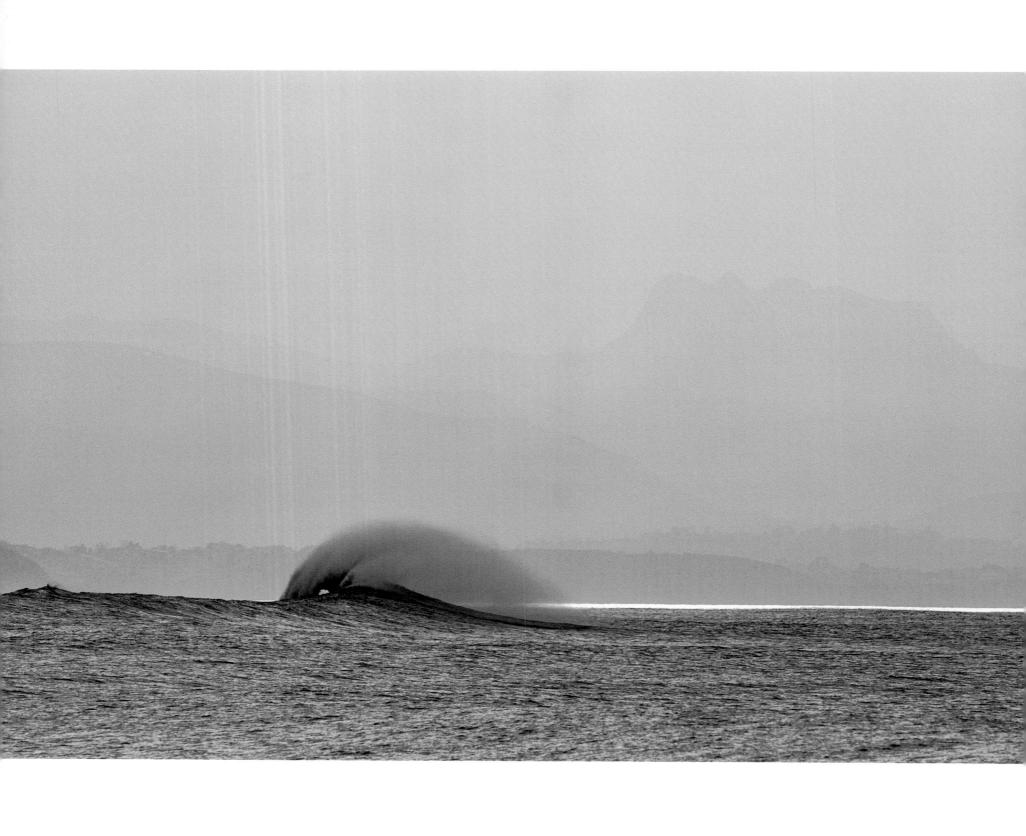

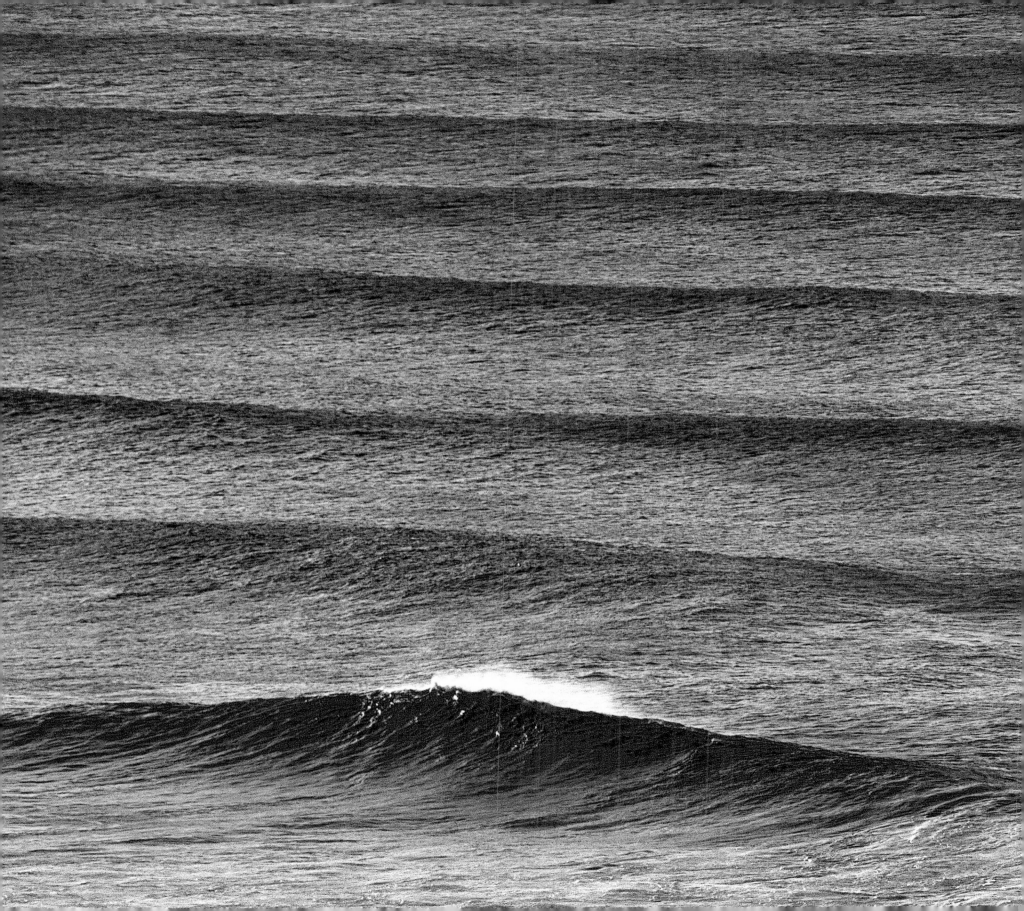

The Birth of the Surf Spot

The concept of the "surf spot" is a very specific one. A surf spot is an exact place where you can find a good wave. It could be a beach, or just part of a beach, a specific rock in front of a specific cliff, the carefully chosen best side of a bay, or even a sandbank indicated by a trash-littered Christmas tree, swept up on the beach.

The few miles of Hawaii's North Shore, for instance, contain a dozen legendary spots: Waïmea Bay, Backdoor, Pipeline, Sunset... Yet all of these mythical spots, each of which has been photographed thousands of times from every angle under the sun, are only a few hundred feet apart, sometimes less. These world-renowned spots are an essential part both of Hawaii's heritage and of the surf planet. Surfers have no choice but to be world-travelers: eternally on the search for that perfect spot, which will satisfy their craving for adrenaline-unleashing thrills, they must surf the world's best spots to pass the rites of initiation, which will turn them into authentic surfers. Back when there weren't so many surfers, the pioneers of the sport happily gathered around an open-air fire, or, more likely, along a bar, in some far-off place, and exchanged information, tips, hunches, good leads, and cautionary tales about surfing destinations. A strong oral tradition disseminated the names and characteristics of surfing spots. Surf tradition built up legends and unofficial rankings and categories. Hazy nights of drinking often led incorrigible locals, always boundlessly proud of their homebred peaks, to give away their best-kept secrets and the keys to their paradises. The morning after would find them hung over, sharing the local treasures with newcomers who had no intention of leaving.

But our civilization is based on the written word. Soon after, passionate surfers secured the support of businessmen with a taste for surfing to publish the first books and articles that methodically listed surfing conditions around the world. Locals suddenly witnessed the arrival of hordes of tourists who had turned their backs on museums and monuments to hit the beach with a surf guide in hand and a surfboard in tow.

An increasing enthusiasm for board sports, combined with a growing interest in nature, the development of our leisure culture (including fashion and marketing) and, especially, the greater accessibility of these types of sports, have led to the overpopulation of great spots. Spots are governed by a primitive law: one surfer per wave, and several waves for a good surfer—which doesn't leave much for the others. Surf spotting could atone for its sins by adding new destinations, sending one expedition after another to remote war-torn countries, along wild, inhospitable shores, and to isolated islands infested with mosquitoes. Wouldn't it be nice to send all the surplus surfers (and maybe even all the beginners) to those far-off places? How would you like to go and discover the waves of Alaska, of the lost islands of the South Pacific, of the Persian Gulf, or, (why not?) of the Amazon River? In short, the potential is immense, and the reservoir is untapped. We've just discovered water on Mars. There are still great days ahead for surf spotting.

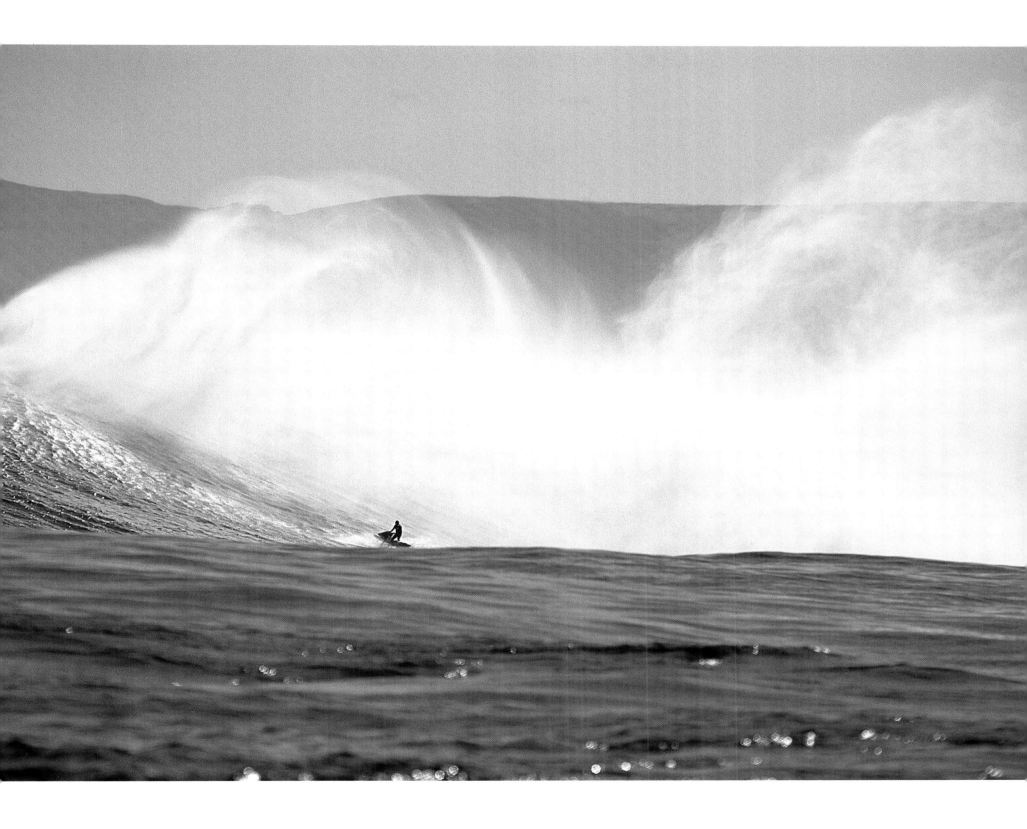

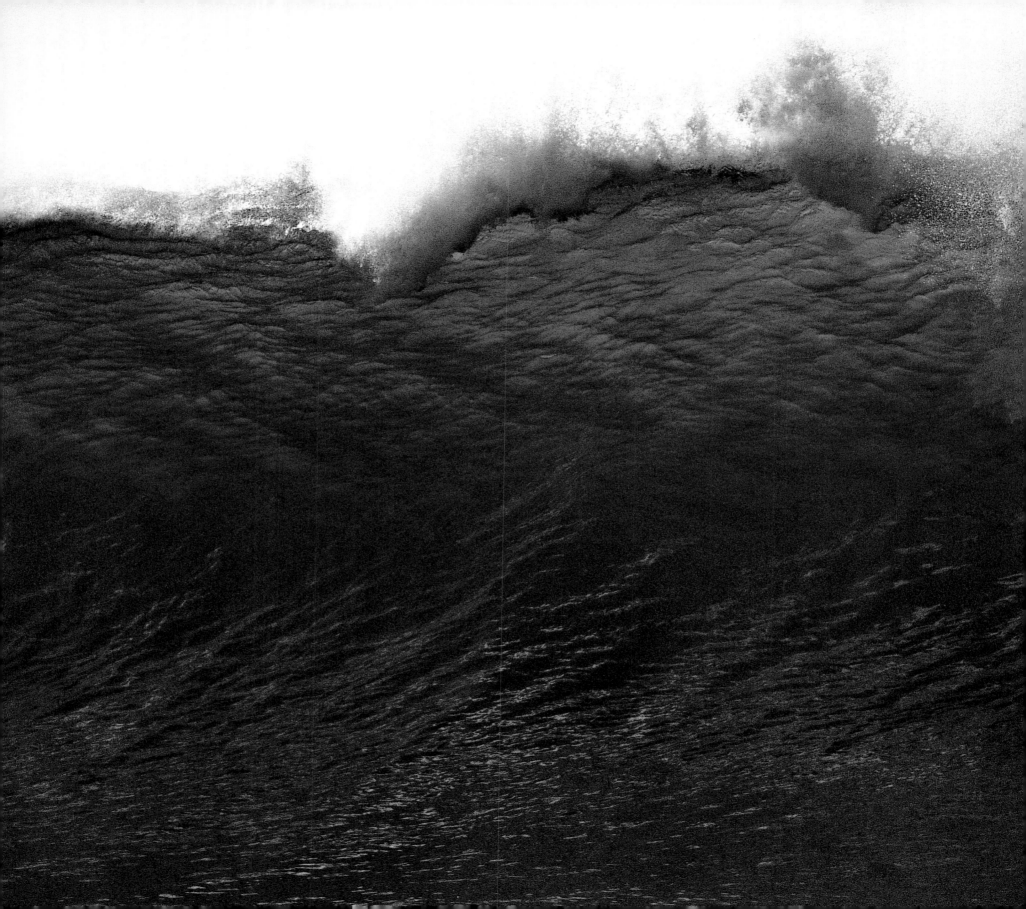

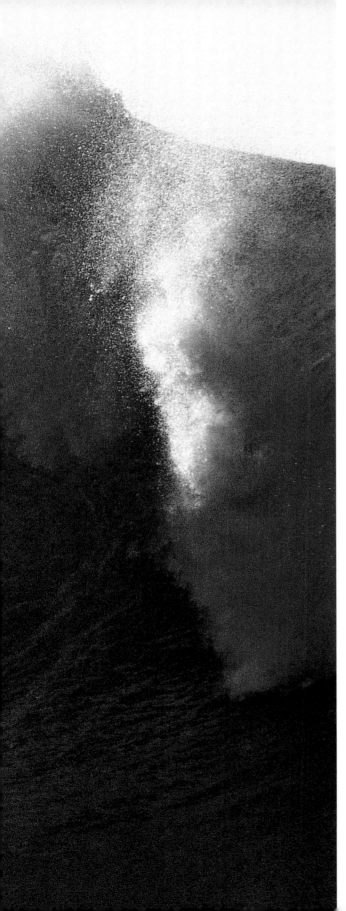

Other Waves

Waves are not all generated by swells. Tidal-bore waves appear on certain coastal rivers when the tidal water moves upstream. This phenomenon takes place at low tide when a significant tidal range is present. The river must also have a strong rate of flow and be relatively shallow. When these conditions are met, tidal water moving upriver runs into water moving downstream, causing a succession of several upriver waves moving through the river's shallow areas.

On the Brazilian Amazon, the tidal-bore wave is known as the *Pororoca*. It can be up to 10 miles wide at the mouth of the river, can reach a height of 23 feet, and can travel upriver for more than 600 miles.

Freak waves are a far more dangerous type of wave, for they are totally unpredictable. They are every sailor's worst nightmare. A freak wave is a wave so massive that it bears no relation to prevailing weather conditions. The stacking of several excessively large waves creates this wall of water, which may or may not break. On January 1, 1995, during a regular storm generating 32–39-foot waves, the *Draupner* oil platform in the North Sea was hit by a giant wave. The wave severely damaged the platform's lower deck, which was situated at 59 feet above sea level. The height of the freak wave was estimated at 100 feet!

A wave that has become tragically all-too familiar is the tsunami. A *tsunami* (also mistakenly known as a tidal wave) is a giant wave that destroys everything in its path and can even penetrate far inland. An underwater earthquake or a landslide can set off a wave, the propagation speed of which is proportional to the square root of the water depth. This wave can cover tens of thousands of miles. The 2004 Indian Ocean Tsunami killed more than one hundred thousand people across thousands of miles. Possibly the biggest tsunami ever recorded was the 229-foot wave, which devastated the Kamchatka peninsula in Russia in 1737.

Standing waves are seen along the coast in areas where tidal currents move against the swell. The speed of the current must be equal to or greater than the swell's propagation speed. In these cases, the wave breaks on itself and remains at a standstill before it disappears. This type of wave also occurs in rivers with particularly high rates of flow. For instance, locals regularly surf a standing wave in the very heart of Munich, Germany.

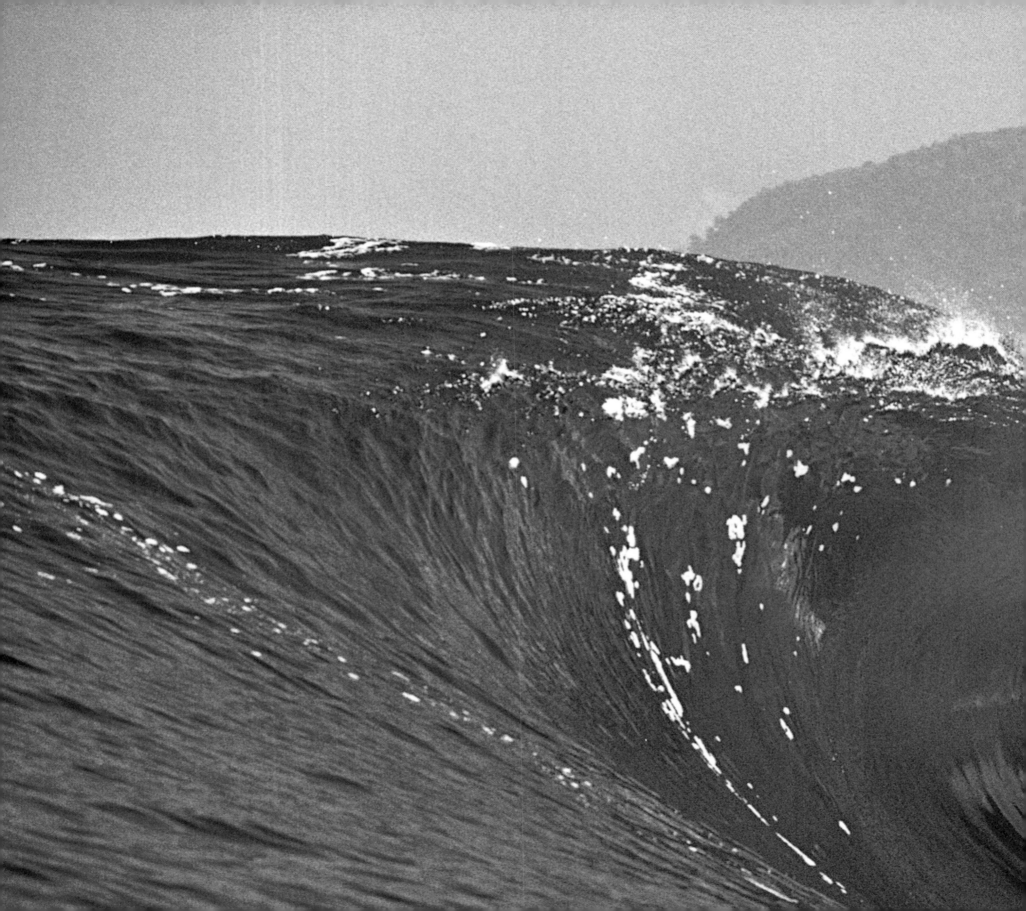

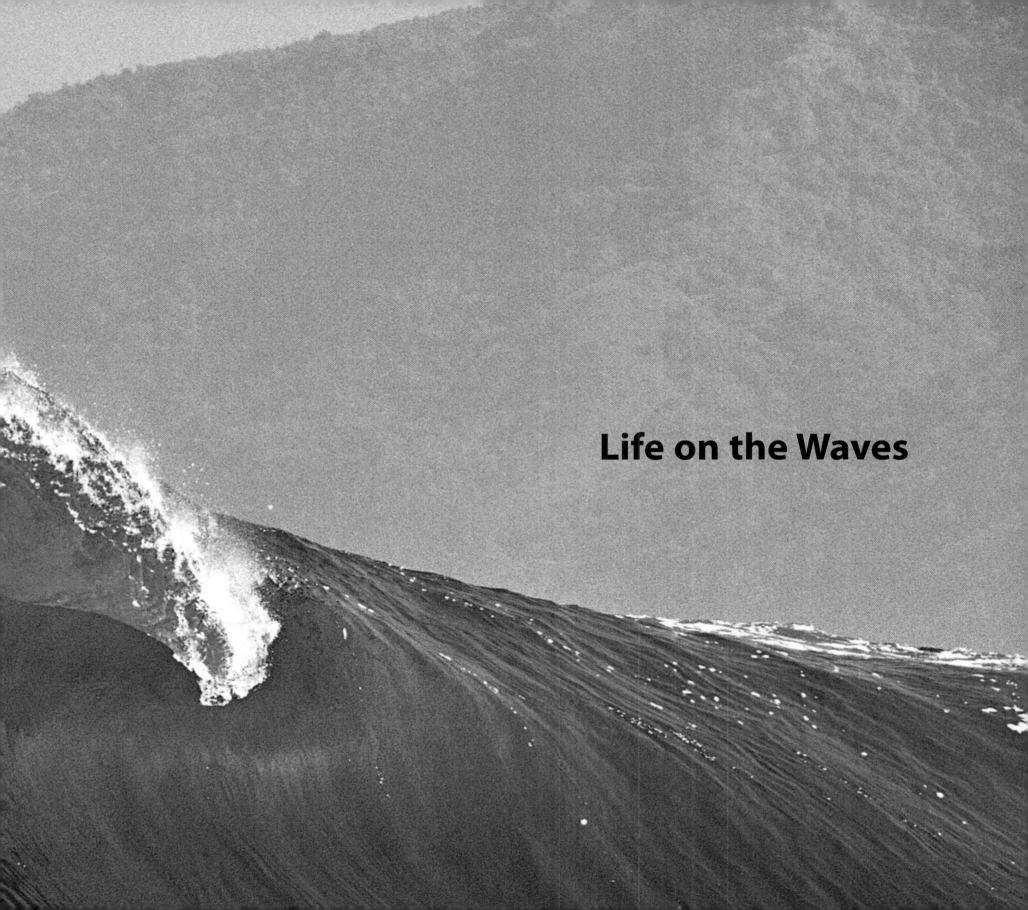

Life on the Waves

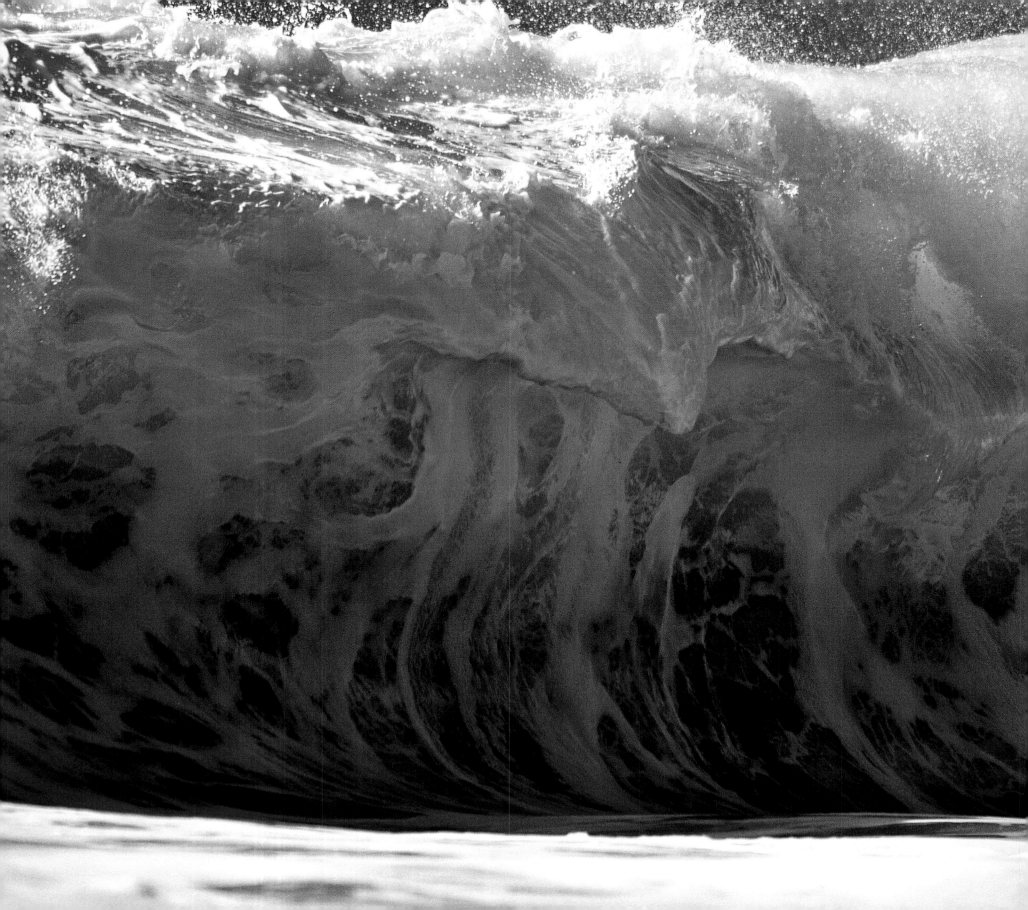

The Violence of the Shorebreak

The sunbather, tugging on her wide-brimmed straw hat and making sure her sunglasses were in place and the sunscreen well spread, did not notice the powerful shorebreak (any shallow-water area where waves break in frequent succession) rising 60 feet below, sucking up all the surf as it bore down on the beach. She thought it was the time to dip her feet in the water and enjoy the beach.

Out to sea, the wave was looking like a 6-foot wall of water, and a vast sheet of saltwater was rushing across the beach at 55 Knots (60 mph), heaving all the sand into its break in one impeccably fluid sweep.

Her eye was drawn to the powerful backs of swimmers diving under the wave some 60 feet from her. Kids squealing with delight charged up the beach to get away from the wave.

Then the wave exploded with a sinister snap, and the children screamed twice as loudly. The wave rolled into itself and plowed up the beach, buttressed like a tractor on an incline. The torrent of white foam caught everything in its path, snatching up plastic toys and spitting out flashes of tangled limbs and brightly colored bathing suits. By the time she thought to look, it was already too late—she had already been tackled by 15 inches of unbelievably violent, furious water.

Emerging from the froth, completely disheveled and coughing up water, the sunbather saw a young man lying nearby, flat on the ground, his hair full of sand and a broad smile on his face. He commented, "That was one violent break."

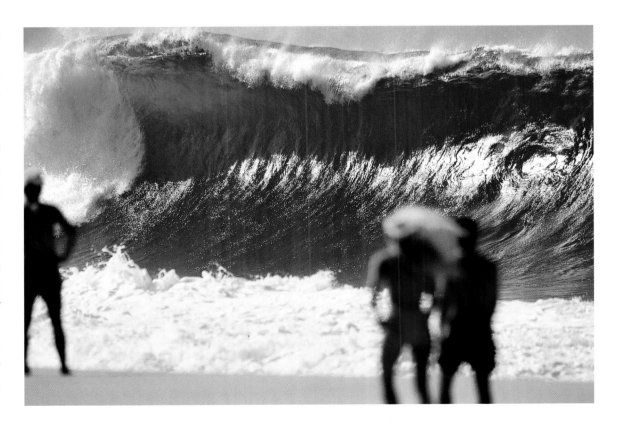

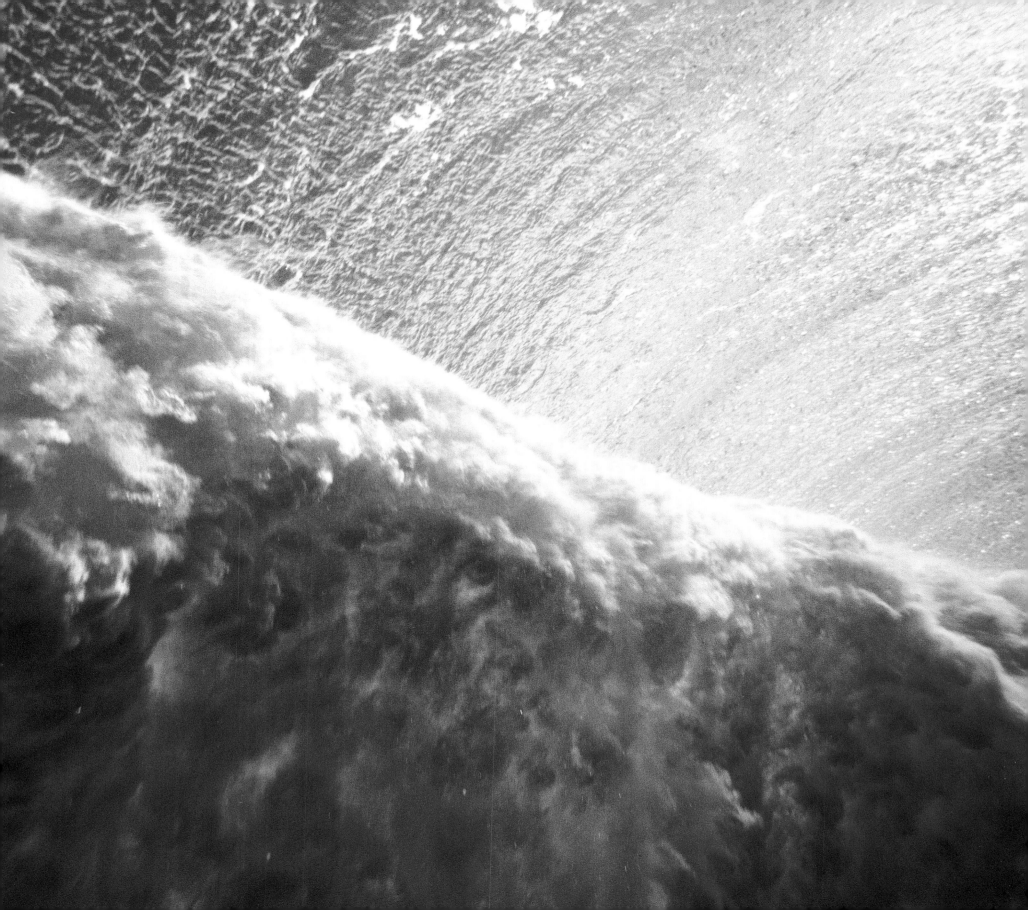

The Washing Machine

The best metaphor for being sucked up and dragged by a wave is a washing machine. Washing, spin-drying, rinsing: you're put through the whole cycle. First, the wave lifts you up, with the unsettlingly gentle, silent sweep of an elevator. The wave nestles you against its flank, then pauses to allow you a moment to realize what is happening to you. And then the lip hurtles forward, dragging you with it on its dizzying path, exercising the total control of a Judo master over your rag doll limbs. The wave pitilessly spits you out as you're about to hit the surface. You're stuck beneath the water, desperately trying to keep your eyes open and your mouth closed. Your surroundings are dark and foreboding. A whirlpool of frothing foam catches up to you and crushes you. Like an unstrung puppet, you go spinning through the water, your feet flying over your head so many times that you're unable to determine whether you're swimming toward the surface or the sea bed. You let the rushing water drag you toward the beach, waiting to let the whirlpool settle before you return to daylight. Your lungs are burning. The ordeal may last only a few seconds, but they're seconds that leave you desperately gasping for breath for lingering minutes after it's all over. You pop up to the surface like a cork projected from a champagne bottle, your eyes stinging from the salt, your mind groggy, and your body trembling with shock. Just in time to be rinsed, when the next wave hits you right in the face.

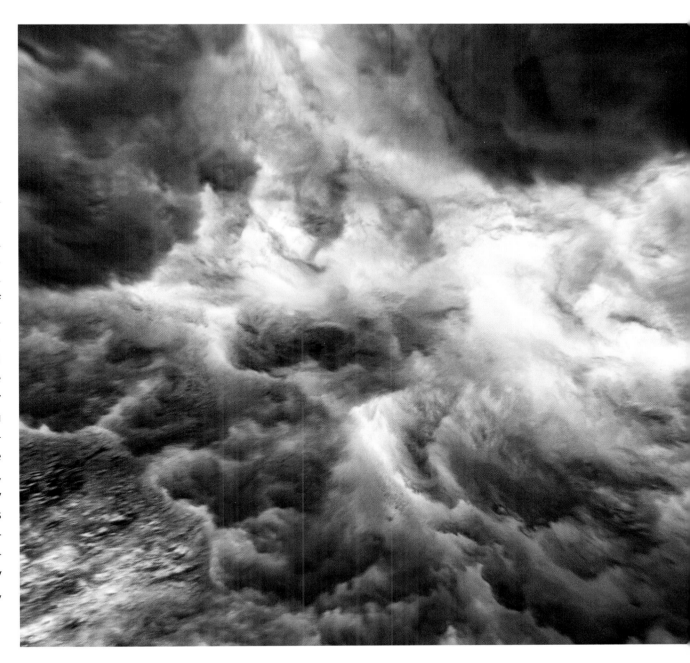

A Primitive Fear

Those who face waves have innumerable ways to describe fear. Adrenaline often comes up, though it is actually a symptom rather than a cause. Surfers also frequently talk about respect, and humility, to evoke the terrifying feeling of inferiority inspired by the ocean. But more often than not, surfers do everything possible to avoid the word itself, as if admitting to one's fear was a sign of cowardice. Fear grips whomever dares to face off against the ocean: swimmers, surfers, and sailors. Before seafarers have even seen the water and evaluated the challenge, anxiety distills its insidious venom in their nervous systems, making them stronger, or more vulnerable, depending on the person or situation. Fear of waves reaches down to our most durably coded genes and brings our most primitive instincts and survival reflexes back to the fore. Run or fight. Submit or react. Fear can prove a tremendous motor. It can allow us to evaluate a crisis more quickly and accurately. Fear pushes you to get away from the rocks you've dangerously drifted toward. Thanks to fear, you get back to the security of deeper water as quickly as an endangered marine mammal would.

Fear helps, but only up to a point. Then it reaches its most disturbing level: panic. Panic blocks reflexes and muddies our lucidity. It is uncontrollable. Sea rescuers will confess to occasionally having to resort to physical violence to stop a panicking swimmer from dragging them down.

Even when fear stops short of panic, we should be wary of overexposure to its effects. Regular confrontations with the ocean cause rushes of adrenaline and endorphins which act like a potent drug, leaving a string of haggard, burned-out wave junkies in their wake. It is an addiction that can condemn the slightest social impulse to back down. Am I scaring you? That's exactly what I'm talking about.

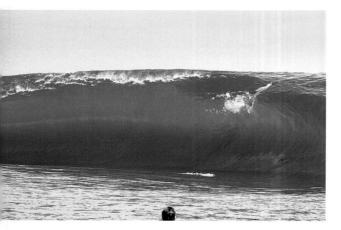
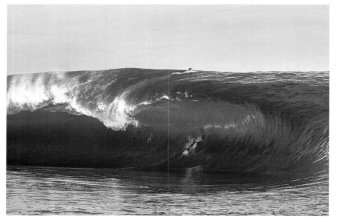
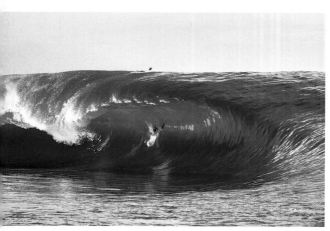
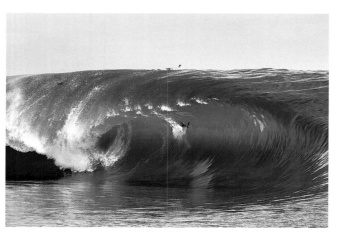

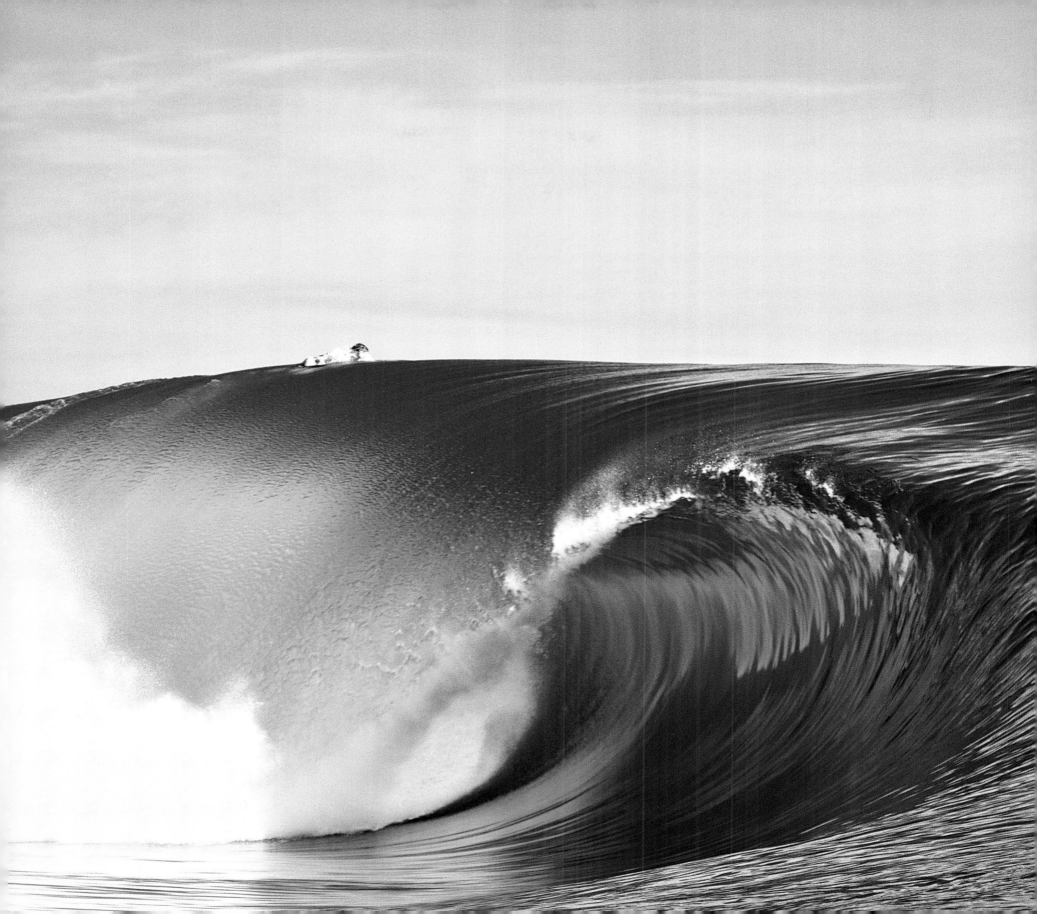

Baïnes: the Ocean's Traps

The *baïne*—"small basin" in the Occitan language—is a fascinating phenomenon found on the most beautiful beaches of the Gironde and the Landes regions. While waves present an obvious, massive, and frontal danger, the menace posed by the baïnes is far more insidious, even treacherous.

Baïnes (known in English as "rips") use the invisible forces of the ocean to spin their implacable web, a deadly network of highly elaborate aquatic traps. *Baïnes* are generated by a combination of the swell, the coastal current, and the sedimentary transport the current causes. When the long Atlantic swells hit the shore at an oblique angle, creating unstable mounds at the bottom of the foreshore, these basins form between the sandbanks and patiently await high tide.

Once the waves begin to ram into the sandbank with increasing intensity, and start breaking over it, the *baïne* is ready to swing into action. It fills up very quickly, but the water inside it is soon chased out by the backwash from other waves. As the apparently calm water from the *baïne* gets pulled out to the open sea, it forms a devastating current. Anyone in the *baïne* will be dragged out to sea in a violent circular current, the diameter of which can be anywhere between 300 and 3000 feet. These little sea demons are particularly active during the last two hours of high tide and the first two hours of low tide. They are methodical, dedicated killers, which attack their victims by surprise, most frequently preying on completely unaware swimmers.

The standard warning is encompassed in a single sentence: don't fight it, let the *baïne* sweep you up in its dance.

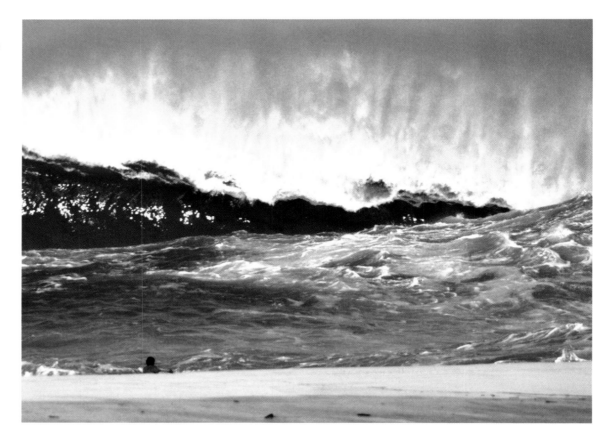

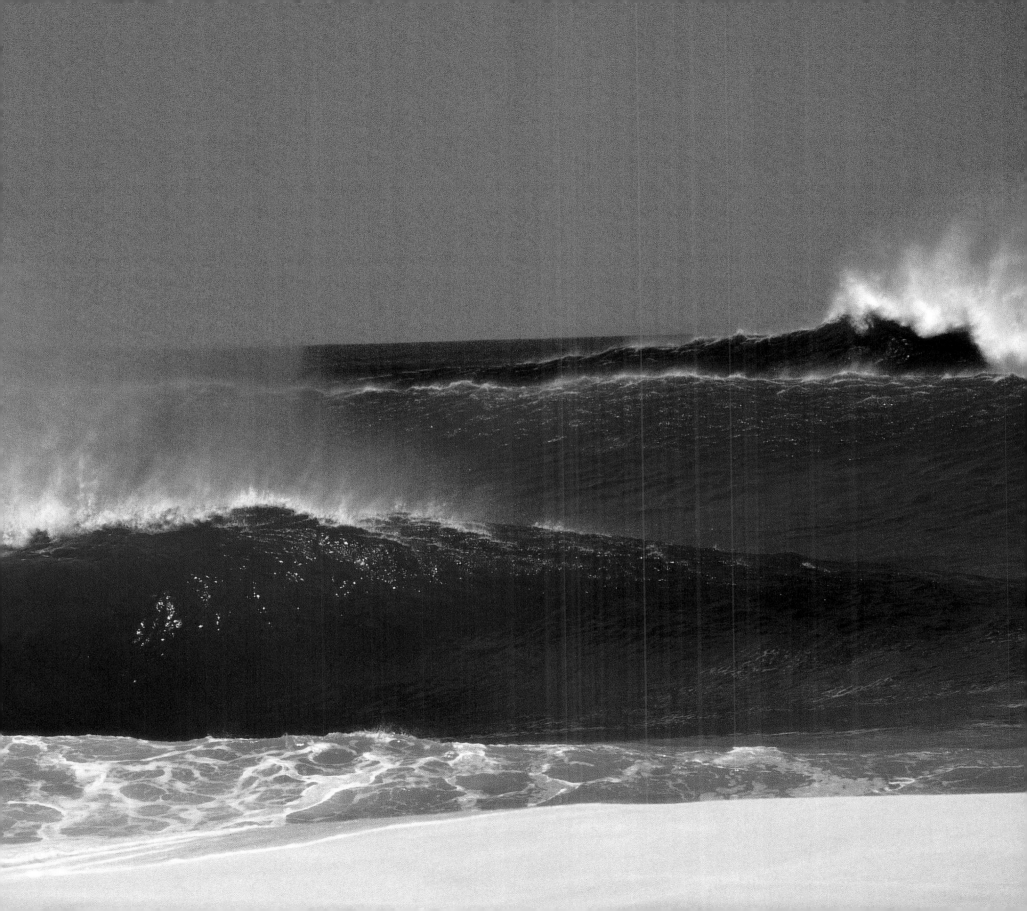

Salt Scars

Reef surfers are quick to show their scars. Surfing scars are easily recognizable, as they are usually due to very deep wounds cicatrized in rough layers of violet scar tissue. Surfers generally have scars on the tops and soles of their feet, on their calves and shins, and on their hands and forearms. These are the areas most prone to damage as surfers roll, fall, or bounce to protect a bone. Surfing wounds are treated by vigorously rubbing a lime on the injured area. Those who have had to resort to this kind of treatment never fail to shudder when they recall the excruciating pain it provokes.

Falling on a reef requires a specific technique known as the "starfish." Surfers try to land as flat as possible in order to avoid sinking into the water. They must then attempt to maintain the starfish position, with their arms and legs spread out, in order to ensure their body does not dip underwater. This technique is particularly necessary on fire coral, where the slightest contact with the reef will shred the skin as viciously as a *katana* would. When falling on duller reefs or in deeper waters, however, the opposite is true. Surfers plunge as deep as possible into the water, in order to find shelter under a rock and let the turbulence wash over them.

This explains why reef surfers try to know every nook and cranny of the reef they are surfing. They know how to analyze the water surface to distinguish providential spots, such as deep and narrow trenches in the coral barrier, which could shelter them in case of trouble. Then all they need to do is aim straight or stay on their boards.

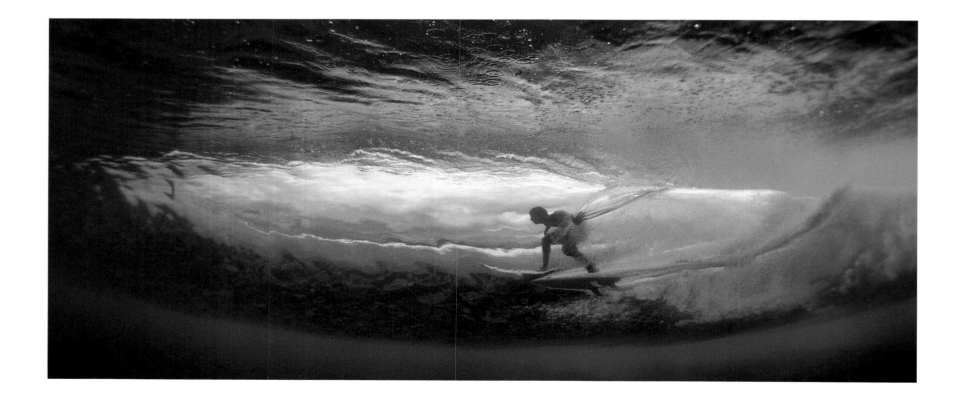

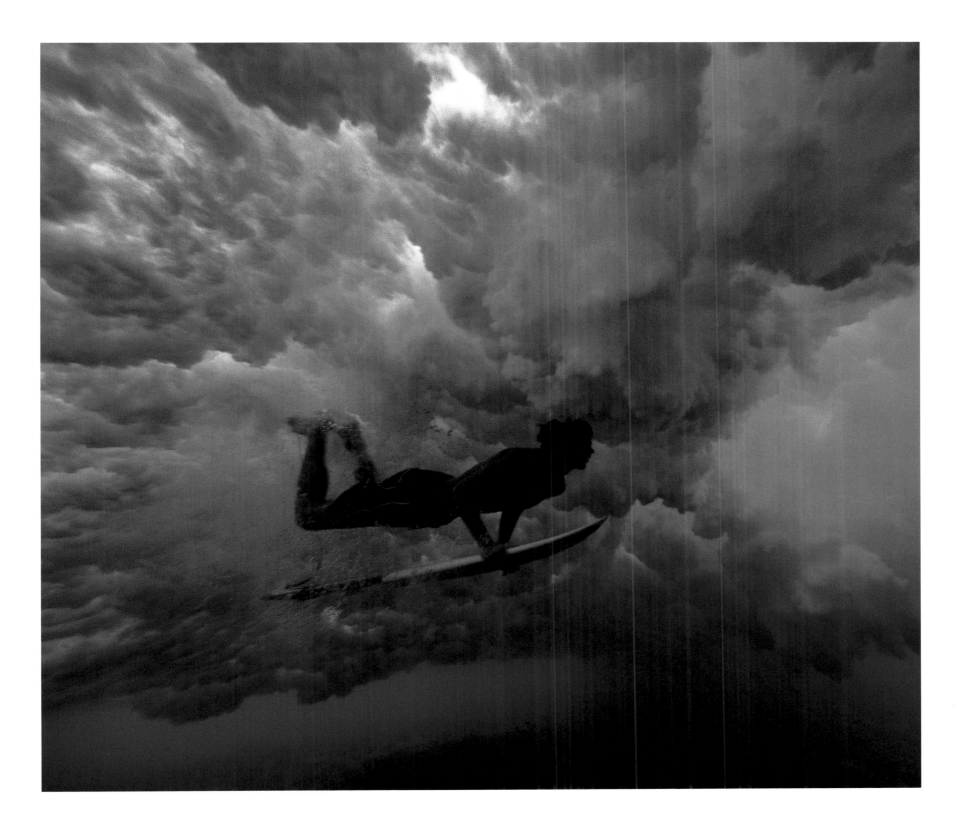

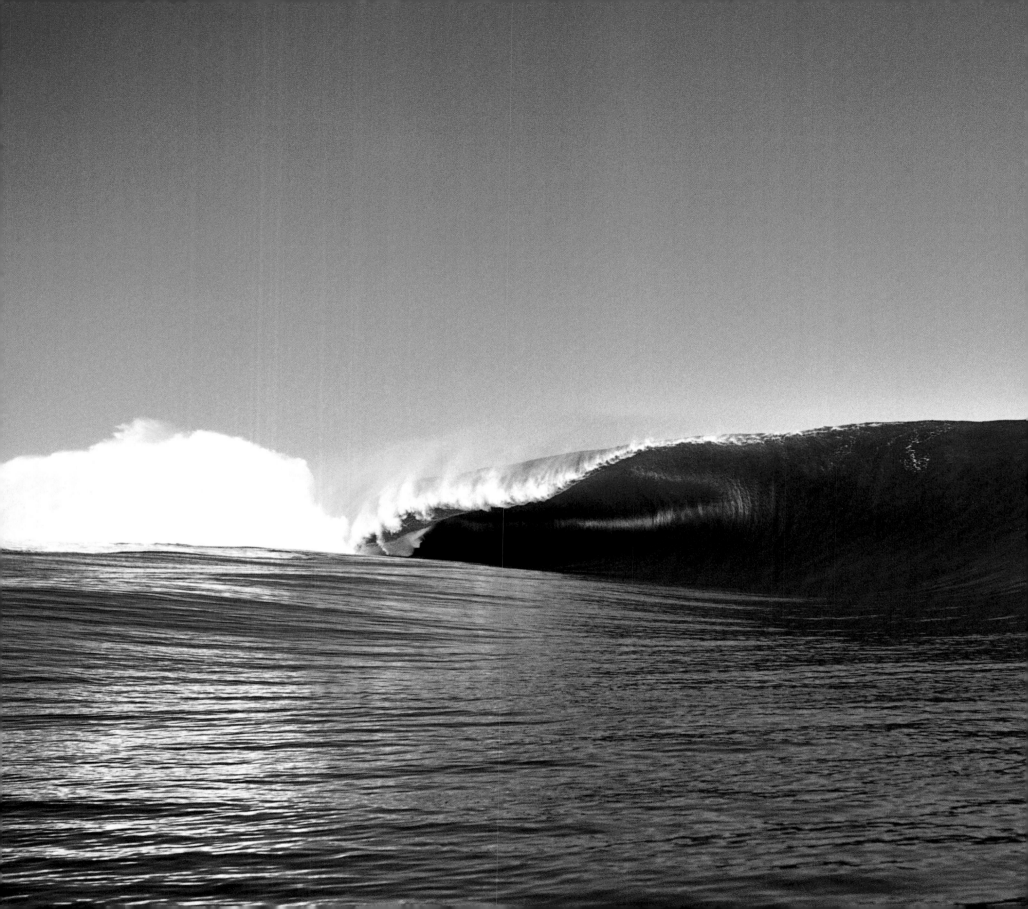

Unnameable Teahupoo

There is no word, no expression, no superlative capable of expressing the incredible power of the moving wall of water known as Teahupoo. The legendary *Surfer* magazine once printed the title "Oh . . . my . . . God" on its cover, admitting to its inability to come up with a more appropriate comment.

Nonetheless, numerous writers and journalists, who have personally witnessed the monster, still try to describe the unnamable. The range of words they use generally underlines the savage nature of this unique wave, discovered in the 1990s in the Havae pass, close to the peninsula of Tahiti. Teahupoo has been described as "Satan reincarnate," "a pitiless, barbarian tube," "a magnificent man-eater with an insatiable appetite," or even, "an extraterrestrial wave, a mutant, totally improbable." In fact, Teahupoo is an incomprehensible, mathematics-defying tube; an optical illusion; a comic-book wave.

The beast tears through a scintillating blue lagoon to spit its anger and tons of water out a few hundred feet from the shore. From the black sand beach, one can distinguish a raging wall of spume rising over the pale water along the coral barrier. When the powerful west Pacific swells crash into this strip of fire coral, all the reef's water is sucked up, creating an astonishing drop in the sea level. Then the terrifying mass of dark water rises inexorably, freezes for an instant, and breaks with the shattering sound of a tropical thunderstorm. Everything in sight gets entangled, dislocated, and atomized in an astoundingly violent explosion. The Teahupoo tube forms a dark and worrisome cavern, which could easily house a diplodocus. Polynesian legend has it that King Vehiatua Teahupo'o was killed here by his rival, Chief Moeterauri. The son of Teahupo'o, Oromaito, allegedly avenged his father by killing the assassin and eating his brain. Teahupoo means: "the graveyard of skulls." As savage as the wave itself.

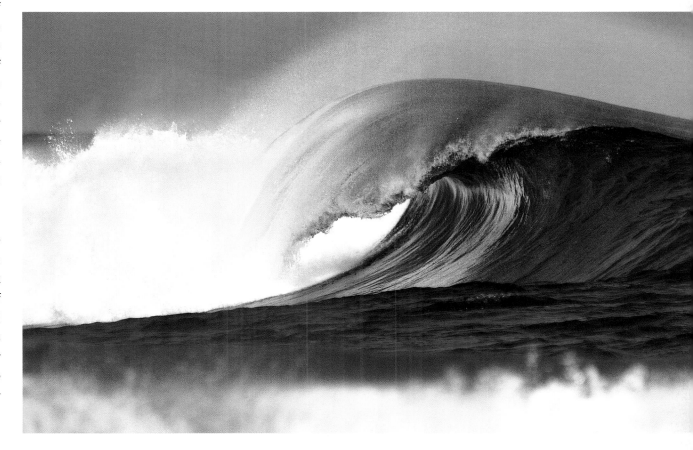

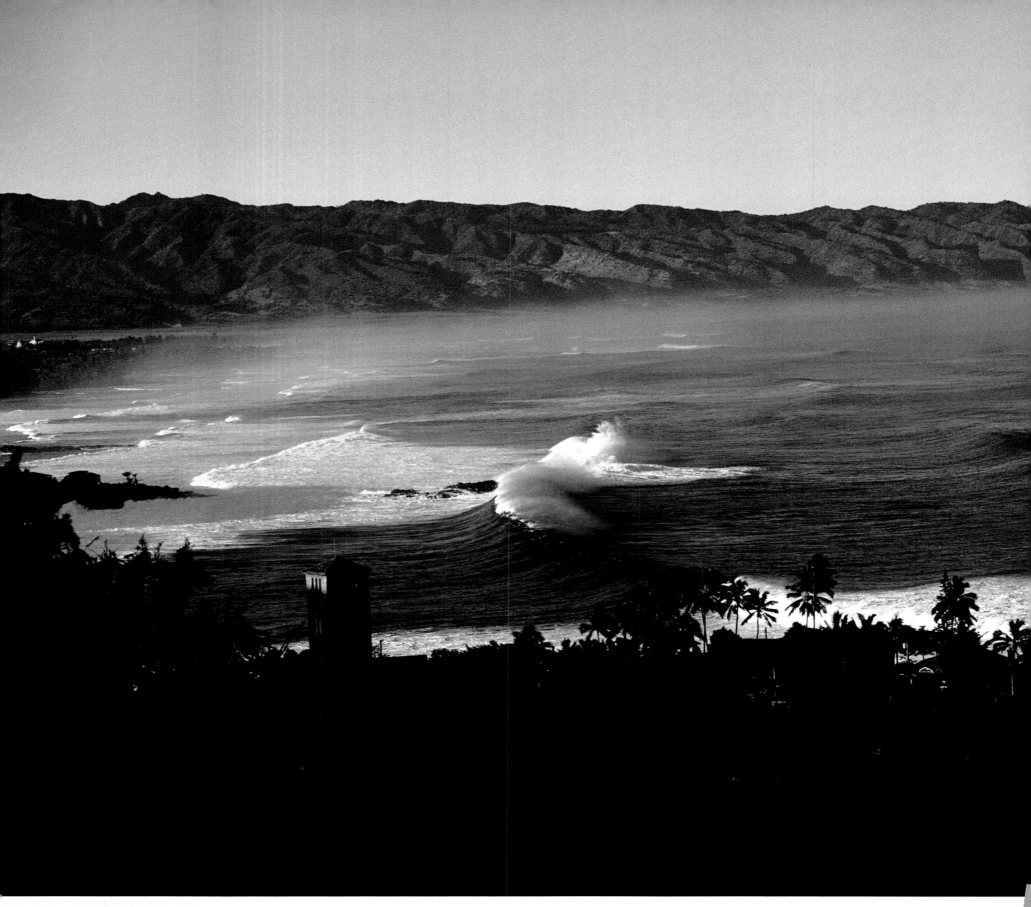

High-Surf Advisory on Waimea Bay

After collecting data from weather buoys situated around the archipelago, the Hawaiian coast guard had issued a high-surf advisory for the North Shore of Oahu. As dawn was beginning to break and sumptuous rainbows pushed the night showers toward the Kaena Point Mountains, all the coastal waves were saturated, hurling torrents of foam onto gardens and the Kamehameha Highway, the only road on the north coast.

By five in the morning, a crowd of aficionados—well-informed spectators and photographers equipped with powerful zooms—had gathered along the parapet overlooking Waimea to take advantage of the unique spectacle of the furious Bay. Beat-up pickup trucks crawled along the edge of the cliff as their drivers leaned out the window in an attempt to catch a glimpse of the Pacific erupting across this coconut tree-lined natural arena.

About twenty daredevils had already headed out to sea, while others impatiently waited for a lull to try their luck. Sitting on the beach with their huge 9-foot boards over their knees, the stragglers were looking for a window in the tumultuous water to allow them to reach the open sea without being subjected to the notorious shore break, an unbelievably powerful monster of white

foam capable of snapping their surfboards, and every bone in their bodies, in the blink of an eye.

Between two sets, the stragglers paddled out to the peak with all their might. They took their place among the other surfers in the channel, waiting for Waimea to rain glory down on them, with one of those waves that the oral tradition of

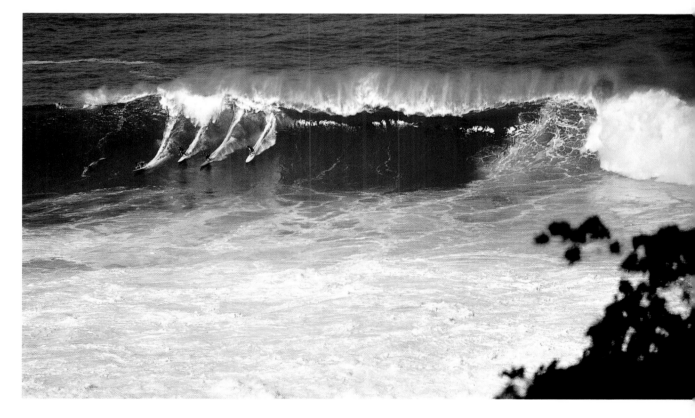

surfing has kept alive for centuries. That particular day, word was out that you could hear the rumble of volcanic rocks rolling along the ocean bed like giant marbles. The surfers were in their temple. They weren't afraid to die.

A Wavy Sense of Scale

"Reality is the pole in front of the Ala Moana wave, in Honolulu, which is 18 feet 16 inches above sea level at high tide. When a wave covers the pole, it's considered 10 feet tall. But that's 10 feet on the island's south shore, which means 8 feet on the north shore . . . "

Hawaiian surfer Mark Foo, who died in 1994 confronting the freezing, giant waves of Half Moon Bay, in California, gave the above description of the Hawaiian sense of scale in "Unridden Realm," his seminal article on the size of waves.

The proud Hawaiian people, who know the ocean better than anyone else, have a tendency to downplay the size of the waves breaking on their shores. They will often refer to a 6-foot wave when the wave in question is actually close to 10 feet tall. Aside from this Hawaiian quirk, which is closer to a folk tradition than a concerted attempt to impose a Hawaiian sense of scale on the world, surfers and scientists will always more or less agree on the size of waves 10 feet and under. Above 10 feet, however, they step into a realm of speculation and empirical calculations. The size of the swell, the thickness of the lip, and the eyewitness accounts all matter when it comes to evaluating the size of a particularly large wave.

Further along in "Unridden Realm," Foo referred to the 30-foot wave—once considered the cutoff point for surfing—as the "ultimate wave," and deemed it "insurmountable." But with the advent of tow-in surfing in the early 1990s, the old boundaries were shattered. With the help of motorized vehicles, surfers could now access giant waves. During the winter of 1999, Californians and Hawaiians began referring to 60-foot "faces," which are empirical calculations of the distance from the wave's crest to its trough. Until that point, calculations had been based on the size of the swell in relation to the water level at the moment the wave broke, without taking any account of the extra height of the wave face, which is caused by water being sucked up in front of the wave. The advantage of measuring the face of the wave is that the wave's size can be estimated based on a static image, and lucrative world records can be established. Today, the "ultimate wave" tops out at 70 feet, a record will no doubt be broken as soon as next winter rolls around.

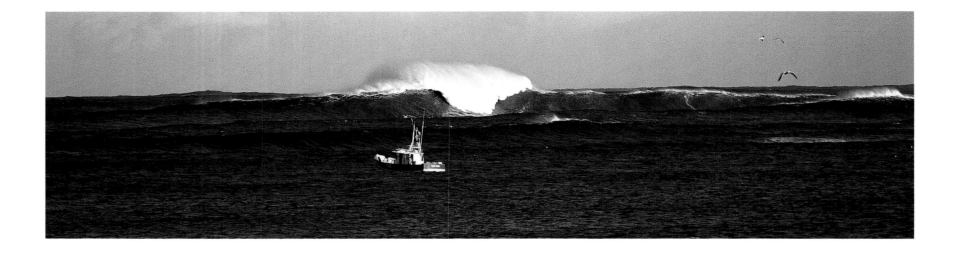

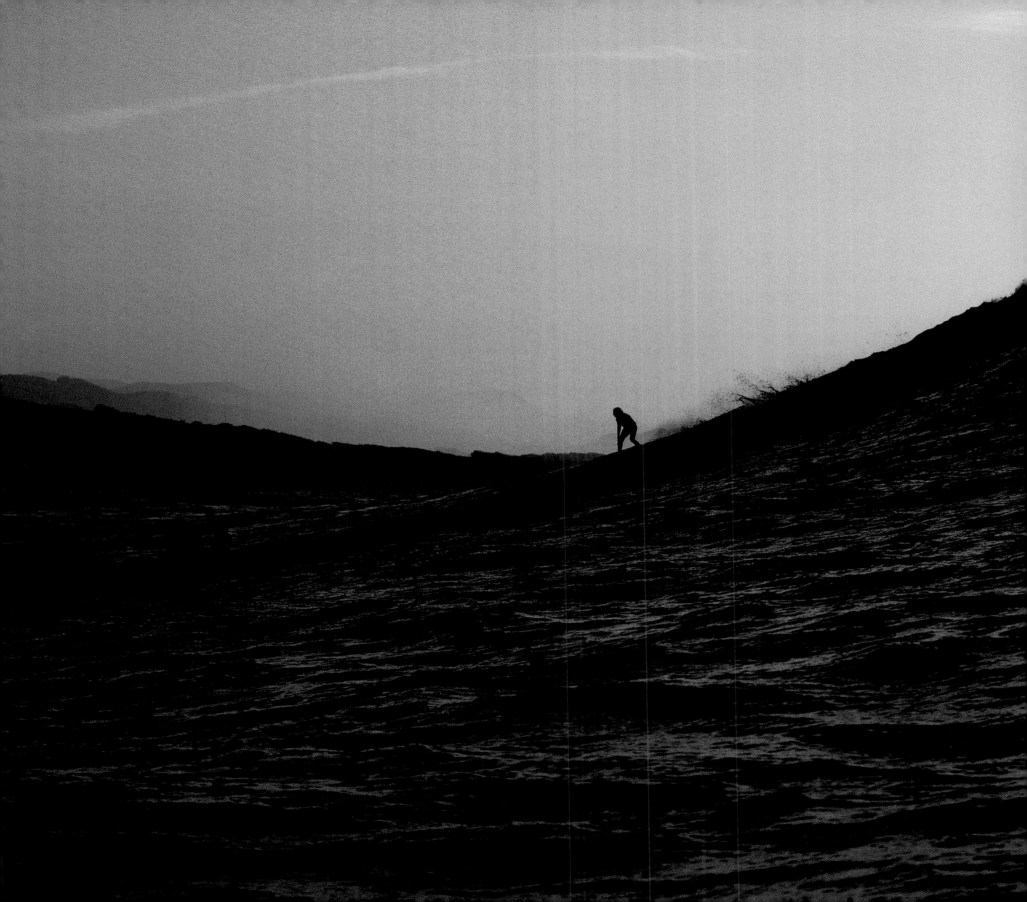

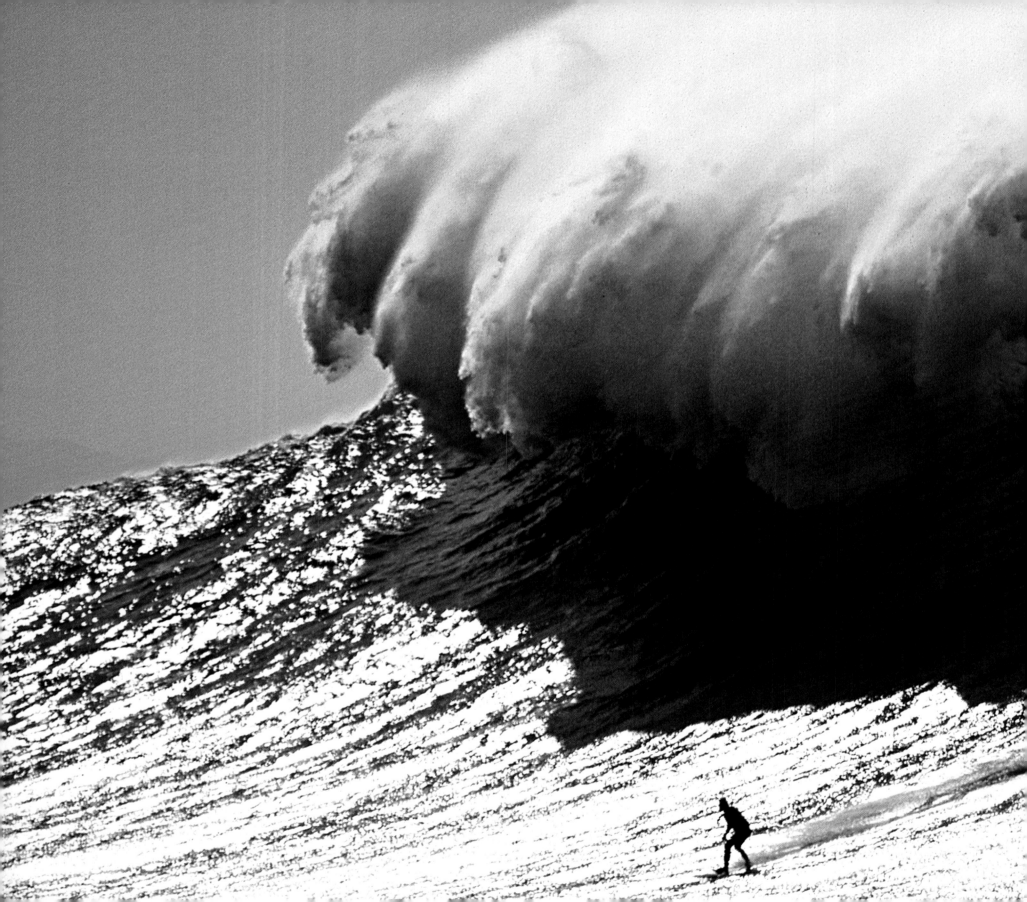

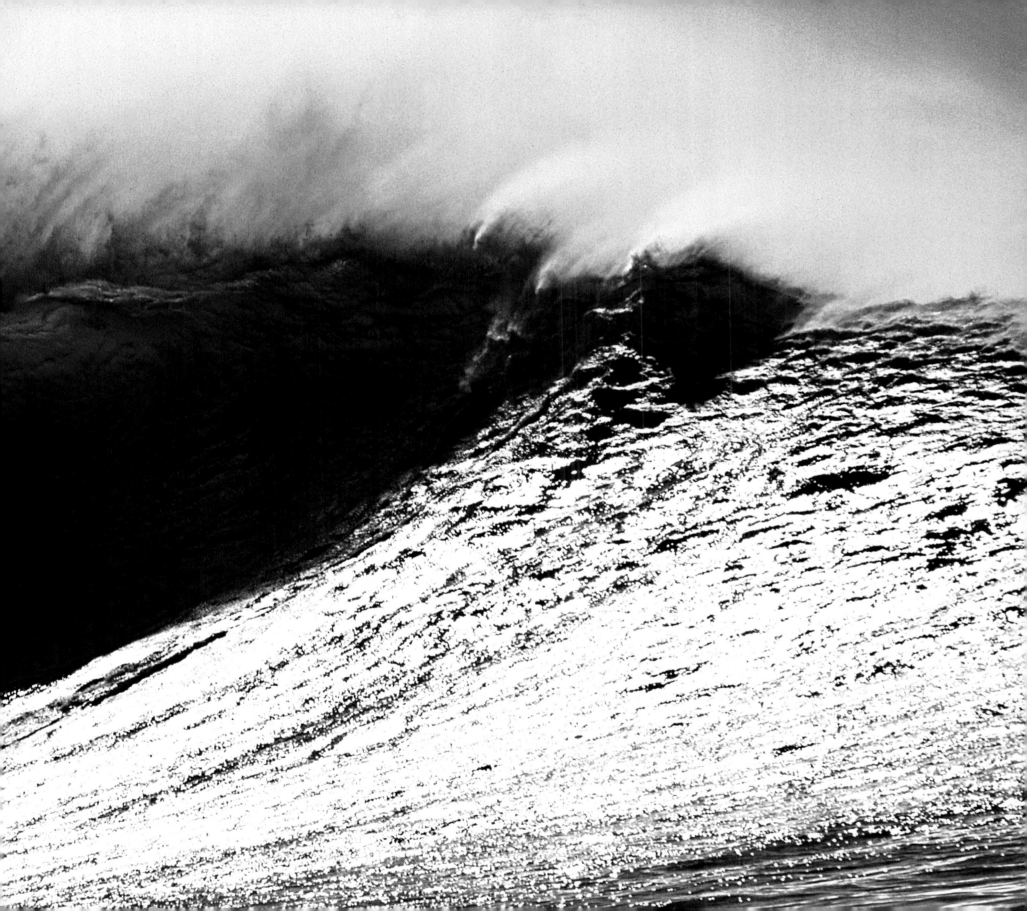

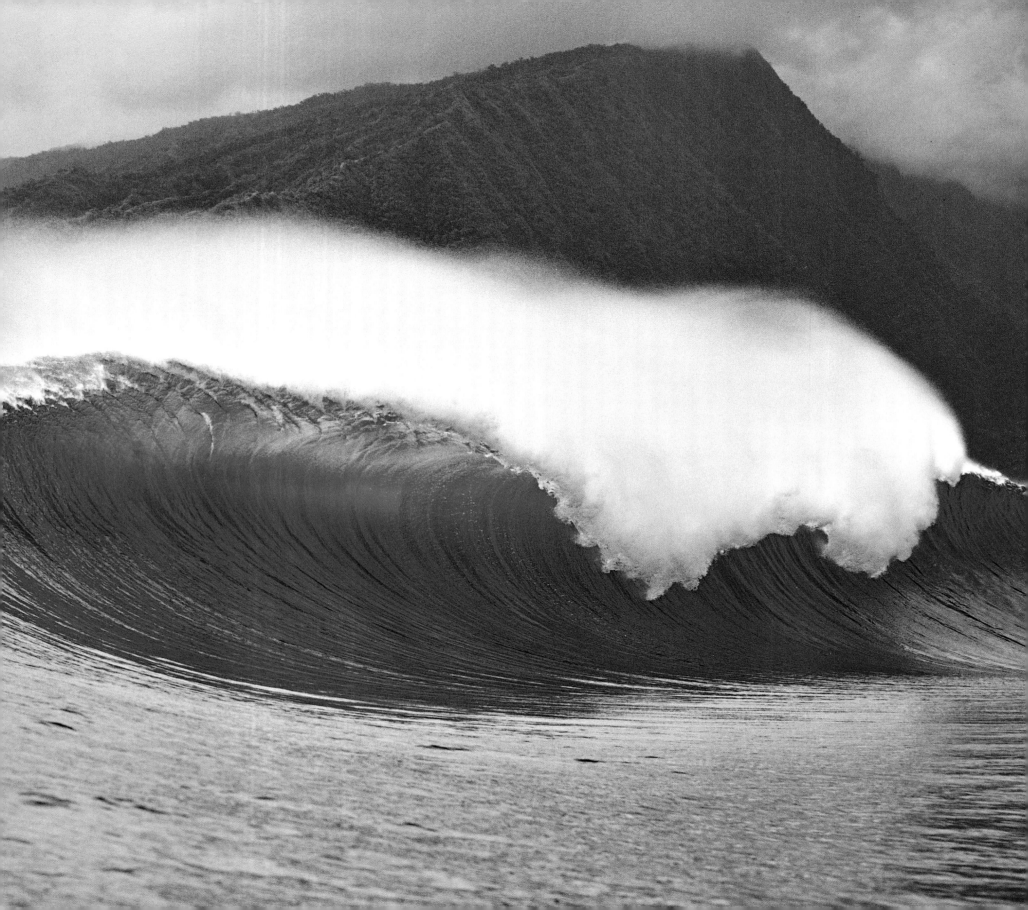

XXL, or the Quest for the 100-Foot Wave

When asked why he climbed mountains, master of the Himalayas George Mallory, who disappeared on Everest in 1924, simply answered, "Because they are there." The giant waves of Jaws, Todos Santos, Maverick's, Cortes Bank, and Belharra have been around since the beginning of surfing, as a challenge set by nature. Once we had conquered the Poles, Everest, and the Moon, the human race found itself faced with a new challenge for the new millennium: scaling (and descending) dizzying peaks of water.

The technological challenge of searching for the biggest wave has been made possible by Laird Hamilton and the group of visionary watermen who began using Jet Skis to take off on the giant waves at Jaws, on Maui. These waves had previously been inaccessible because they were too fast to be approached by paddling out.

The group's exploits have given rise to more than a few vocations. From Mexico to the Basque country, from California to Hawaii, overachieving "aquanauts"—capable of swimming for miles on end and of surviving two minutes without oxygen under tons of rushing water—dream of conquering those untouched peaks, which have been taunting them since they first set eyes on the water. Of course this new human adventure

has a price. The XXL challenge now offers $50,000 to the person who can surf the winter's biggest wave. The avowed goal is to conquer the mythical 100-foot wave, though no one has any idea what such a wave would be like, or even if it could exist, for it has never been seen. But if this first aquatic

Everest should indeed rise up on one of the seas, its existence alone would be sufficient reason, as George Mallory believed, to face off against it.

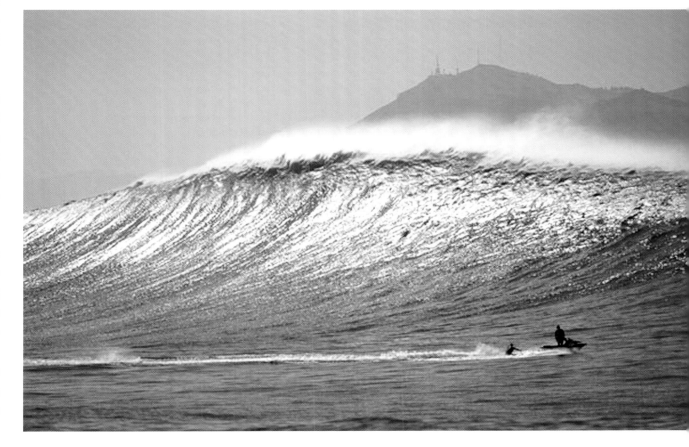

Banzaï Pipeline

Ours is an era in which every giant swell draws cameras, helicopters, and tow-in surf teams to far-off reefs in the middle of the ocean; in which artificial waves are "made" for amusement parks and charter tours drop crowds of tourist-surfers all around the world. Can we really expect to find a wave capable of maintaining its power of fascination over even the most blasé of crowds among all this mad scrambling for thrills?

The answer is yes: Pipeline.

Banzaï Pipeline is the untamed bronco of the wave world. Any other wave's legend must be measured up against that of Banzaï Pipeline. Some waves are longer, some are bigger or more dangerous, but none provide anything like the experience of riding Pipeline. When the Pipe unfurls, it offers the ten most fascinating, intense seconds in all of creation.

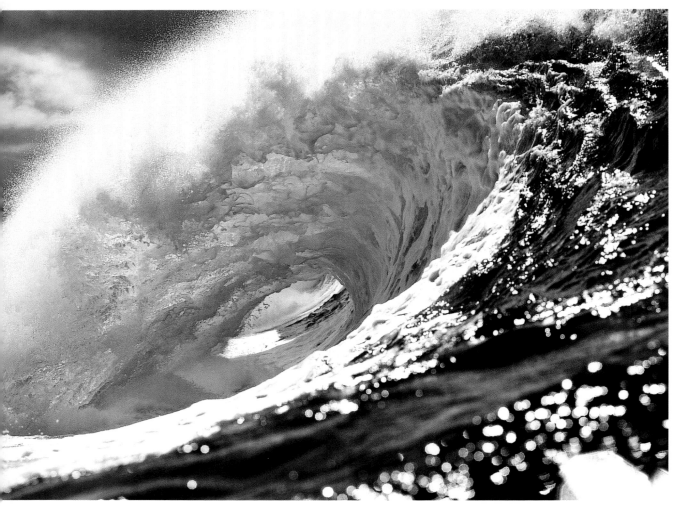

The legend of the tube—which started out as an ambitious maneuver and developed into a philosophy and a quest—was built on this volcanic reef, through the brilliant intuition of Phil Edwards (in 1961), the insolent grace of Gerry Lopez (in the psychedelic 1970s), and—in our time—the quasi-scientific mastery of Kelly Slater. Above all, Pipeline, which is the most photographed, the most filmed, and the most downloaded of the planet's waves, has imposed its standard of aesthetic perfection on the collective unconscious. Close your eyes for a moment, and imagine a wave rolling in. You always see it from the side, as if you were in the water, in the channel. It is an unearthly, nearly metallic blue, and seems to unfurl forever. It is hollow, fast, and powerful, with a teardrop-shaped tube and an explosive spray which goes off like fireworks. The wave you're thinking of is Pipeline.

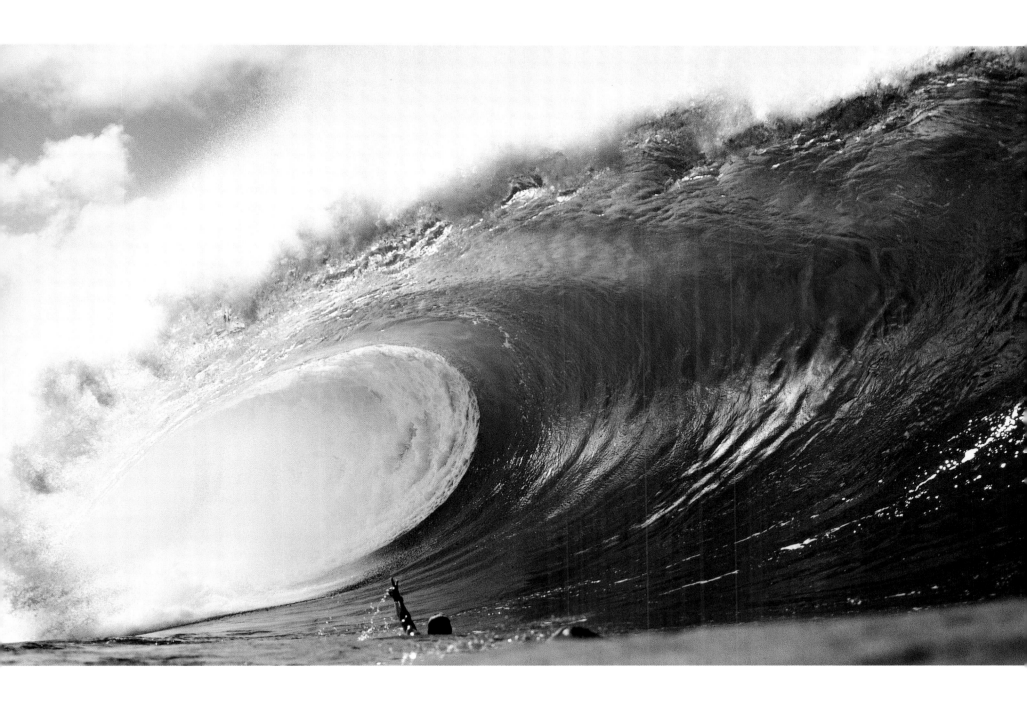

A Fantasy of Perfection

All kids who dream of the ocean draw waves in their schoolbooks. They draw perfect fantasy tubes in which every single drop of water is exactly where it should be. Rows of waves are evenly distributed across white beaches in groups of three. The water is rife with left-handers, right-handers, even left-right peaks. They pencil little commas into the face of the wave to give an impression of movement, of hollowness.

The perfect wave isn't the biggest or the most dangerous one, it is simply the most beautiful. It is the most well-defined wave, the one that is best put together. The perfect wave is the incarnation of an aesthetic absolute, an artistic quest for beauty.

The Australian Webber brothers' legendary film, *Liquid Time*, was born of this obsession for the ideal wave. For two years, the directors used macro-cameras to film hundreds of mini-waves, which were under 4 inches tall, but unbearably perfect. Filmed in the wake of boats or at the edge of glassy seas, the waves are so well crafted that they appear to have been sculpted of the most exceptional alloy. Once they are projected on the big screen, the waves take on a terrifying yet sublime three-dimensional quality.

You can try to film or photograph the most beautiful wave in the world. You can try to describe or paint it. You can try to bear witness as faithfully as possible to the ephemeral beauty of the ocean in motion. Yet, by definition, the perfect wave doesn't exist. It could be the last wave you rode. Or the one you'll never catch.

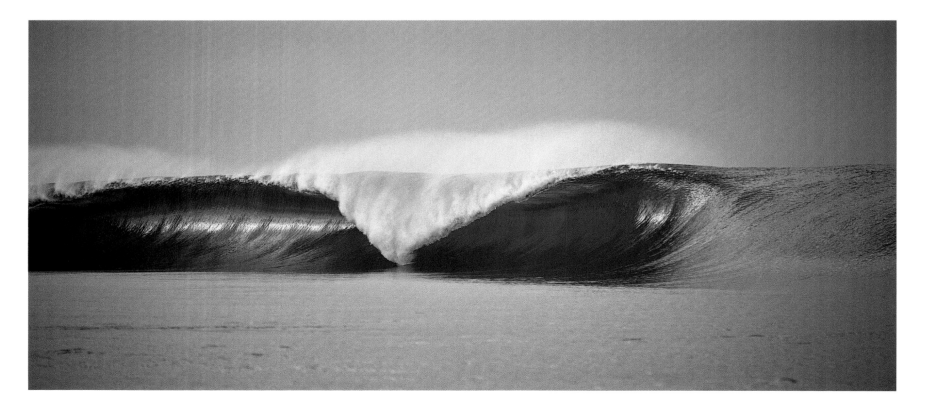

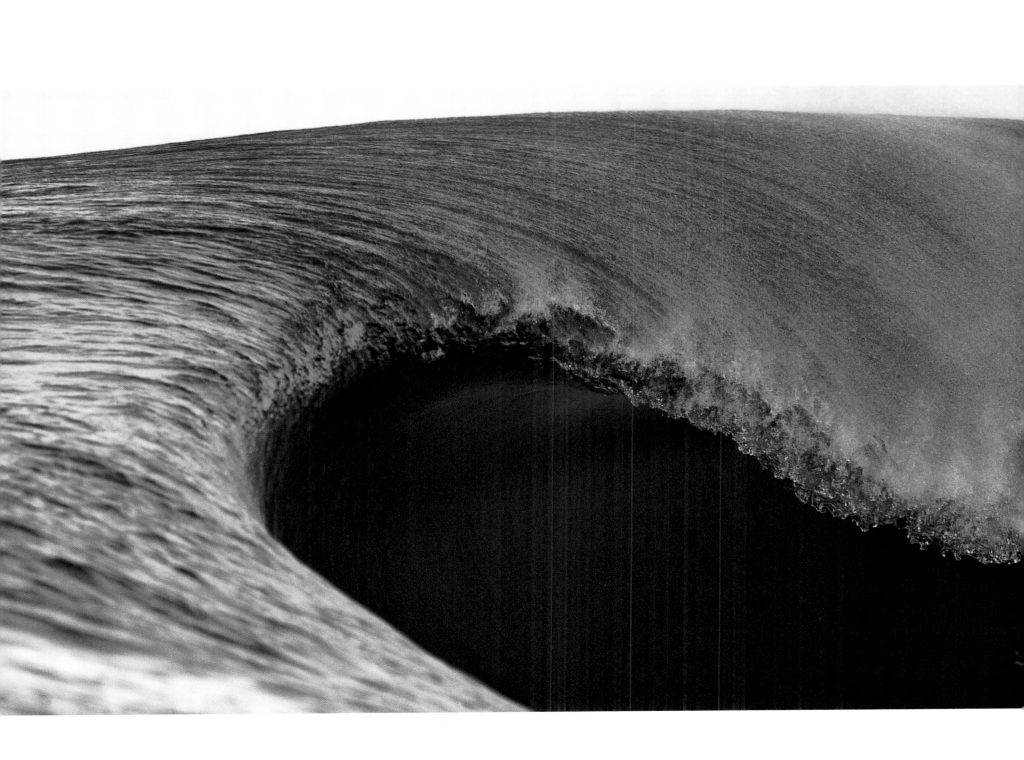

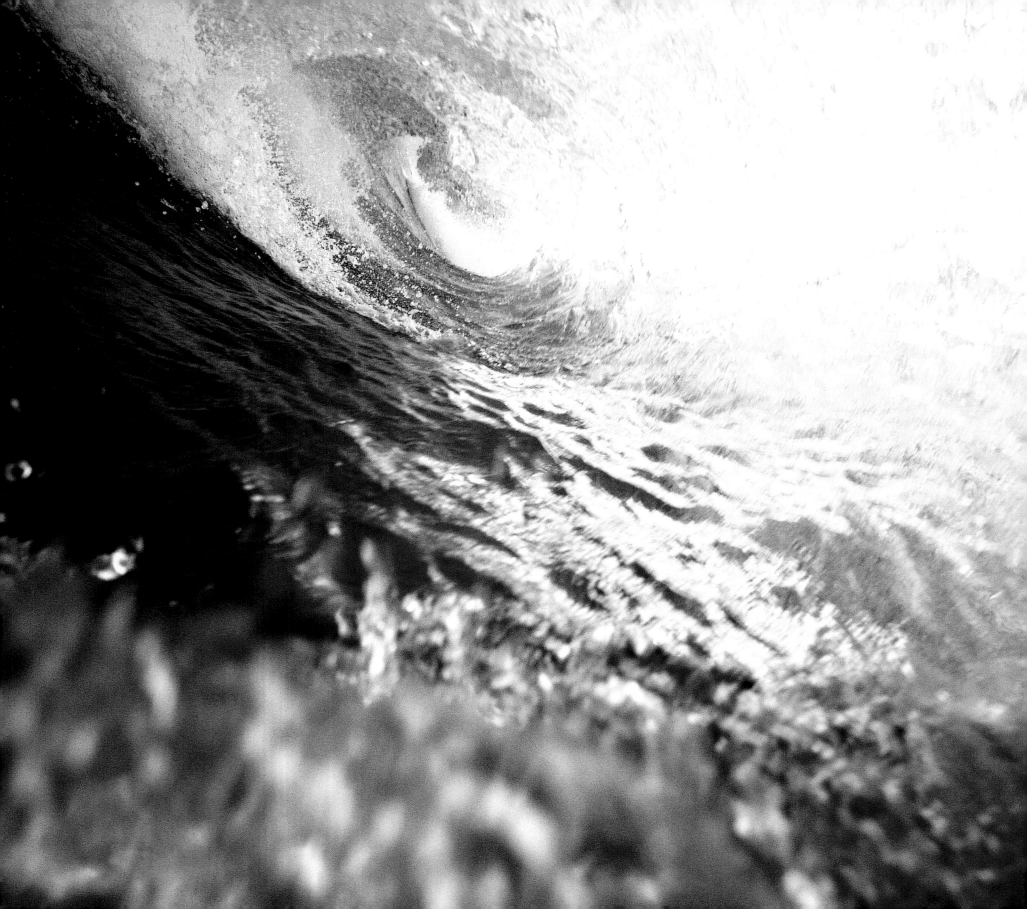

Metaphysics of the Tube

"God is a tube," wrote novelist Amélie Nothomb in her novel, *Metaphysics of the Tubes*. Anyone who has surfed the ocean waves, including the most ferocious agnostic, would have to credit her clairvoyance. Surfers might want to make a small adjustment to her motto: "God is *in* the tube."

Watch surfers plunge into this moving cathedral. They are inspired, apparently possessed with the revelation of what must be accomplished in a few tenths of a second. They move as if connected to the divine, propelled by supernatural forces. Their bodies tense, then stretch, as they use their well-honed sense of balance to apply just the right amount of pressure to brake, then to speed up again at the ideal tempo. Seen through a transparent wall of water, their fluid movements look like a sacred dance.

Now watch the spellbound expression on their faces as the power of the wave spits them out on its shoulder, in an apotheosis of light and water. Listen to the ecstatic narrative of the journey under the illuminated vault of the "green room," and you will come to realize that spiritual metaphors are the only words powerful enough to describe the magic of the tube.

Some try to explain the tube by referring to pleasure and orgasm, while others compare it to the accounts of near death experiences, in which a comatose state plunges the victim into a dark tunnel, inexorably drawn to a glittering light at the far end of the darkness.

Nonetheless, there is one constant: in the tube, time becomes elastic. Though you may only ride the wave for a few seconds, the experience actually lasts several hours, and continues far into your dreams. Even the most pragmatic surfers consider the tube a crack in the space-time continuum.

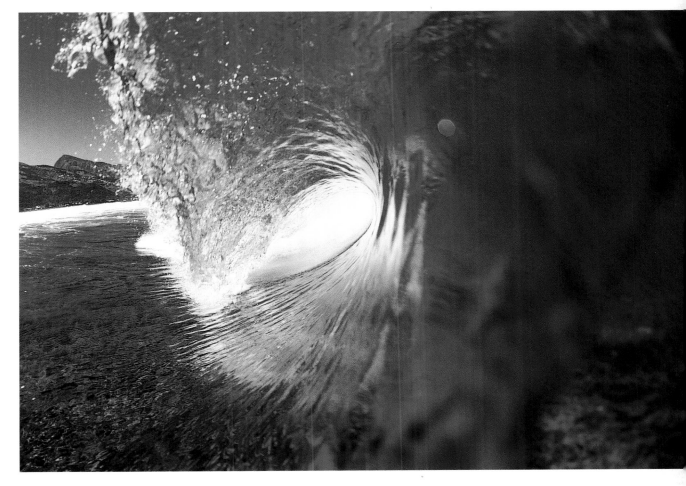

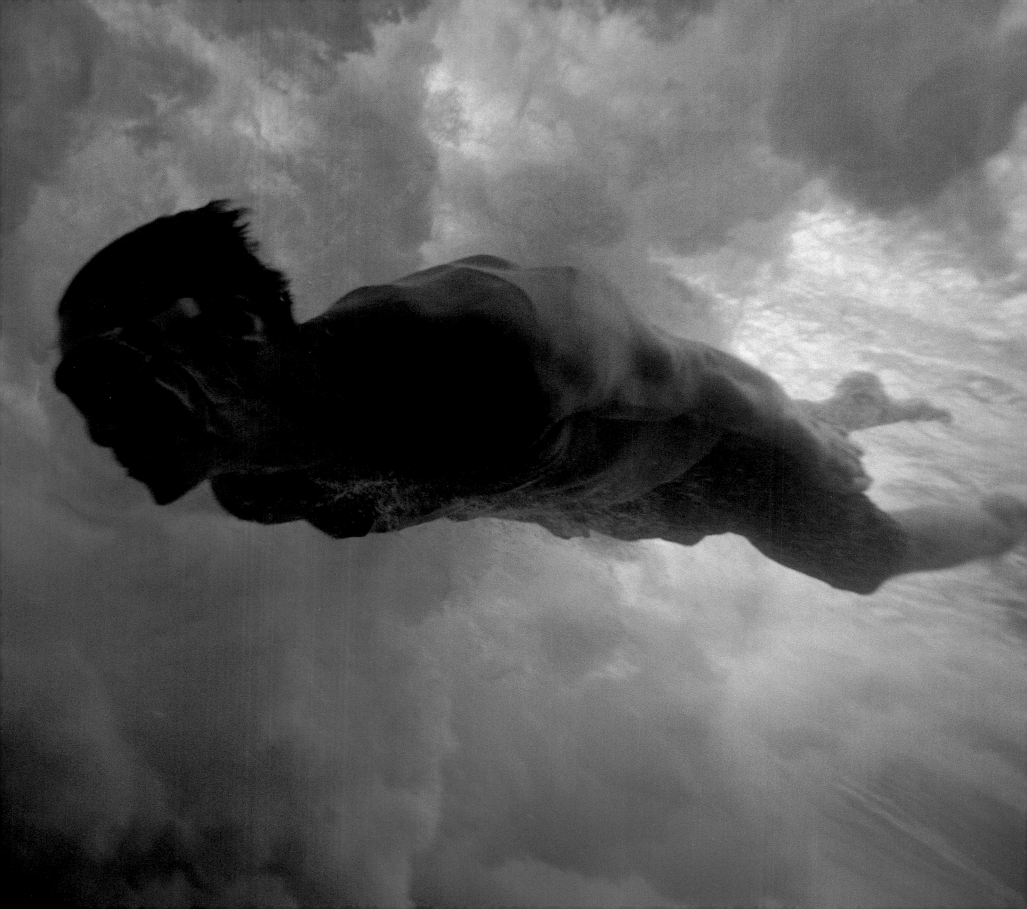

Bodysurfing

"Let me tell you that we're up here in the sky and on our rocky peaks having a good laugh at your expense. We're the seabirds—the albatross and the frigate bird, the penguin, the seagull, and the pelican—and we cannot stop laughing when we see your pathetic attempts to imitate our diving techniques with your oceanic tomfoolery. The best is when you try to "duck dive" the waves—we have special gatherings to watch that! It's the most hilarious thing ever, though, to be honest, it's a little insulting to our web-footed brethren.

Our friends the marine mammals are a little less snide about humans, maybe because you've instinctively uncovered a technique they pioneered: using your body to surf the waves. Seals and sea lions are masters of surfing, but they hate sharing the waves with you. If everybody stayed where they belong, there'd be a lot more fish to go around.

Only the dolphins respect you. They leave the ocean swells to let you play, and sometimes they'll even stoop to swimming with you. That's dolphins for you: tolerant and Zen. They're the sages of the sea. Dolphins can slip over and under the water, using the power of the wave to generate their speed. Allegedly, some of you bipeds are very good at this, thanks to artificial flippers based on the morphology of our feet. You call it bodysurfing, and rumor has it you've been doing it since time immemorial, all the way back to the ancient kingdoms of Polynesia.

We open-air seabirds practice a more aerial form of bodysurfing. We swoop into the hollow of the wave in formation and follow the wave as it breaks, letting our white bellies glide over the surface of the water. Maybe you laugh when you see us doing this, noticing that we can't quite be at one with the wave, that we can't truly integrate with it. I suppose that would be a legitimate response to all the mockery we've subjected your clumsy conquest of the ocean to."

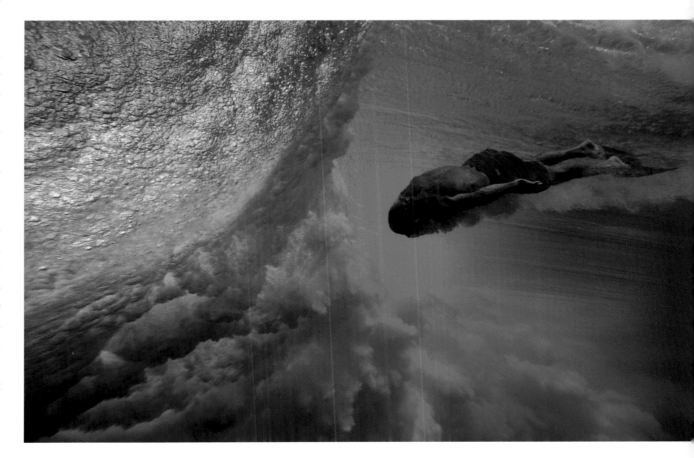

Holdup in Superbank

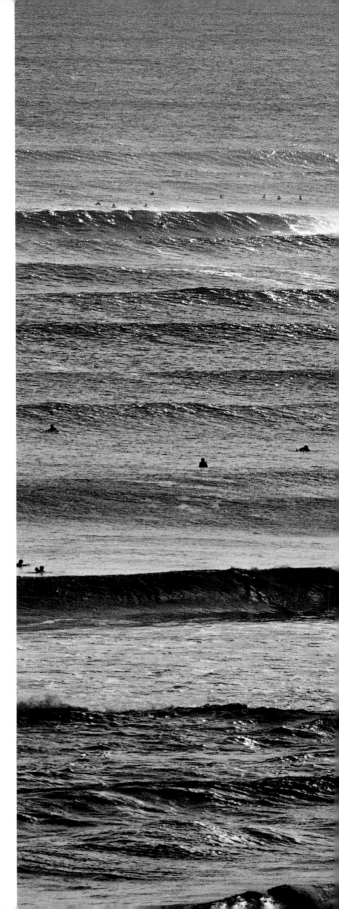

June 17, 2002, 5 AM. Dawn patrol for Damon Harvey, a young Gold Coast surfer. Like hundreds of other Australians that morning, Damon's goal was to be the first in the water. He climbed up the mountain overlooking Kirra, a perfect lookout for the waves up and down the coast, and was shocked to discover that the tropical cyclone swell hitting the Gold Coast that day would, theoretically, allow him to catch a wave off the Snapper Rocks, and ride it all the way to Kirra Bank, which is more than a mile away.

A few years ago, the wave machine known as Superbank didn't exist. Then the local government decided to dredge the sand at the mouth of the Tweed River. The sand was given a free ticket to its natural destination directly south, along the sheltered beaches of the Coolangata Bay. The result of this work of nature, accidentally enhanced by the hand of man, was a magical, perfectly straight, and phenomenally long sandbar.

When Harvey caught the wave off Snapper, he didn't have a clue he was about to pull off the perfect holdup, a feat which would soon be making headlines across Australia. He rode into the section known as Snapper, smoothly executing every move in the book over a distance of some 650 feet. He maintained his speed, elegantly started up again, and covered another 1000 feet by connecting with the section stretching from Rainbow Bay to Greenmount. As he reached the large sandbank between Greenmount and Coolangata, he caught himself an added bonus: 1200 feet on a fast, perfectly tubular wave. At this stage, Harvey had already cut ahead of more than 200 of his fellow surfers. As Kirra Point appeared in the distance before him, some 3000 feet away, his stone-hard legs were in agonizing pain. He gritted his teeth, threw himself into his fourth tube on the same wave, then stylishly cut out of the wave of a lifetime. He hadn't made Kirra, but he had spent four minutes on a single wave. Harvey's ride had been the longest communion with a wave on record.

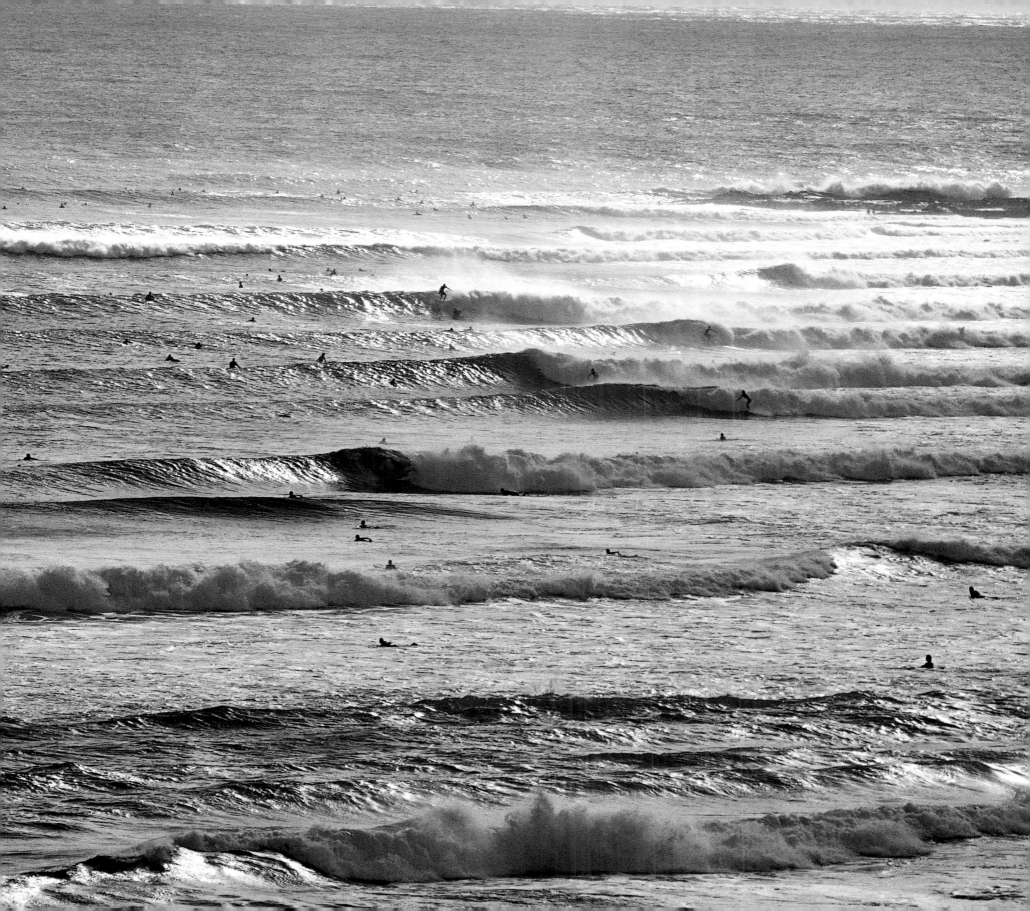

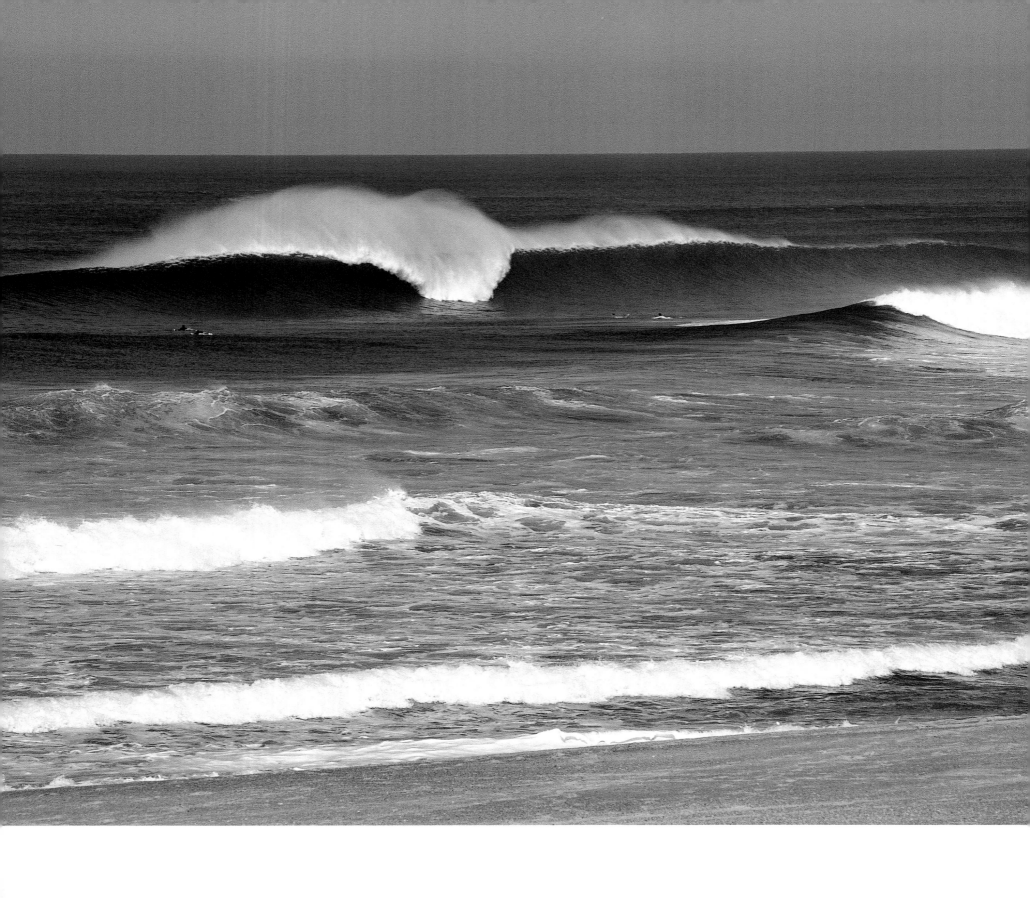

Sandbank Hunters

Between the lakes and forests of the beautiful areas of Maremne and Marensin, in the Landes, a particularly ruthless and erudite breed of wave-hunters plies its trade. As soon as the season opens, with the Atlantic storms becoming rare and gradually disappearing under the effects of milder anticyclones, these men track down sandbanks using the sixth sense and determination of purebred bloodhounds.

It is said that the best sandbanks in the world are found here. Clearly, the greatest beach-break hunters in the world fully agree—they've been flocking here since the 1970s. Some have even bought themselves a patch of land in the area and stayed on to hunt the rare prize of the surf world, the ultimate sand wave.

Sandbanks are slippery, difficult prey. One day they're there, all lined up, a well-disciplined flock of quartz and mica. Yet by the next day, a rough sea will have moved them to another beach. Hunting sandbanks requires time, and a certain kind of personality. Holiday crowds threaten their fragile makeup and reproductive cycle simply by walking along the beach. Once they are disturbed, the sandbanks take off like frightened pheasants.

The waves of the Landes offer an unmatched variety of shapes, colors, and power. They are the antithesis of the reef wave, which is as regular as a metronome, without surprise or room to improvise. Beach breaks are unfathomable and capricious. They bring joy and disappointment. They are the essence of the instant and the ephemeral. Beach breaks are just like life.

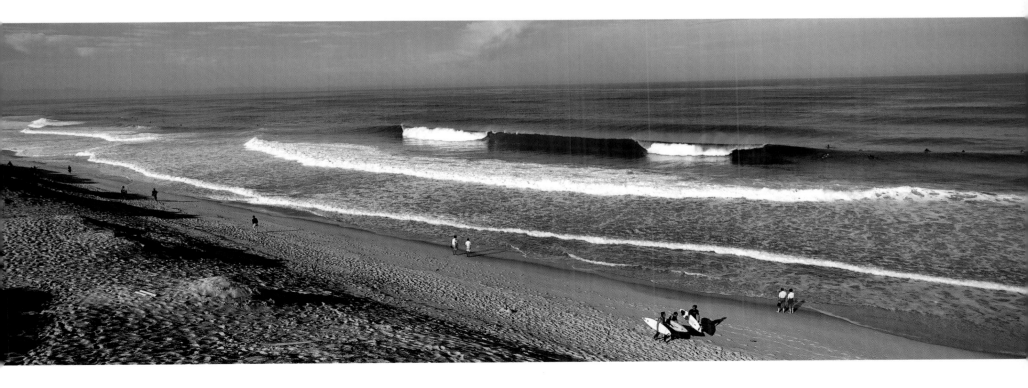

Fakolhya: Invitation to a Voyage

It was our skipper who came up with the name. With a burst of laughter, he had grumbled, "Fuck all ya," in his unmistakable Australian accent. That was all it took. We had named a virgin wave, and managed to throw in a touch of class by expressing our exact feelings for it. Now we needed to find a striking way of spelling it, with an exotic touch to keep it mysterious.

We were all alone, a group of adventurers of every age and background. Though our gleaming sailboat had already visited ten Caribbean islands, this latest one held the most beautiful surprise of our surfing lives. There was Fakolhya, wrapping around a white sand outcropping jutting out from a deserted part of this beautiful island. The wave was small, but absolutely perfect. We had discovered it by bodysurfing, then realized its potential and gotten our boards out.

Most of the time, wave names that aren't directly related to the name of a beach don't appear on any maps. Wave names might refer to a place: the Lighthouse, the Pier, the Jetty. They could also refer to the shape of a wave, as with Pipeline, or, in the case of the Slaughterhouse or Massacres, to how dangerous a wave is. Sometimes it's easiest to name a wave after the person who discovered or mastered the spot in question: Lance's Right, in the Mentawai Islands, or Peyo's Left, in the Basque Country. Some waves are stuck with ridiculous food-based names, such as Macaroni's, in Indonesia, or Cloud 9, named after a Philippine chocolate bar.

Of course, any wave will always be found out. After a few rounds, surfers who have discovered a remote, virgin spot always feel obliged to brag about their good fortune. But Fakolhya has a good chance of beating the curse. Yeah, fuck all ya.'

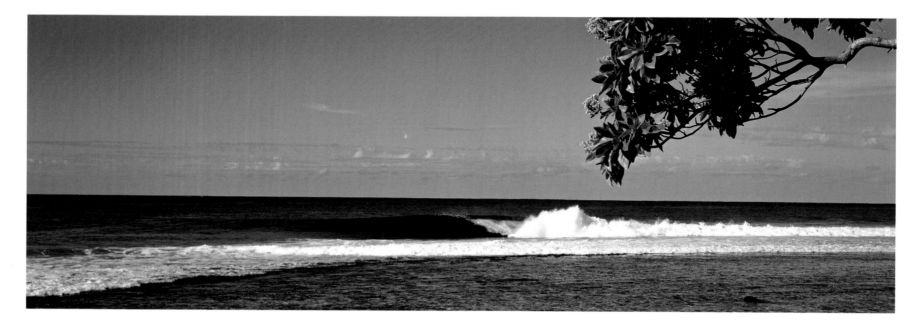

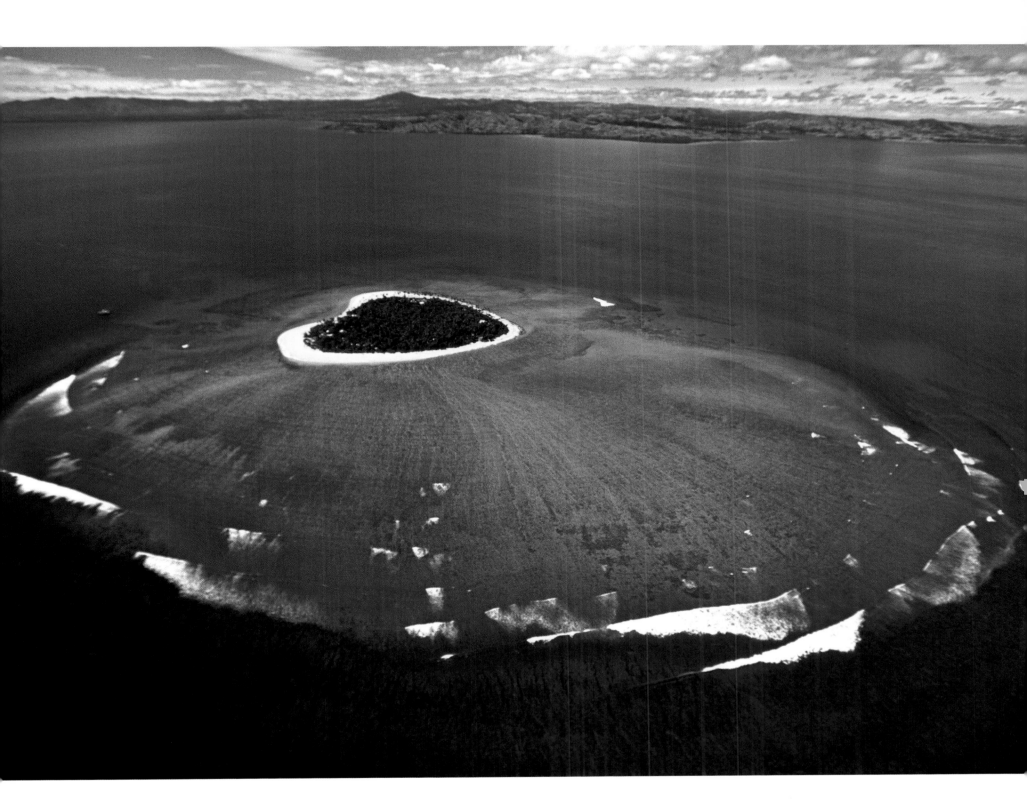

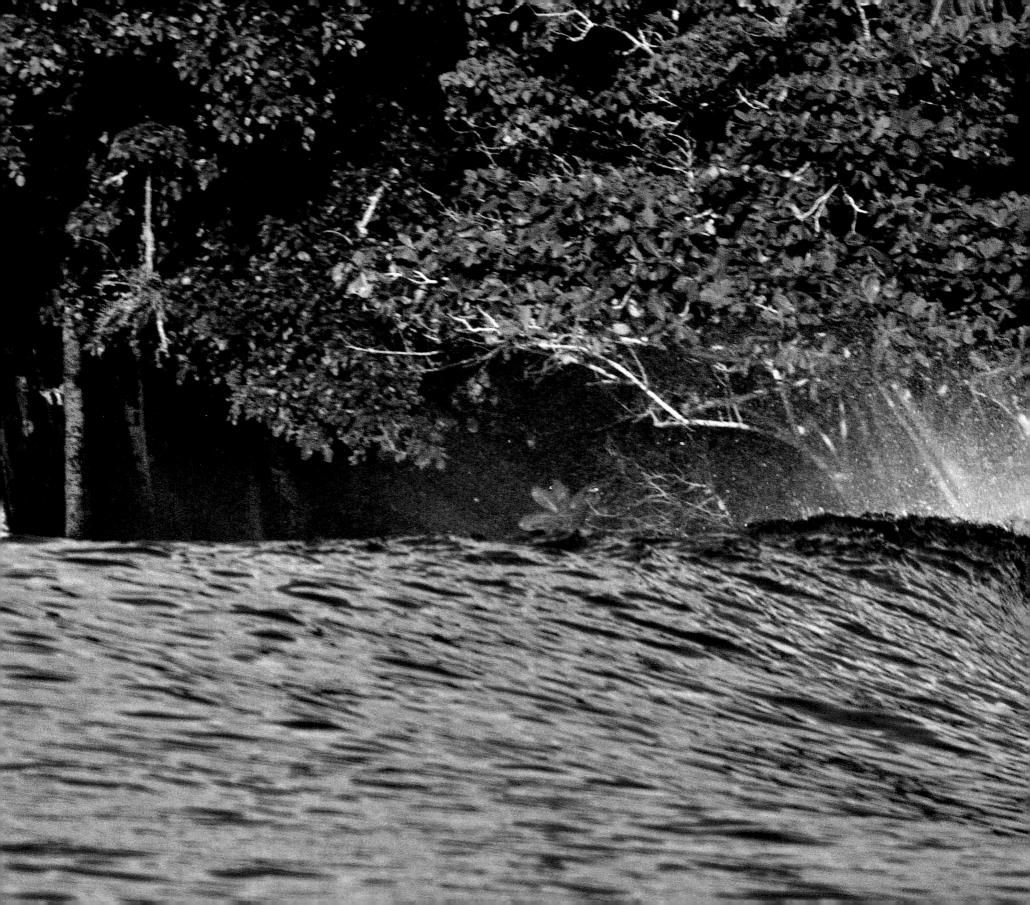

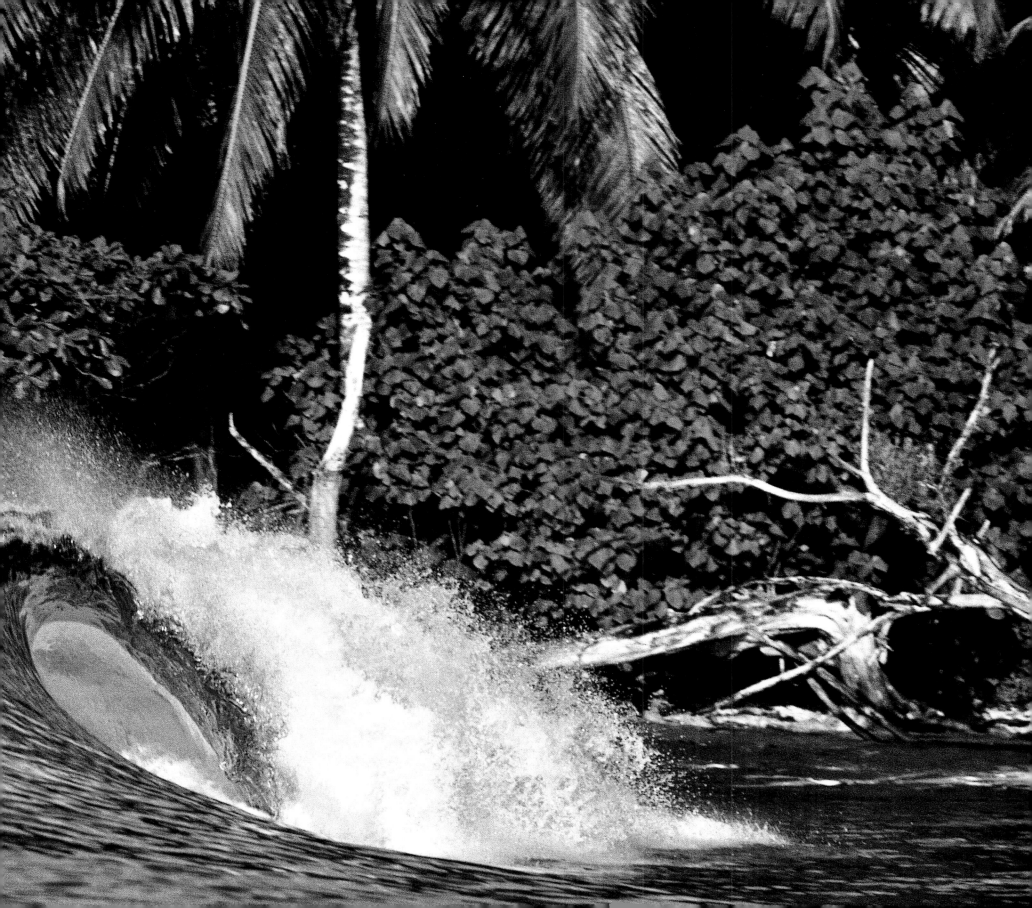

A Last Wave

The sky goes dark, and a mild golden rain illuminates the ocean with a slightly wicked, mystical light. In the fiery light of the agonizing sun, the waves take on a cast of phosphorescent oranges, pinks, dusky grays, and hesitant greens. The offshore wind carries the odor of seasonal flowers, and scatters sounds from the coast road. We are witnessing a magnificent spring sunset, the kind that lasts for a languorous eternity, managing to simultaneously fascinate and soothe our eyes and souls.

Out in the open, a handful of surfers linger in dazed contemplation of their favorite spectacle. No one wants to give up. It's time for the knights of the evening surf to face the challenge of seeing who'll be the last to get out of the water, to enjoy a solitary tête-à-tête with the ocean. Now a clear white three-quarter moon has appeared and smiles upon this childlike contest.

A last ray of sunlight traces a broken line toward the horizon and is lost in a distant scintillation of light. The apocalypse of bright colors is over. It is increasingly dark, and from the water you can no longer see the sets arriving from the open sea, or the outline of the waves, which continue to break in the growing obscurity. The most patient surfers await a good last set. The only thing that matters to them, the most important thing in their lives at that precise moment, is to catch a last wave before night falls.

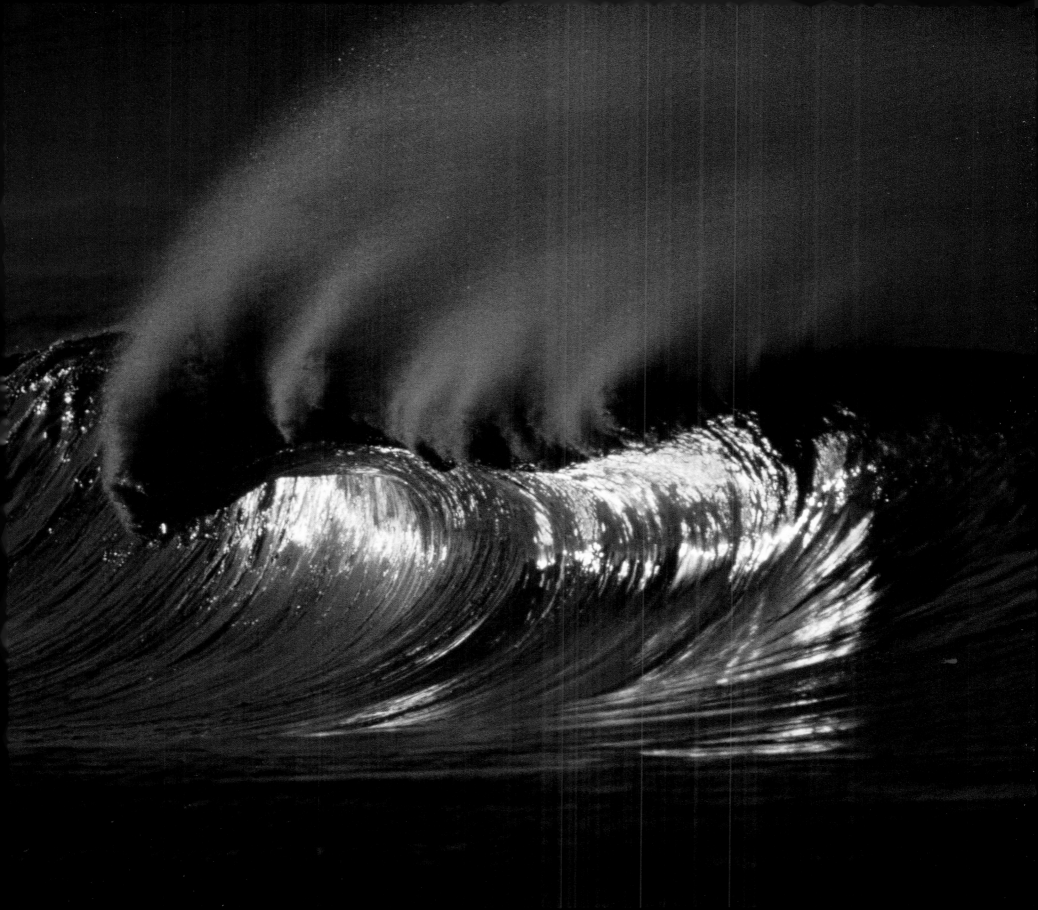

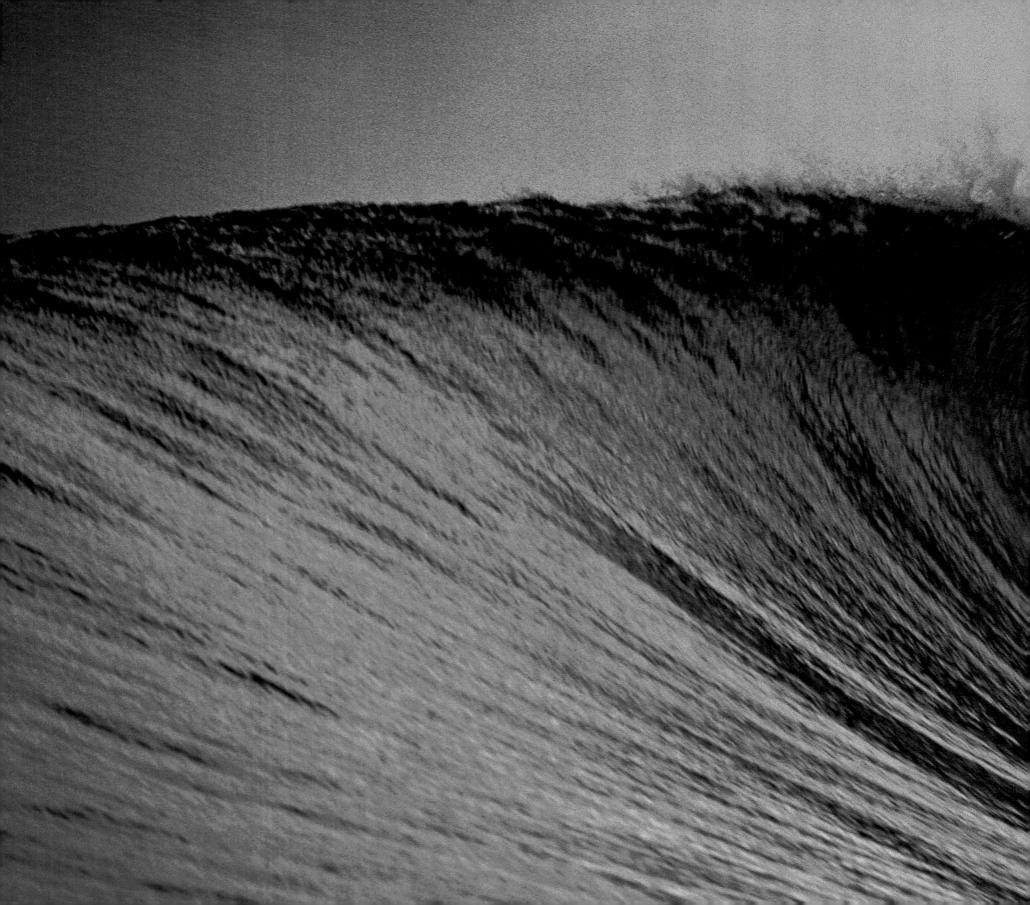

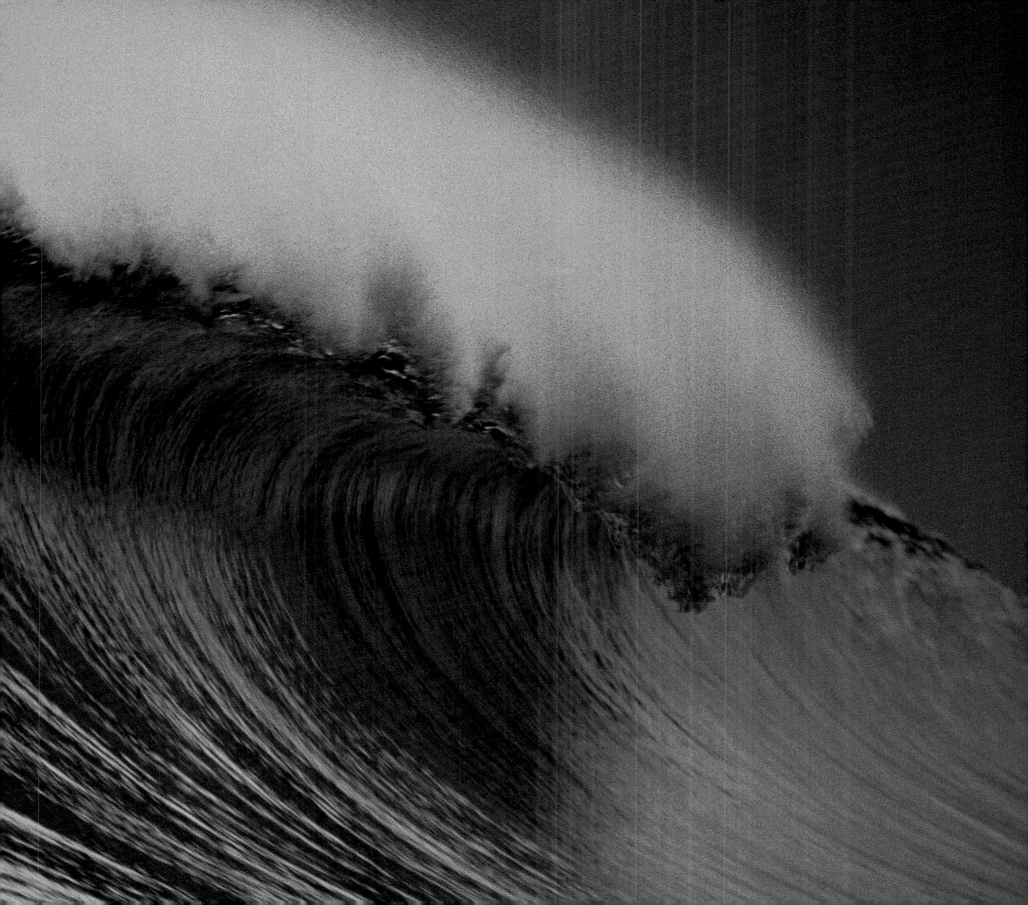

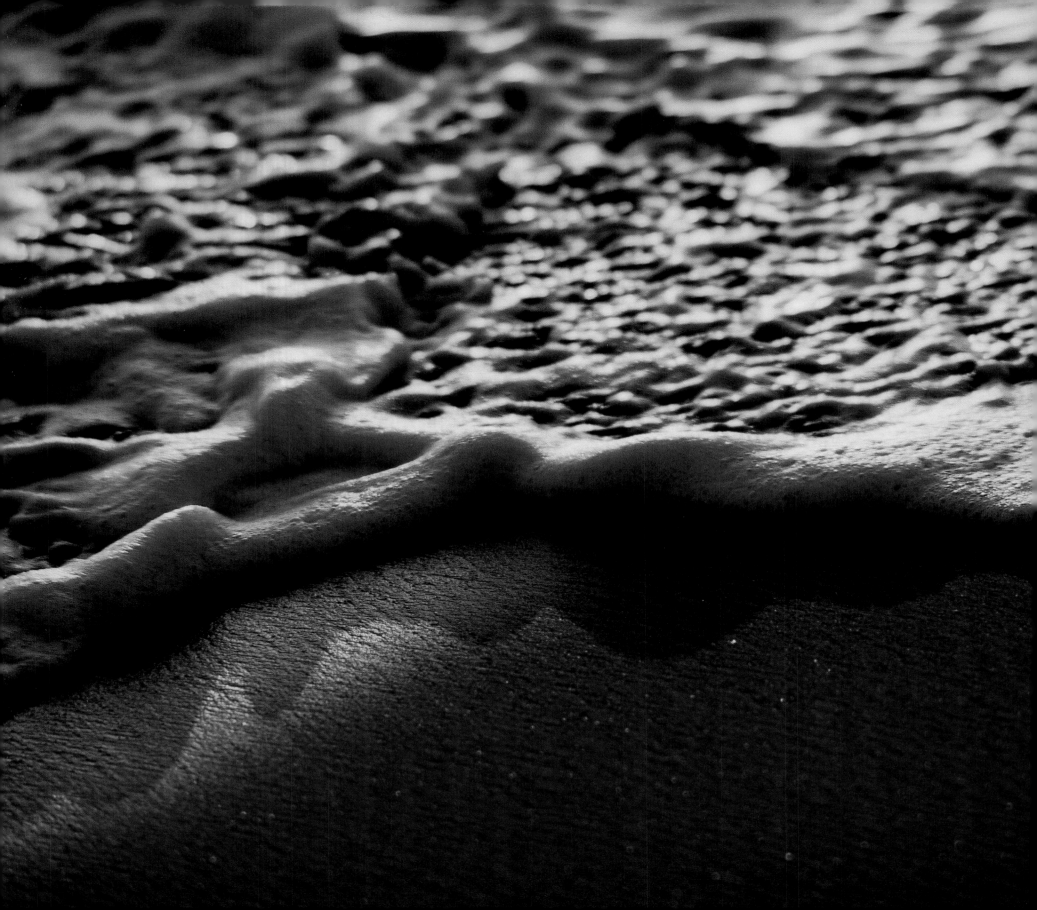

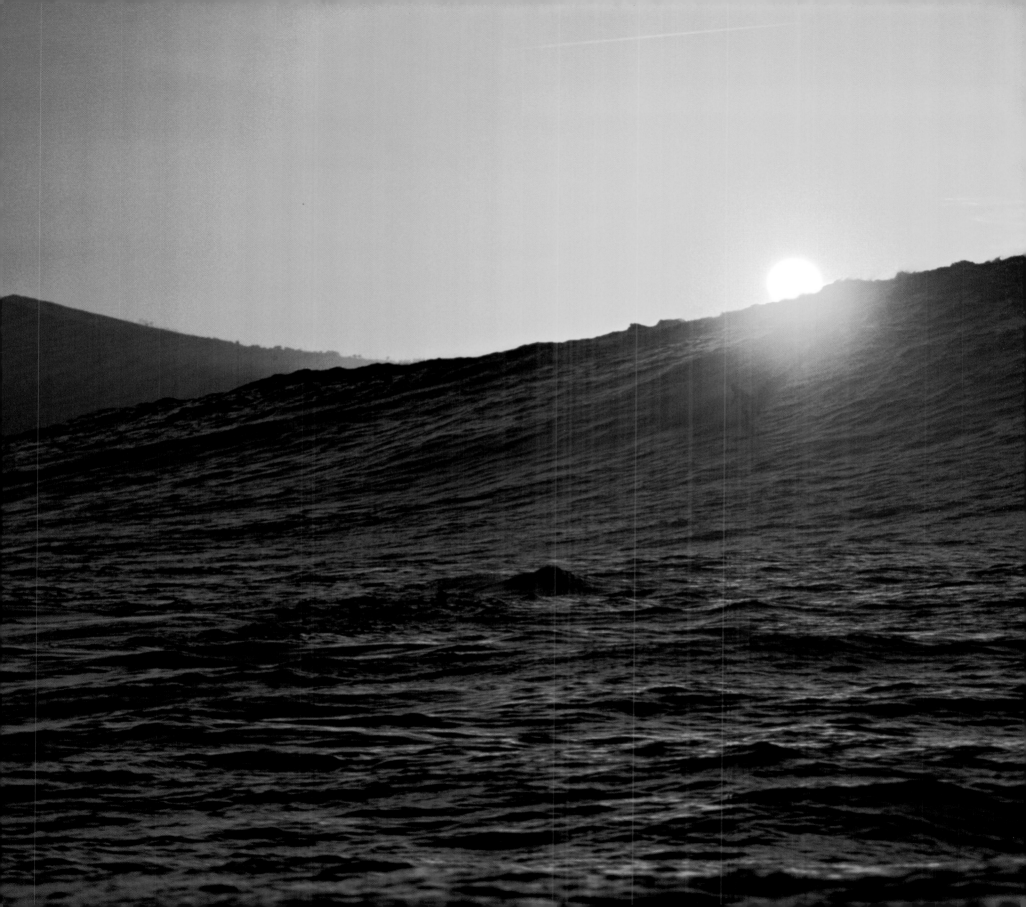

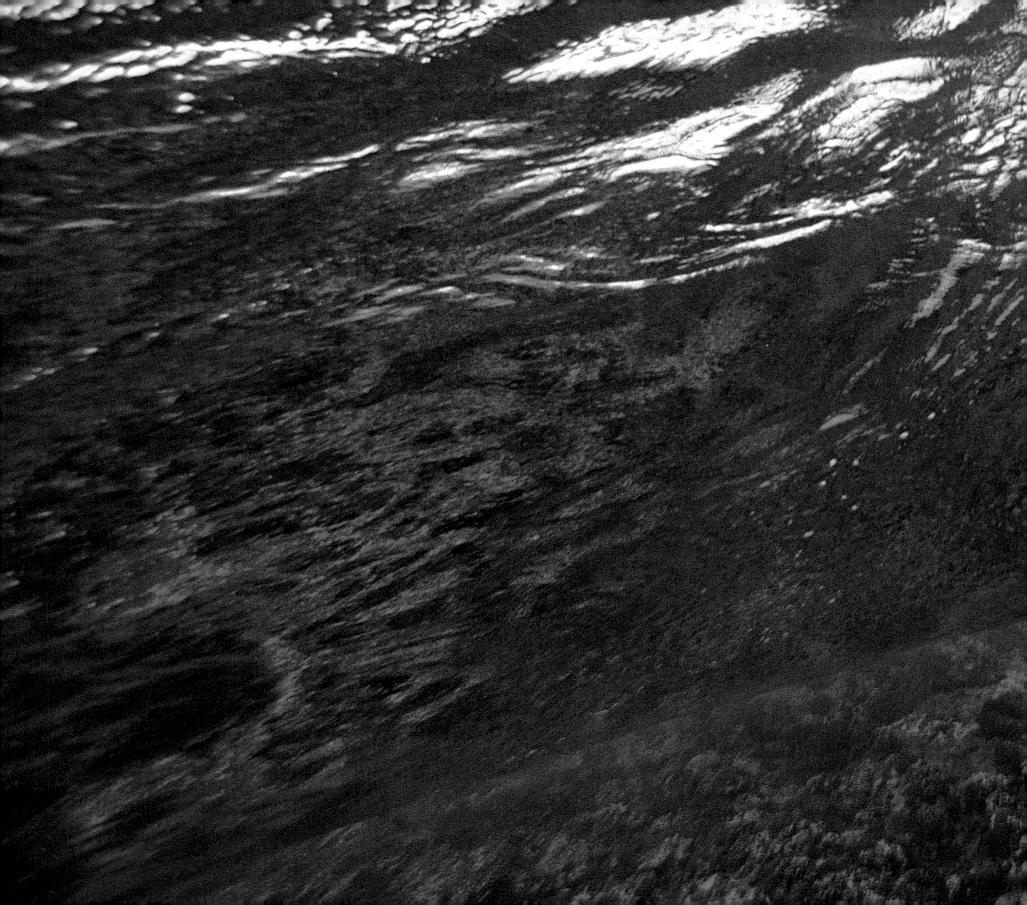

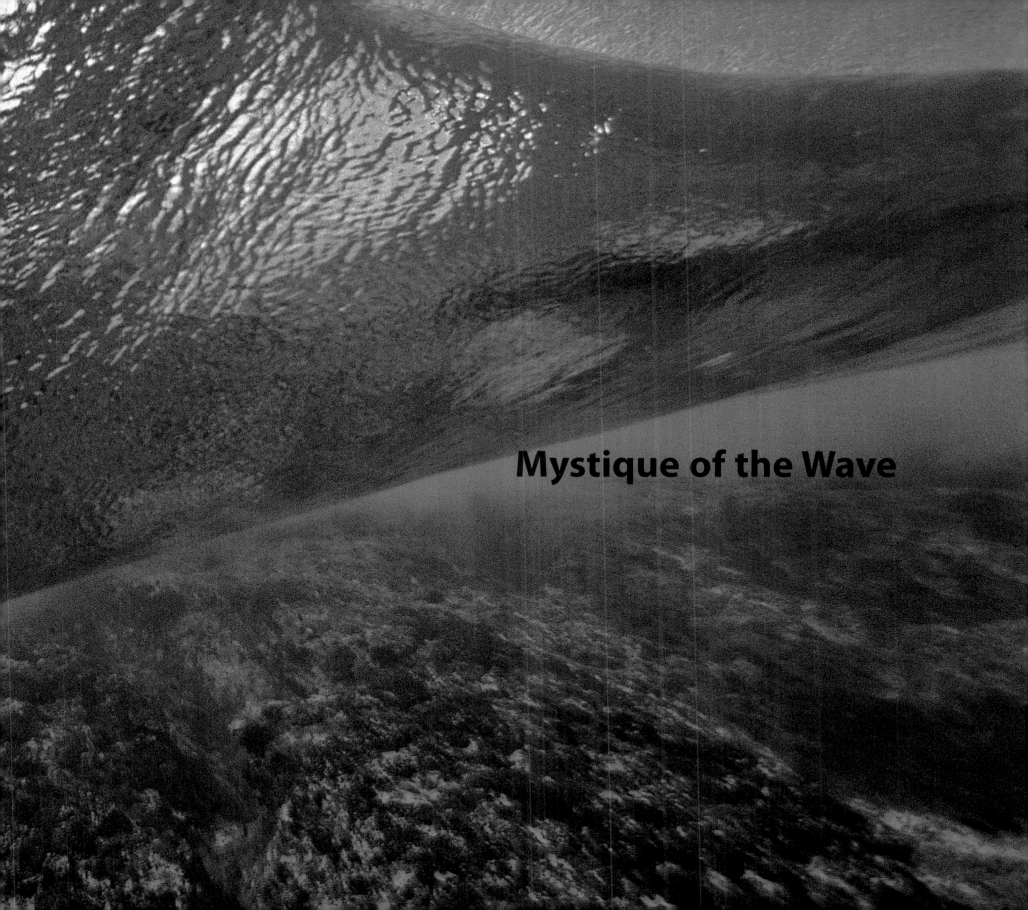
Mystique of the Wave

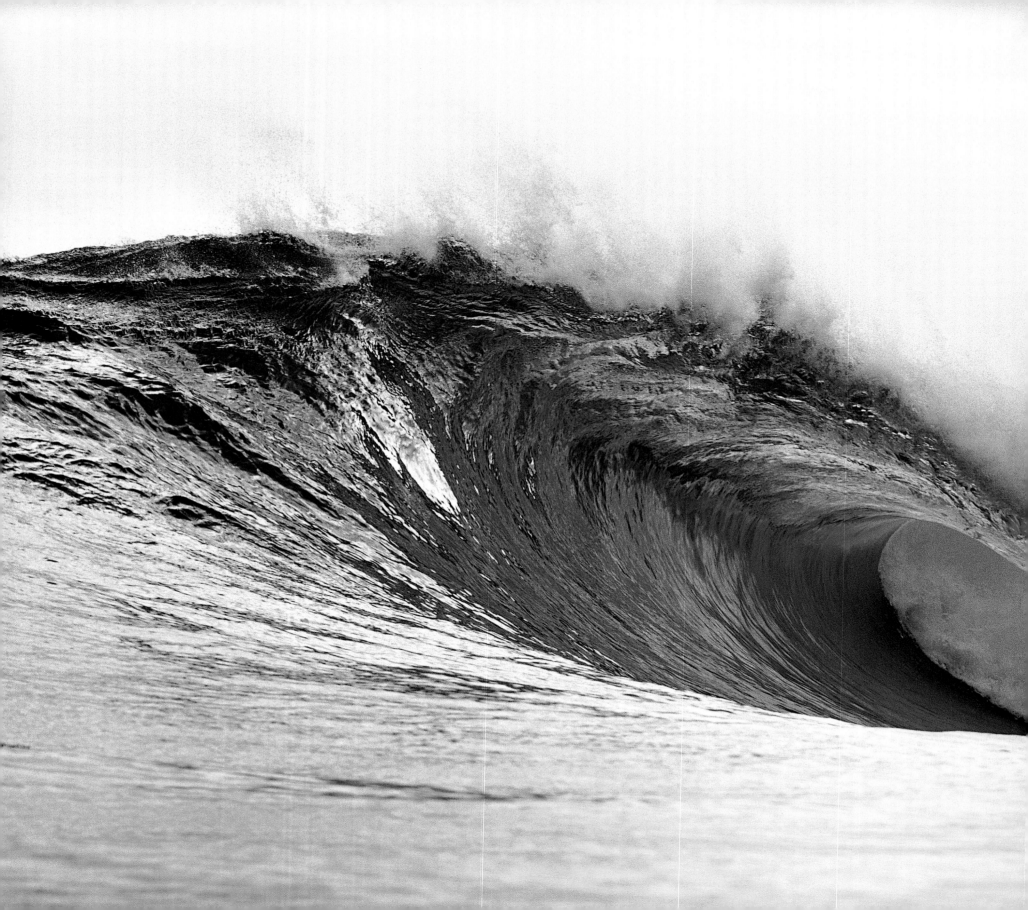

The Eye of God

We call it the eye of God. We stand before it a little dreamily, contemplating the strange oval on the photograph. By some unpredictable phenomenon, the occasional wave is subject to a singular diffraction of light. A blurry translucent ovoid appears, outlined by spume, on the dark-blue mass of the vertical wall of water. This fleeting water-mark seems to be inhabited by a strange shadow.

Though it is ultrafast, quite minimal, and thoroughly unproductive, the phenomenon is so rare that it makes for a particularly exciting sight. But can it actually be distinguished by the naked eye? I doubt it, given that in all my years in the ocean, I've never witnessed it. Yet photographers' contact sheets offer incontestable proof of the eye of God. The alteration of light happens halfway up the face of perfect, absolutely smooth waves, which are frequently of a buoyant blue.

Apparently, there is no known explanation for this crystalline splotch, the surface of which can reach up to 30 square feet. It is so fleeting and, apparently, uninteresting, that not a single researcher has ventured forth to analyze it. When faced with the unknown, we stick to the facts.

All over the world, at this very moment, people are staring out at the waves. Their eyes move as quickly as the rushing water. One person asks: "Did you see the clear stain on that wave?" Another answers: "It's the eye of God."

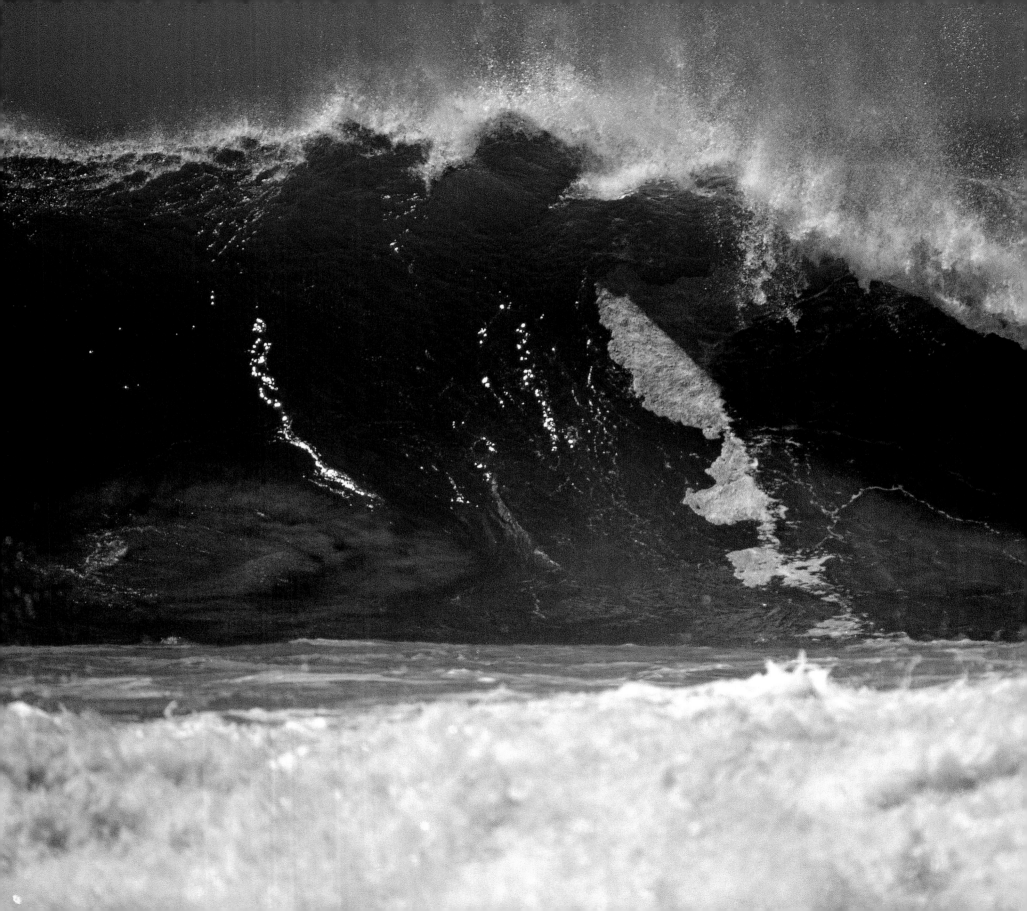

The Cauldron

The eye of God appears only in warm seas. Yet it wouldn't take much to convince me that tropical elves dance in the heart of curls at all latitudes. In the Basque Country, for instance, we have the marmite, or cauldron. What is a cauldron? A constant movement of water, probably swirling around a shale rostrum deep underwater, which translates on the surface as a static bubbling. Cauldrons are found between waves and at their troughs, and are distinguished by water that stirs and pulses without advancing. It's an unsettling sight, at least initially, and it's not exactly easy to surf. Here in the Basque Country, we call the phenomenon a marmite. In this area, where locals were once far from reluctant to burn a witch or two and where their descendants haven't forgotten those days, the appellation "cauldron" is no coincidence. There's no mysticism to it. It's just an unconscious form of commemoration. Local humor, if you will.

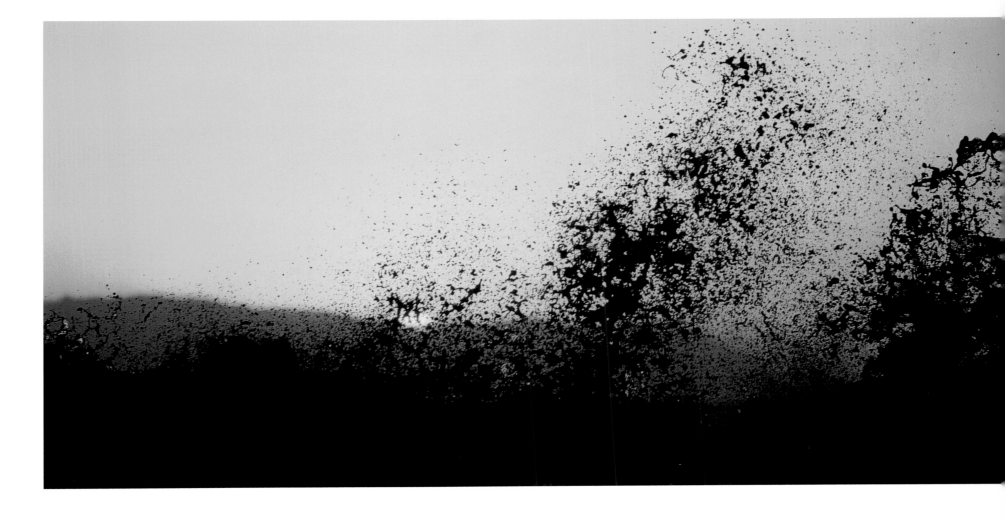

A Window on Infinity

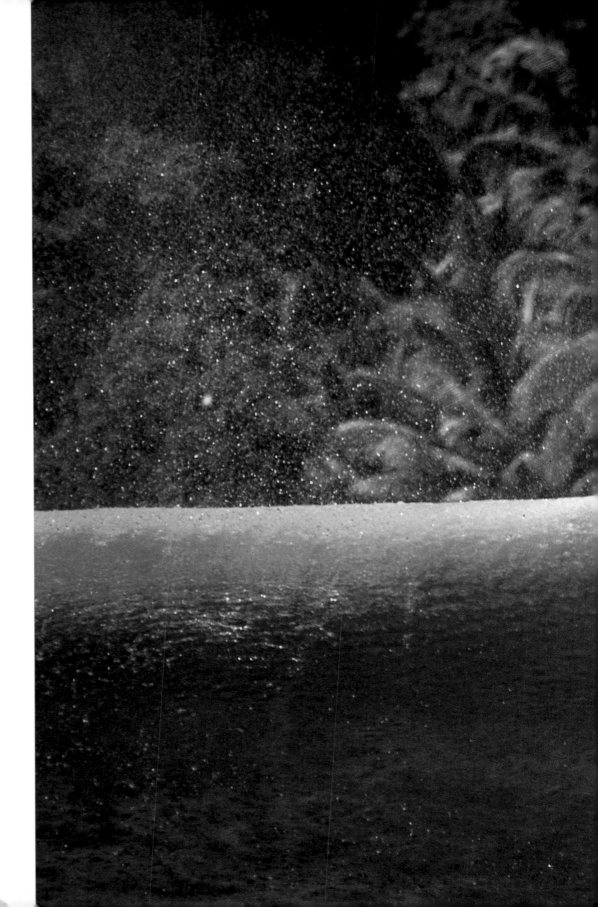

A wave is like infinity, yet there's nothing more fleeting, or more limited. Waves are limited in height and length, especially in comparison to the universe, which remains a good scale reference, particularly when assessing mystical phenomena.

Yet all it takes is a single wave, water drawing up and crashing forward, and you have a glimpse of infinity. It is such a graceful expression of form and color that surfers can only respond with a cowed, "It's perfect." Coincidentally, the Cathars called believers the Perfects. In Christianity, the only thing that's perfect is God. Whether you're a believer or not, you cannot deny that waves deliver a sensation of infinity.

This sensation is linked to the wave's basic composition—half water, half light. Even before scientific justification, man always instinctively felt that the wave played a fundamental part in the development of life. This is why, at the beginning of his epic story, John the Baptist baptizes Christ with the water from a mountain stream, with the waves lapping at his feet.

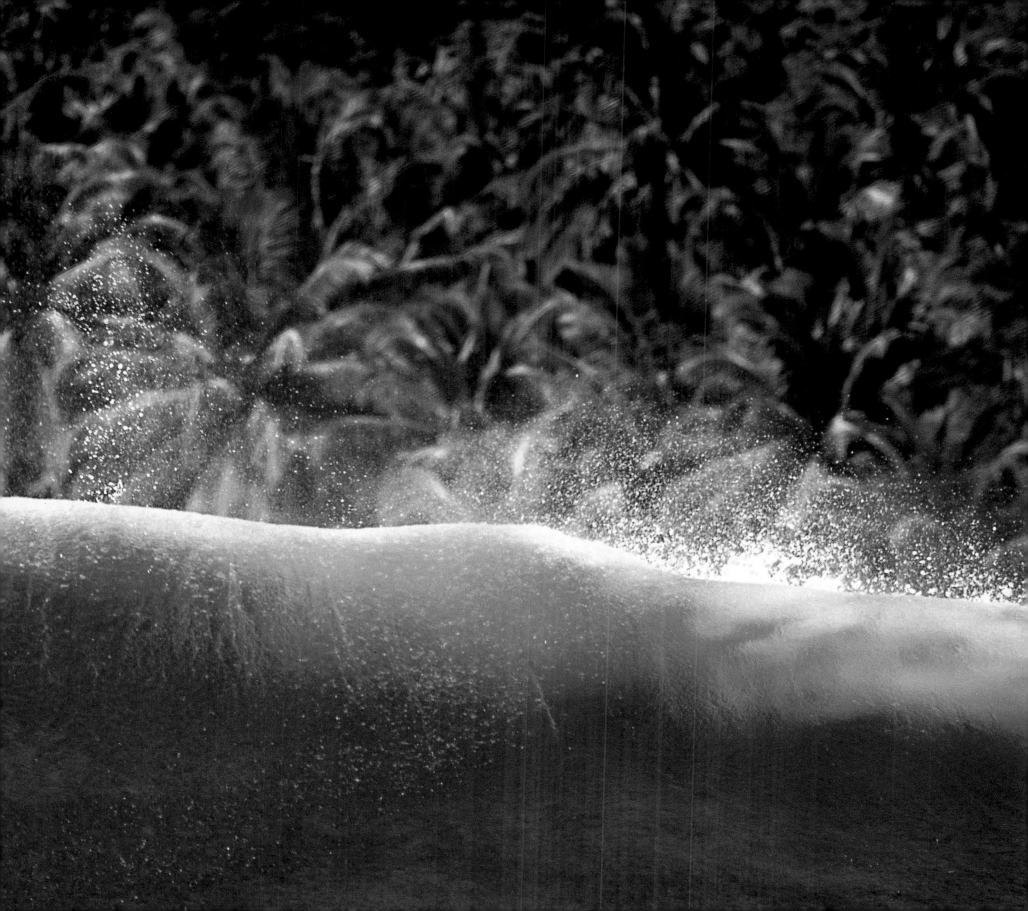

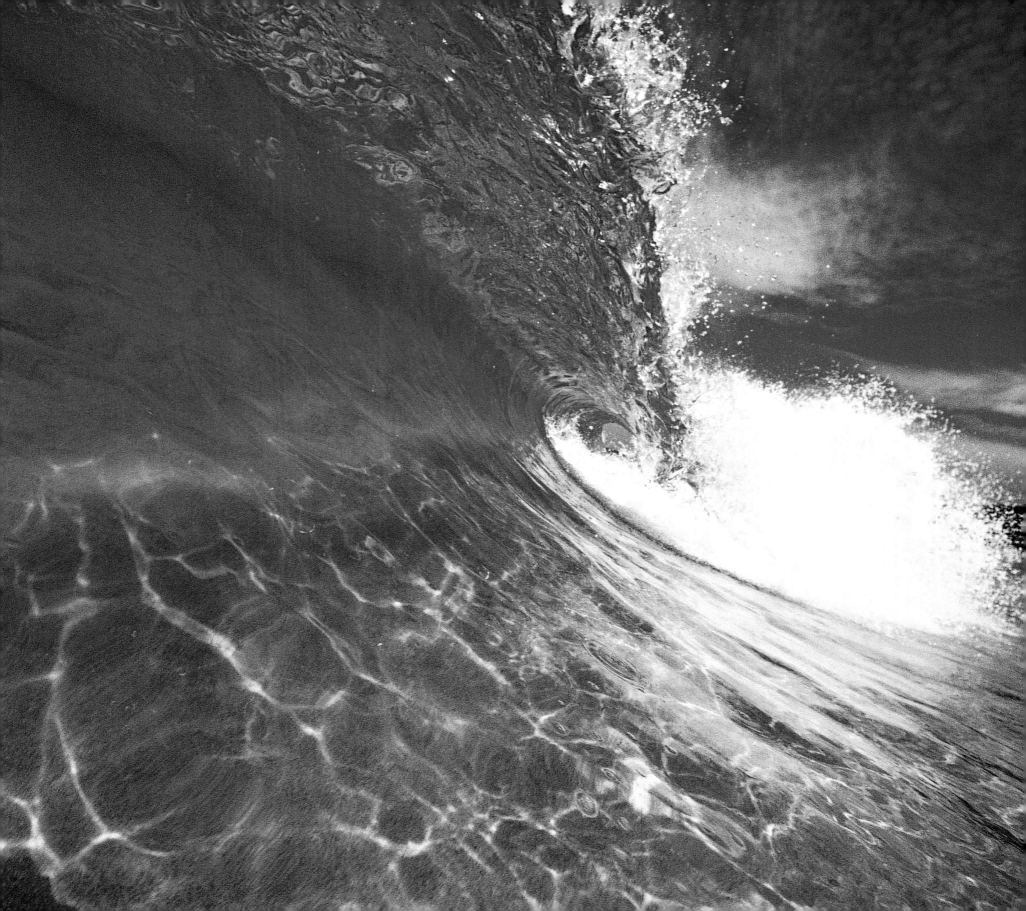

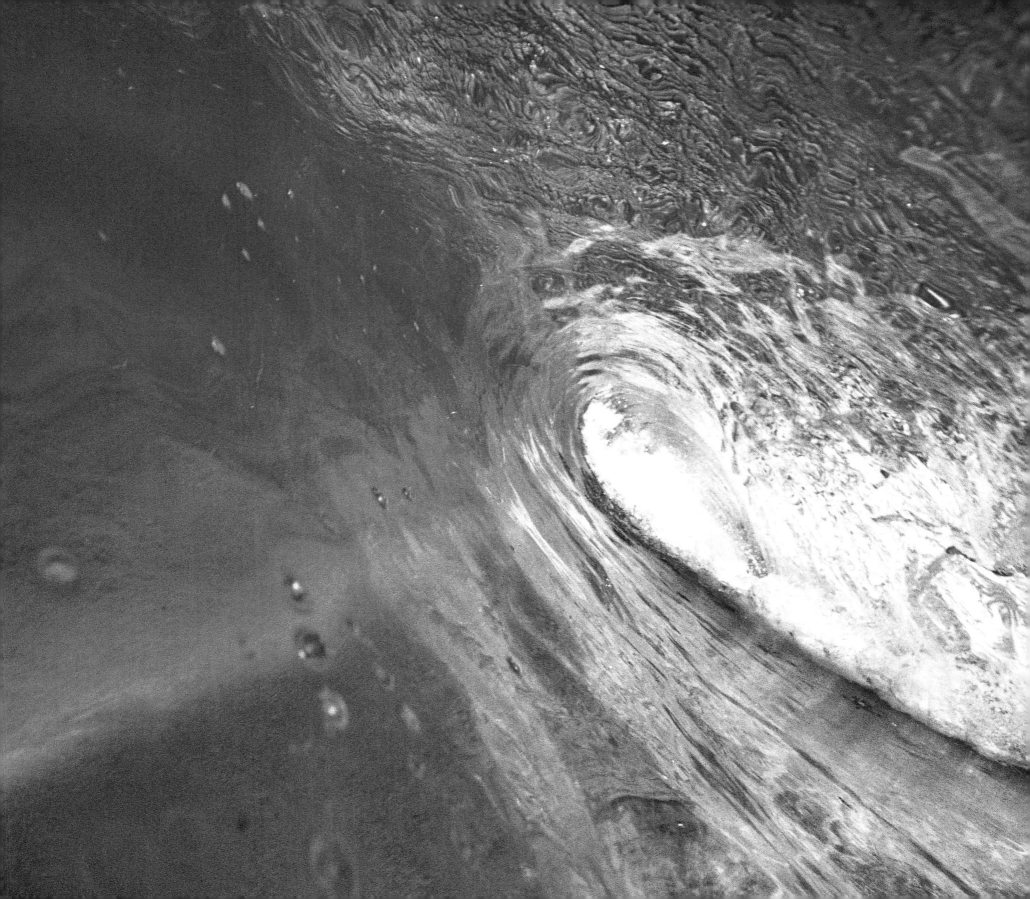

The Surfer Dancer

In Polynesia, men have been diving into breaking waves since ancient times. With the dawn of the modern era, the rest of the world followed the Polynesians. To do so, however, old resentments had to be laid aside. Both the fear of the ocean and a feeling of defiance toward the waves are perceptible throughout Western literature, from Homer to the nineteenth century. Historically, surfers have confronted this repulsion by slipping into moving water in search of fun. Surfers discovered that only the daring were rewarded with unmatched pleasure. Their craft grew subtle and diverse, and developed techniques often excavated from the treasure trove of Polynesian traditions.

The indescribable pleasure unleashed by surfing has multiple roots. It gives us the opportunity to rise to an ancient challenge and to face off against nature. And it is sensual—surfers are practically naked when they give themselves over to the watery dance, in which every inch of their bodies rejoices.

Surfing, and, particularly, bodysurfing, are far more than sports, for they allow a carnal immersion into nature. They allow us to develop a relationship with the water, the waves, and the ocean, which is by turns fraternal and by turns amorous. Surfing and its forebear, swimming, are cosmic sports.

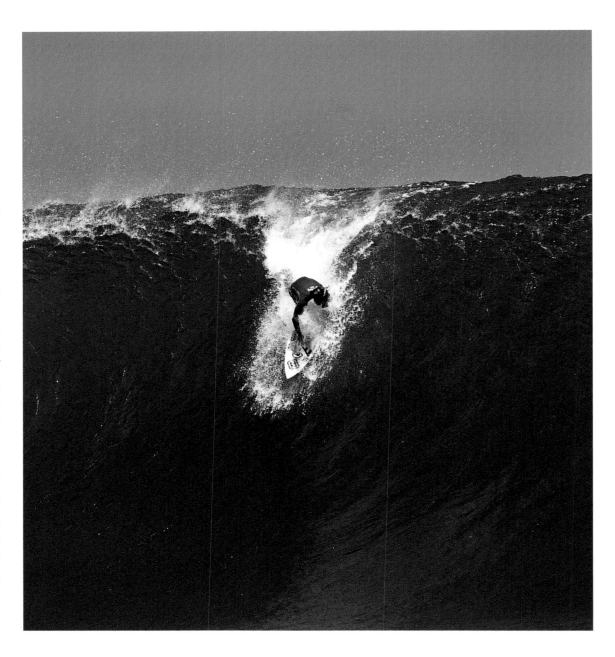

The Wave Versus the Void

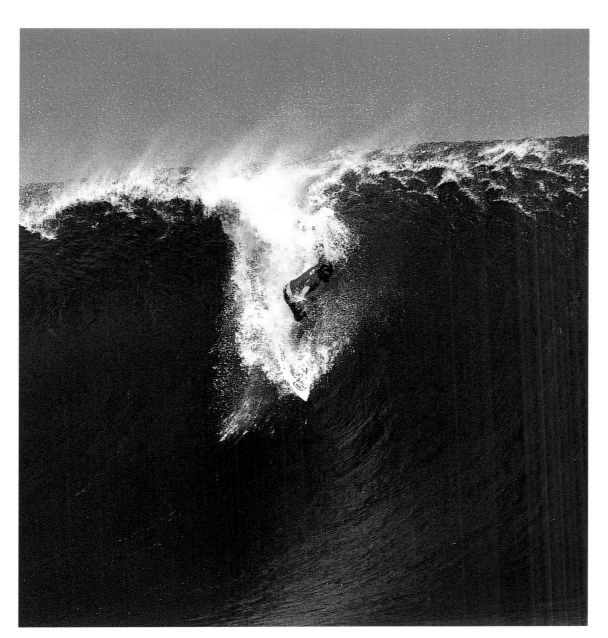

The wave occupies surfers' minds more than any other substance. Some have dedicated their lives to it. Others have dedicated their adolescence to it. During that period when there are so many questions and so few answers, some have discovered that breakers can shed light on the whole mess. Experience shows that the feeling of absurdity can be suspended, if not defeated, by a single wave. How strange that an ephemeral physical phenomenon should be able to assuage a metaphysical fear.

There are probably surfers who have been broken by the spume and lost all sense of reality in the sea's chaotic swirl, thereby losing the last solid elements of their already fragile psychological makeup. Yet the waves have pulled innumerable souls out of despair, they have put hundreds of lives back on track, and uncovered thousands of positive attitudes. I have known children in despair recover their smiles and their taste for pleasure and, through the value of effort, recover their will to progress. I've seen dead-end teens react to the challenge thrown down by the sea by demanding something of themselves. I have seen kids come out of the water grinning from ear to ear.

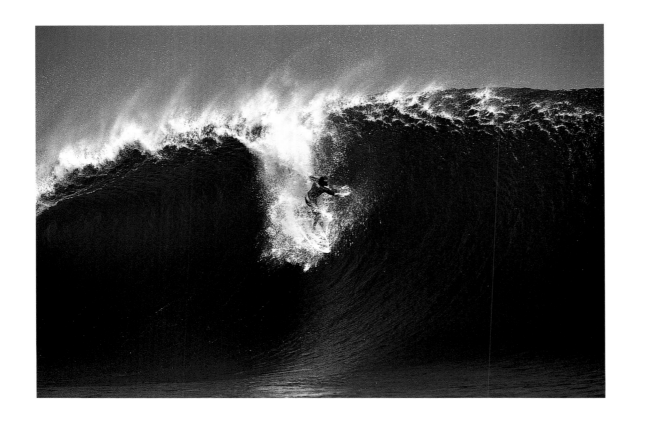
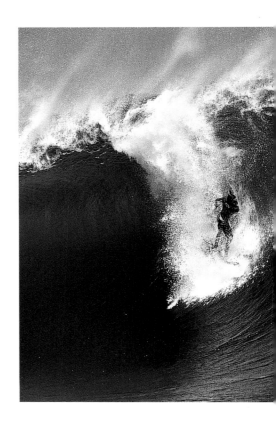
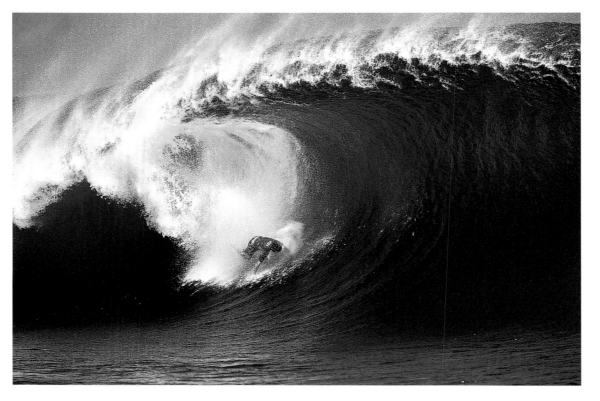
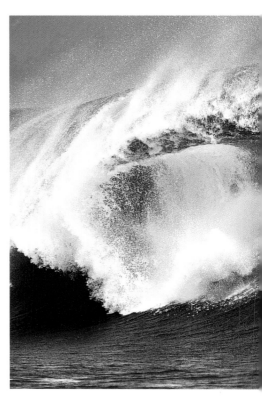

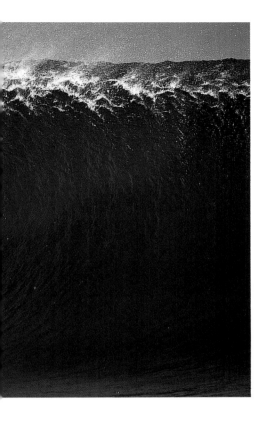
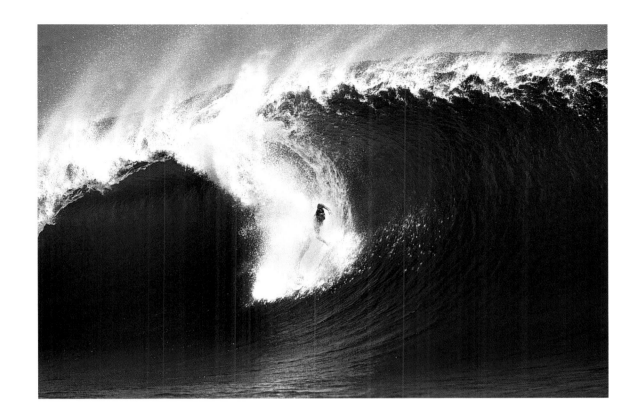
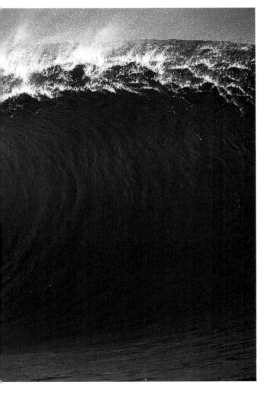
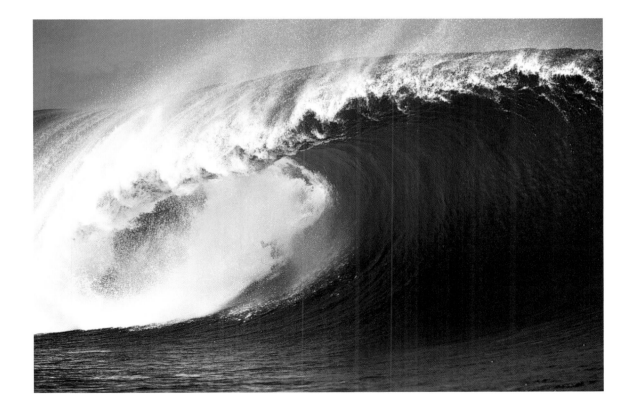

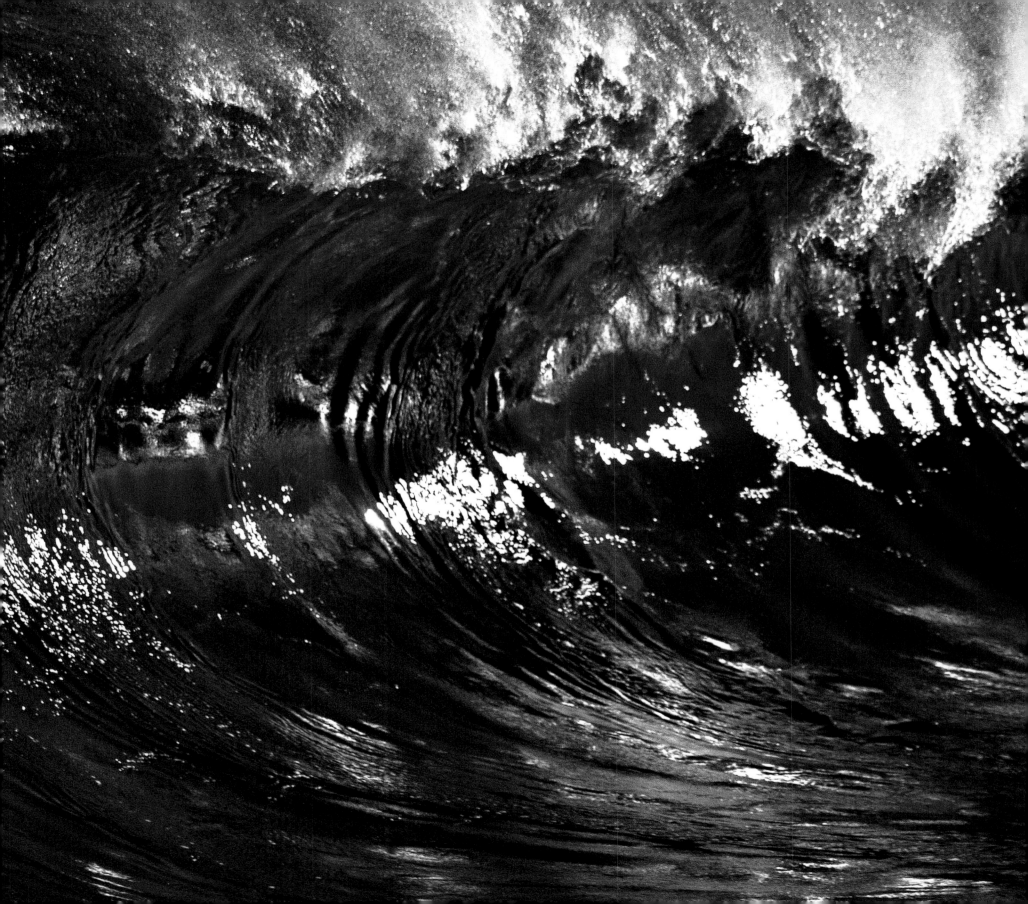

Surf and *Kumulipo*

The origins of surfing are spiritually rich. The cosmogonic texts bequeathed by tradition state that life began in the water. This is certainly true of the Hawaiian *Kumulipo* chants, which link life with the oceanic womb.

Let us listen to this song from the dawn of time. A French ethnologist, Serge Dunis, transcribed these sixteen long chants (which total more than two thousand verses) and published them through the University of Hawaii. This hymn to creation, born of the oral tradition, was written to the engrossing rhythm of an elegy. It has a raw and captivating, but muted feel to it. Its images radiate light.

The *Kumulipo* begins with the heart of the night, and methodically lists each of the species, as they follow each other into this world. The *Kumulipo* takes the differentiation of the sexes as its starting point ("*Kumulipo* of the male sex was born / Po'ele of the female sex was born," verses 14–15, song I). It's also worth noting that the first living being explicitly mentioned is born in the water ("The coral polyp was born / The coral emerged," verses 16–17, song I), and is quickly followed by about forty ocean species (the sea urchin, oyster, etc.). The ocean comes before everything else.

Starting at verse 40, the terrestrial species appear. The terrestrial species are associated with the numerous marine species, which they maintain under their totemic protection ("The perfumed algae 'a'ala'ula was born / Preserved on land by the mint 'ala'ala wai nui / The little red algae nanauea was born / Preserved on land by the taro of the same name / The red algae Ko'ele'ele was born / Preserved on land by the sugarcane of the same name"). The connection between land and water is unbreakable.

Finally, let us note that this creation of the world takes place in total darkness ("Black sun, black night / Everything was black") and that humans are born at the same time as light and surfing. This sets the parameters of the debate pretty clearly:

Things rise out of the menstrual silt / Birth of the era of surf / It is always night. / Beautiful, beautiful child / Of the era when humans were multiplying / Of the era when humans surfed from afar / The humans were born in large numbers / Man was born of the shallow water / Woman was born of the deep water / The humans stood tall / The humans slept / Long ago the couple slept together / A succession of human waves / Red was the forehead of God / Black was the forehead of the human / White was his chin / Serene was the time of the multiplication of humans / Serene was the time when humans surfed from afar / She was named La'ila'i, the serene one / The woman La'ila'i was born / The man Ki'i was born / The god Kane was born / Kanaloa, the ardent striking octopus was born / It is day, verses 593–616, song VIII.

Note that the serene eroticism of the poem's description of the couple sleeping together is immediately followed by the "succession of human waves."

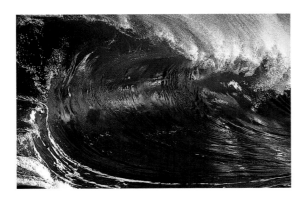 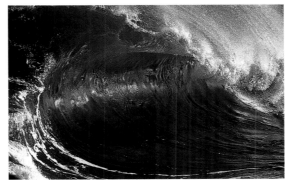 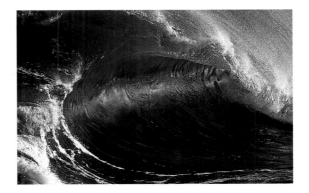

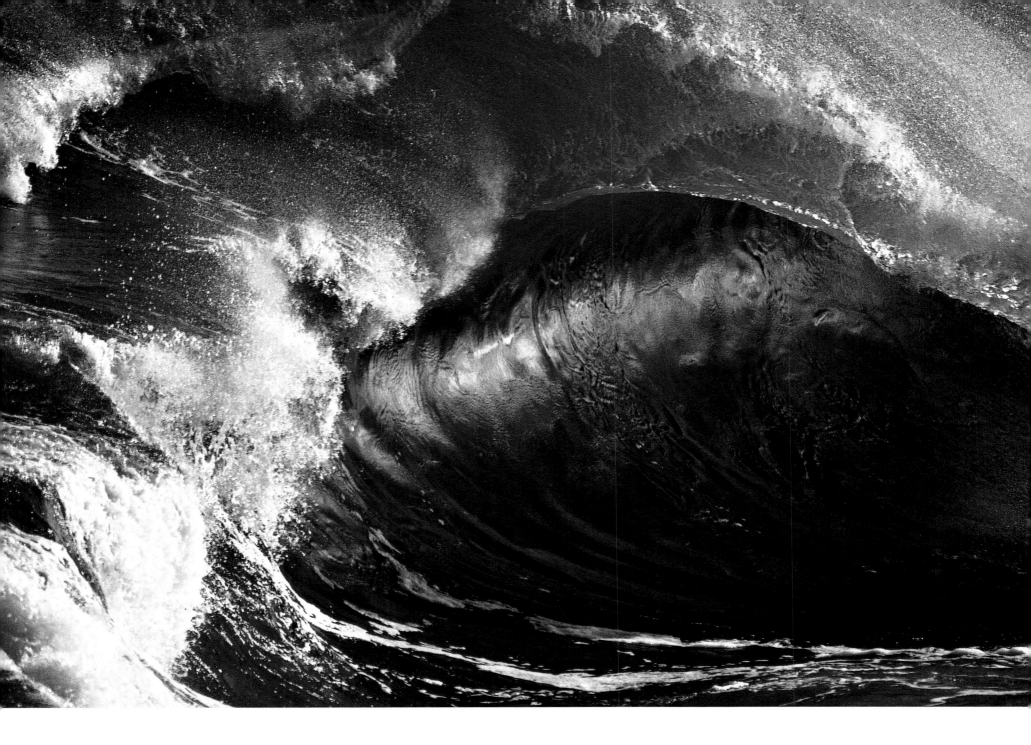

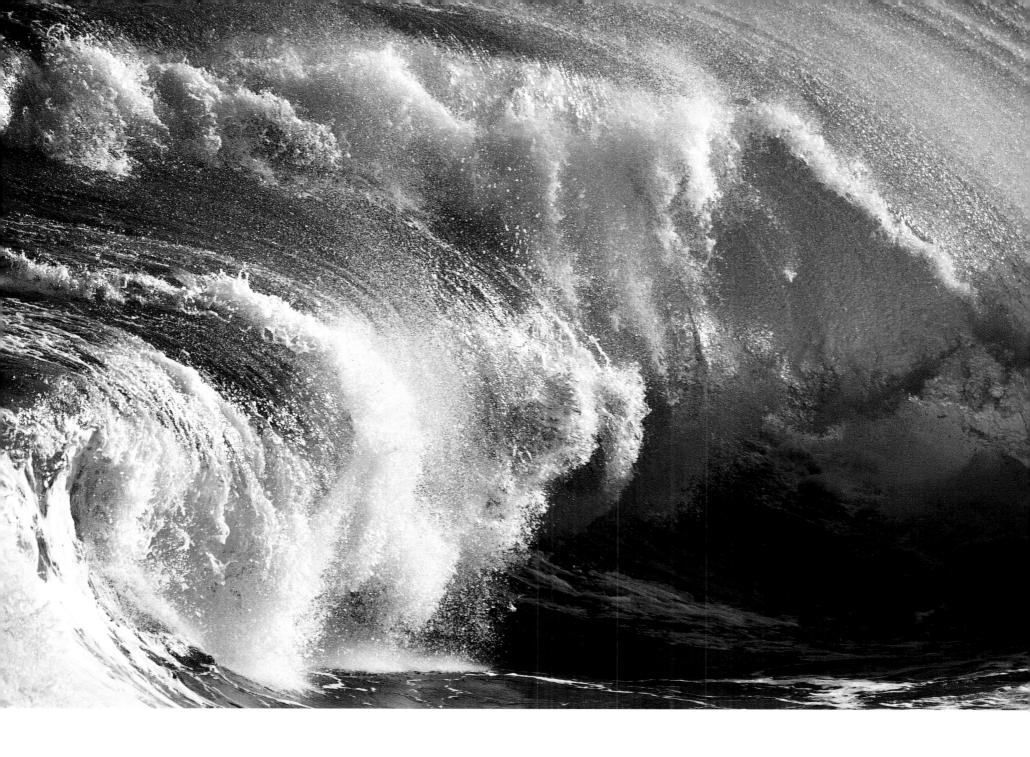

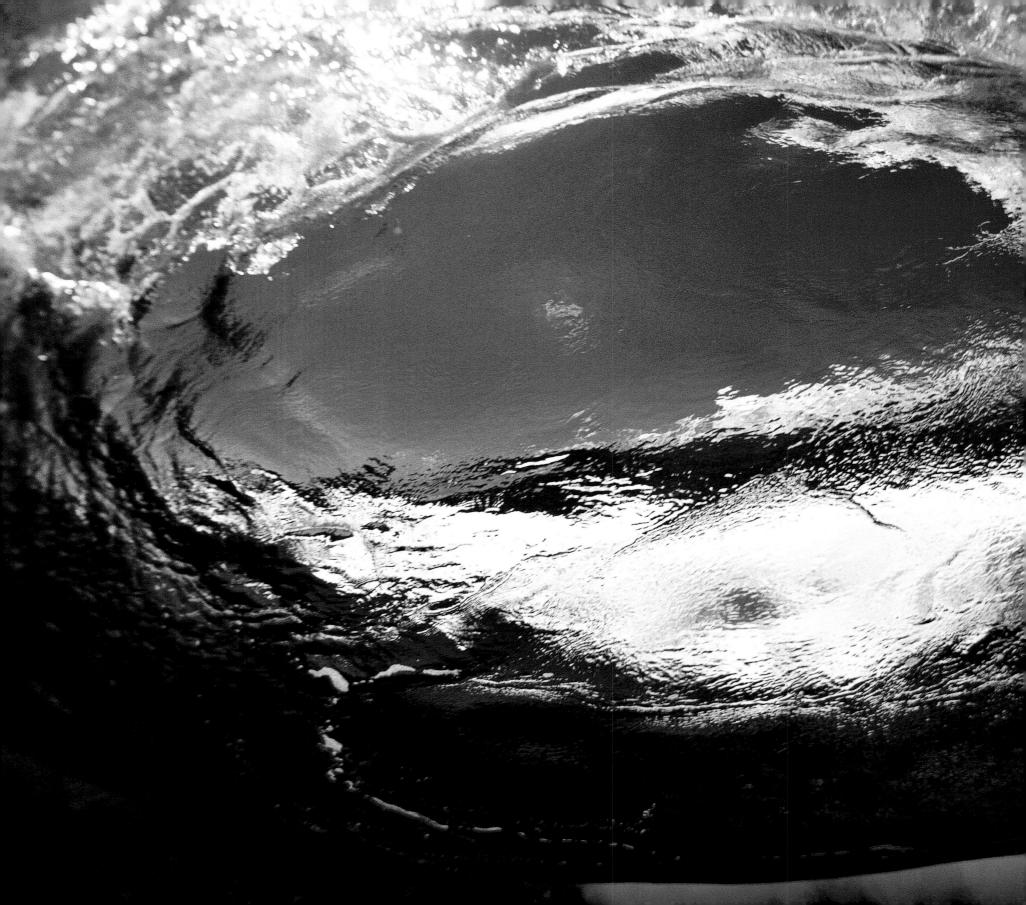

Surfing and the Bible

The presence of water, the great beyond of the ocean, is also strongly felt throughout the Bible. This is all the more surprising given that monotheistic religions have turned their backs on the sea. (Did monotheists consider that the improbably repeating, fleeting, and ever-changing waves have more in common with the endless strands of polytheism?) Yet the first book of the Bible, Genesis, puts the spiritual dimension of the ocean in its second line: "The Spirit of God moved upon the face of the waters."

Then God separated "the waters which were above the firmament" from "the waters which were under the firmament," and called the ones under the firmament "seas." The importance of the aquatic element is confirmed as the text progresses. It is with water that humanity is punished, and it is a sailor who saves both the human race and all the animals. Thank you, Noah! Then comes Christ.

Christ was also a navigator. For a long time, I thought that when Christ walked on water at Tiberias, he had simply mystified his disciples by surfing. I have to admit that I still find it seductive to imagine Christ in his long robe and leather sandals performing an amazing hang ten before the eyes of the benevolent God. Unfortunately, when I reread Saint Mark, I realized that Christ is walking toward the open sea, and that he therefore can't be surfing (although, a sufficiently strong backwash *could* . . .).

I tried to make myself feel better by thinking about the amount of time Christ spends on various boats escaping the crowds (and probably his enemies). The waves are his friends. He sleeps peacefully through the storm.

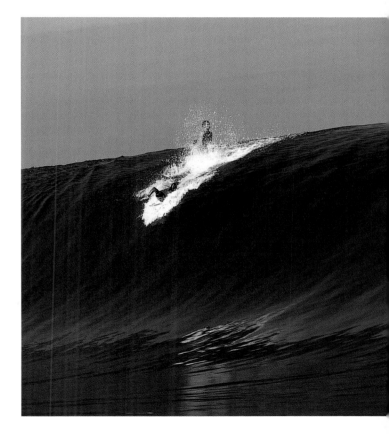

Dialectic of the Wave

According to the creation stories (whether in the Bible or the *Kumulipo*) and the lore of any civilization, the inseparable practice of waves and passion for waves lead to an ethical responsibility, as well as to a historical and philosophical vision of action. The wave isn't a stadium, it's a temple. It's a holy place. Though my statement might bring a mocking smile to the reader's lips, that smile would quickly be wiped away by the explosive breaking of a wave in the early morning quiet. Some Native American tribes take it a step further, claiming that rocks have a soul and that they are also alive.

The old Pacific adages constantly remind us that a human is equal to an earthworm, who is equal to a white shark. It isn't only a question of, "one man, made of all men, equal to all men as all men are equal to him," but of a man made of all animals, equal to all animals as all animals are equal to him. Man eats bonito, yet the bonito is his brother. The ocean is the scene of a family drama, with all the cruelty that entails. The important thing is that all people respect the bonito, and that they thank it for its sacrifice. A Tahitian man called Teva Noble once gave me advice to the same effect: "Go surf, but do not take anything, without giving back. You can make an offering to the ocean, by giving it a leaf, or a rock, or saying a prayer. But if you take, you must give back."

This Polynesian law, expressed by the most powerful, demanding aspects of Polynesian culture, is both fearsome and ripe with significance. If man was to give back to nature everything that he had taken from it, the world would be radically altered! Dream on. Since talking with Teva Noble, I often say a few words to the ocean as I slip out of the water. We all more or less agree that it's useless. And yet . . .

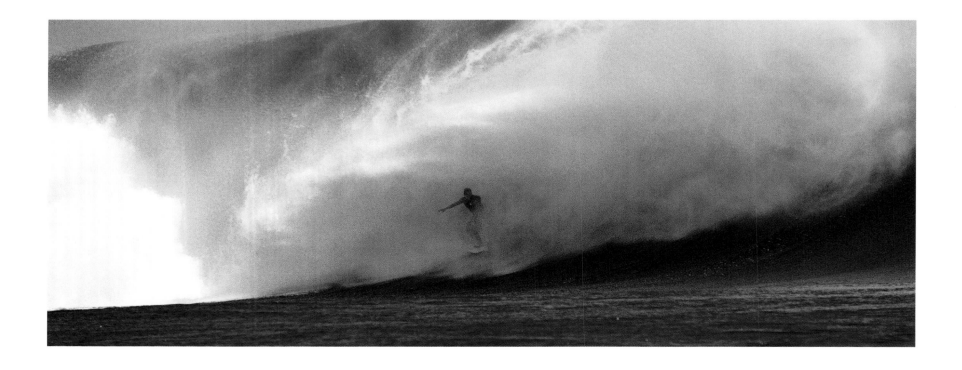

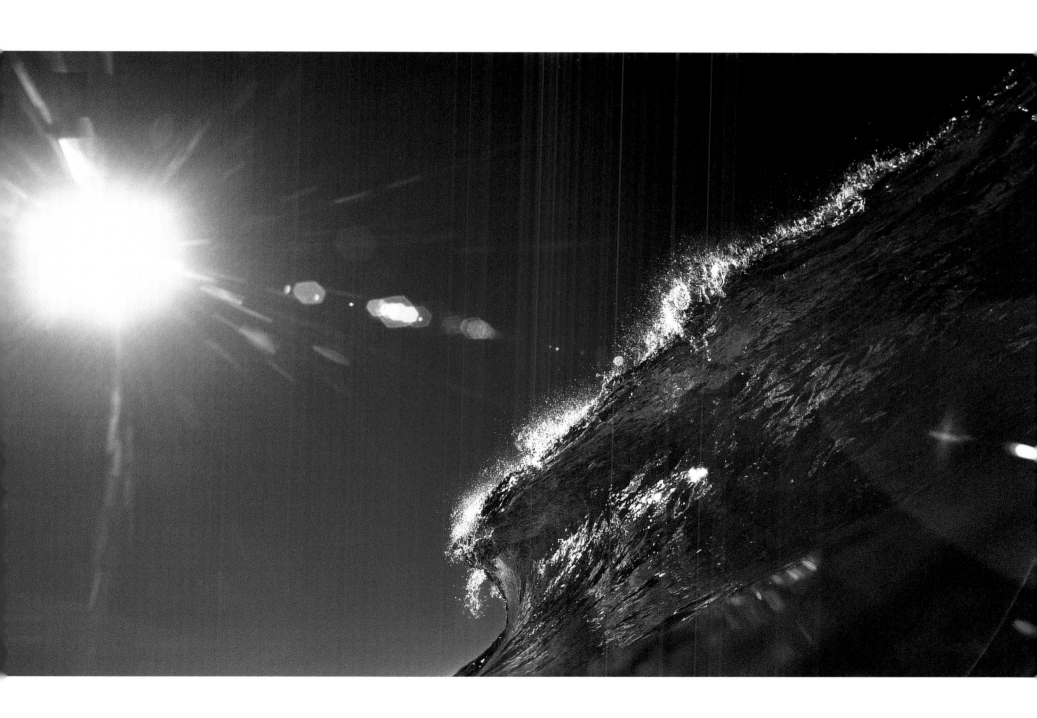

Painting the Wave

It's always surprising to consider painters. Painters don't know how to draw waves, which means they don't know how to look at them. Yet artists, by definition, are observers, first and foremost. They have given us endless masterpieces, but aside from Gericault's *Le Radeau de la Méduse* (The Raft of the Medusa), which primarily focuses on the human element, marine masterpieces are few and far between. There is no *Las Meninas* in the lineup, no *Mona Lisa* peeling off from the left, no *Guernica* of the shorebreak.

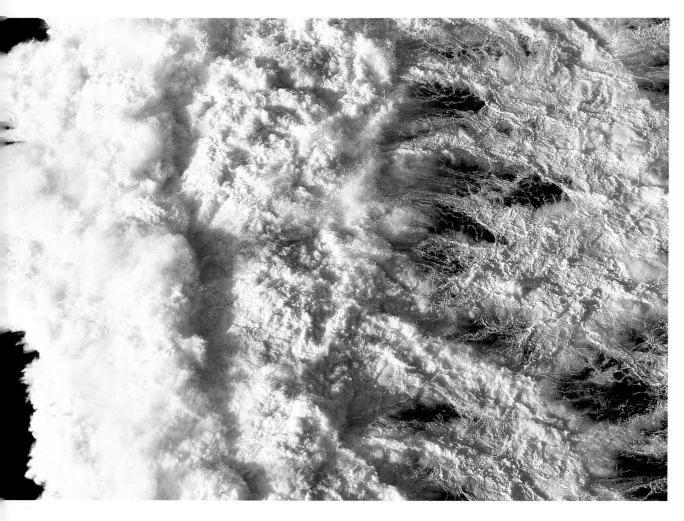

Painting's take on waves simply doesn't have the impact of the original. Even marine painters such as Vernet and Garneray never quite get with the flow of the flow; their work lacks the energy of the spume. Though Monet excelled in capturing the luminosity of the slumbering ponds and mournful water lilies in his *Nymphéas* series, his pictures of the surf lack smoke, iodine, and explosive light. Renoir's seascapes are frozen. Painters have succeeded only at capturing explosions in the sky. Van Gogh's late paintings of night in Saint Rémy de Provence look exactly like breaking waves, and Turner's entire body of work evokes water through its renditions of looming storms and howling clouds.

The best drawings of waves are by Victor Hugo. Hugo isolated the curve of the trough, the hem of the shoulder, the snarl of the lip, and the mesmerizing feeling of the wave breaking. He did this with a quill, furiously dipped in India ink, as if only black and white could compare with the wave's unspeakable swirl of colors.

Yet the success of certain Japanese artists suggests it may not be a problem of color, after all. These artists excelled at rendering storms at the foot of Mount Fuji using blue and white flat tints. Wielding quills to achieve a nearly calligraphic style, these Japanese artists captured the ease and extravagance of the water's curves with a gracefulness that approaches the sublime.

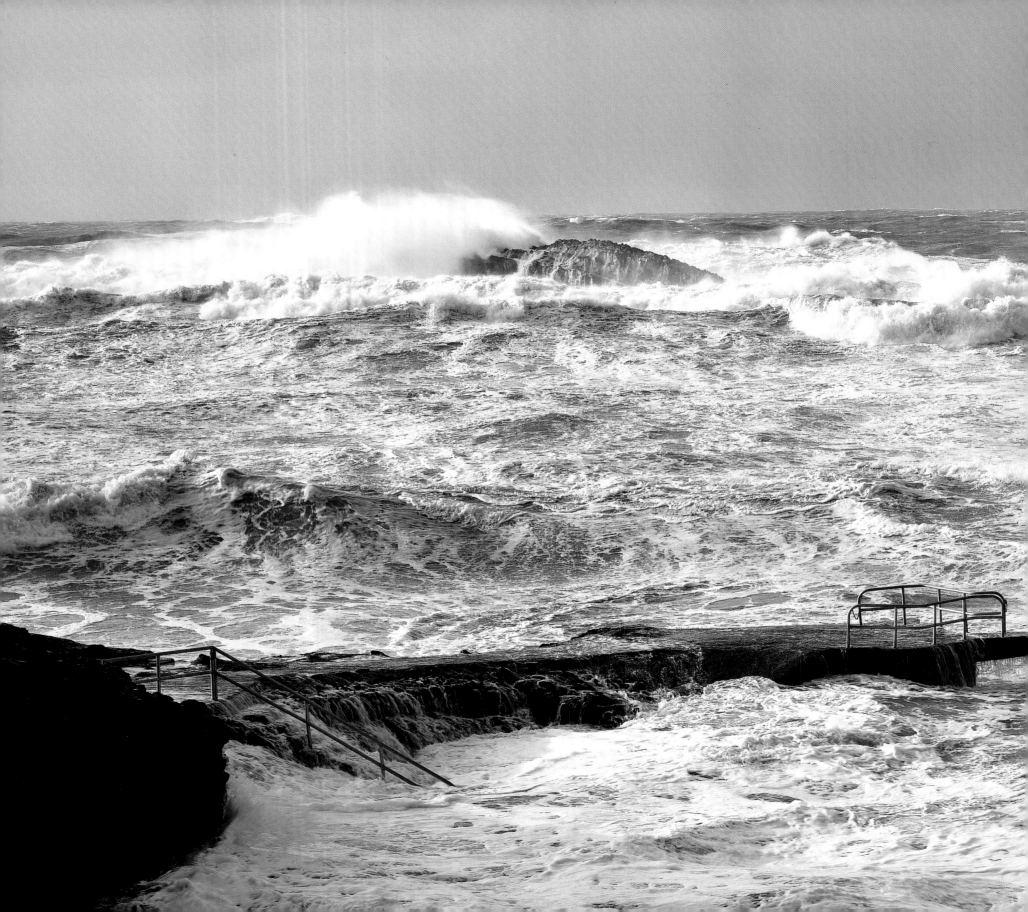

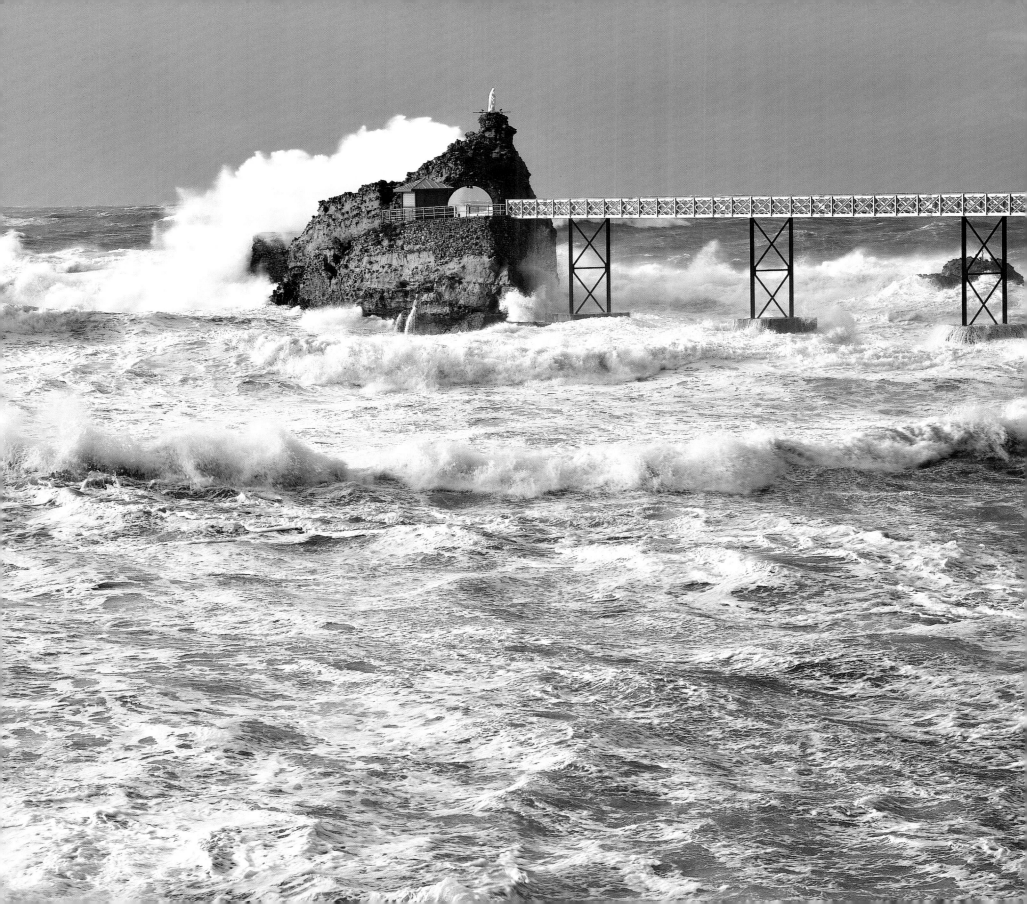

Waves and Photography

While painting struggles in the face of hyperrealism and, particularly, the ocean's dynamism, photography has no trouble in these domains. When it comes to reproducing the state of the water and the structure of the breaking wave, to giving an accurate idea of the curves, volumes, and translucent density of the frothing water, and to capturing the ebullient colors of the sea, photography takes its revenge on painting. Photography triumphs by seizing the ephemeral and breaking down the simultaneously simple and incredibly complex continuum of the wave into a series of snapshots.

Photography shares painting's innate inability to capture the smell of wrinkled algae, the ferocious viscosity of water, and the impetuous nature of underwater currents. Yet photography is both precise and eloquent when it comes to evaluating the power of a wave's lip and placing the sea's violence in perspective. In short, photography is no replacement for reality and experience, but it succeeds in conveying specific details that escape our immediate attention.

A perfect example is the "eye of God," mentioned earlier. Photographers can draw attention or add unsuspected dimension to a lip exploding out of nowhere, or to the unseen, treacherous presence of a dangerous reef. In comparison with painting and sculpture, which were allegedly better at dissecting the human soul and describing its passions, photography was considered a minor art. There may be some truth in this point of view, but when it comes to the ocean, and the wave, nothing beats a photograph.

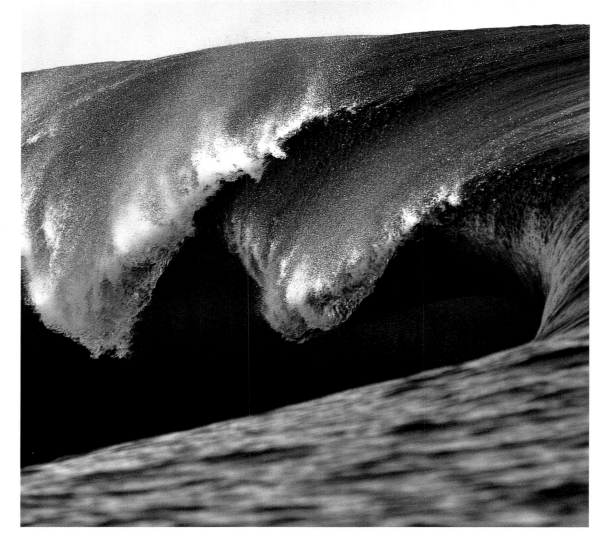

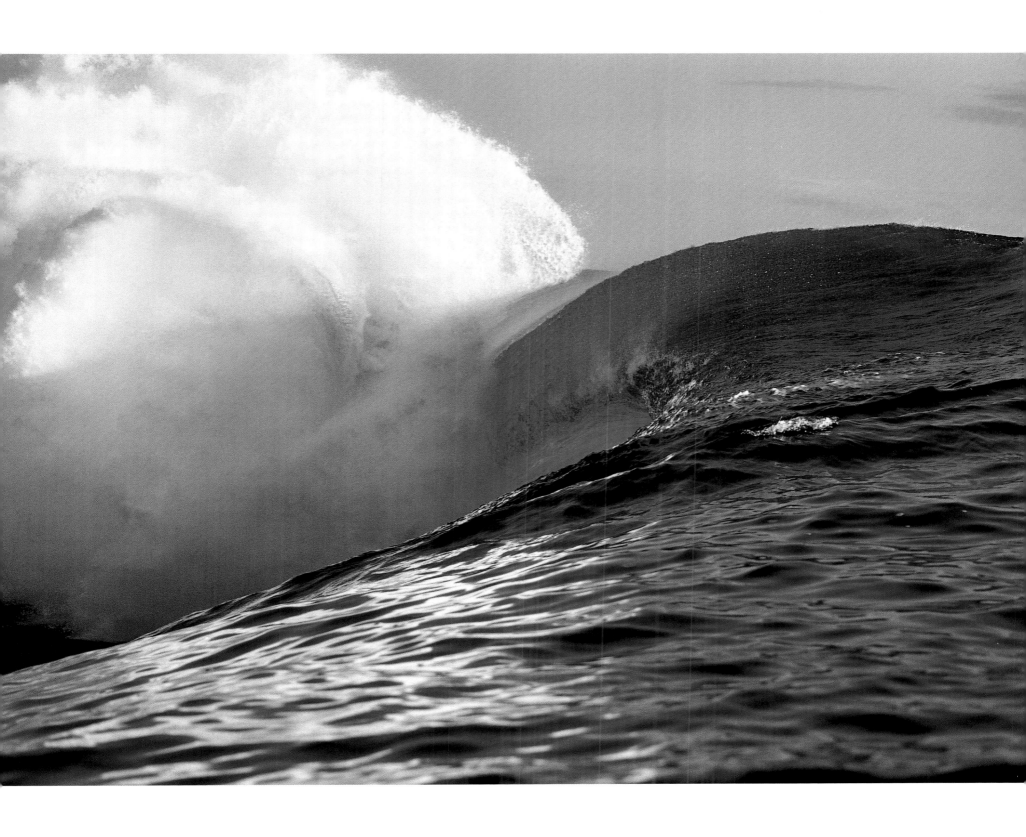

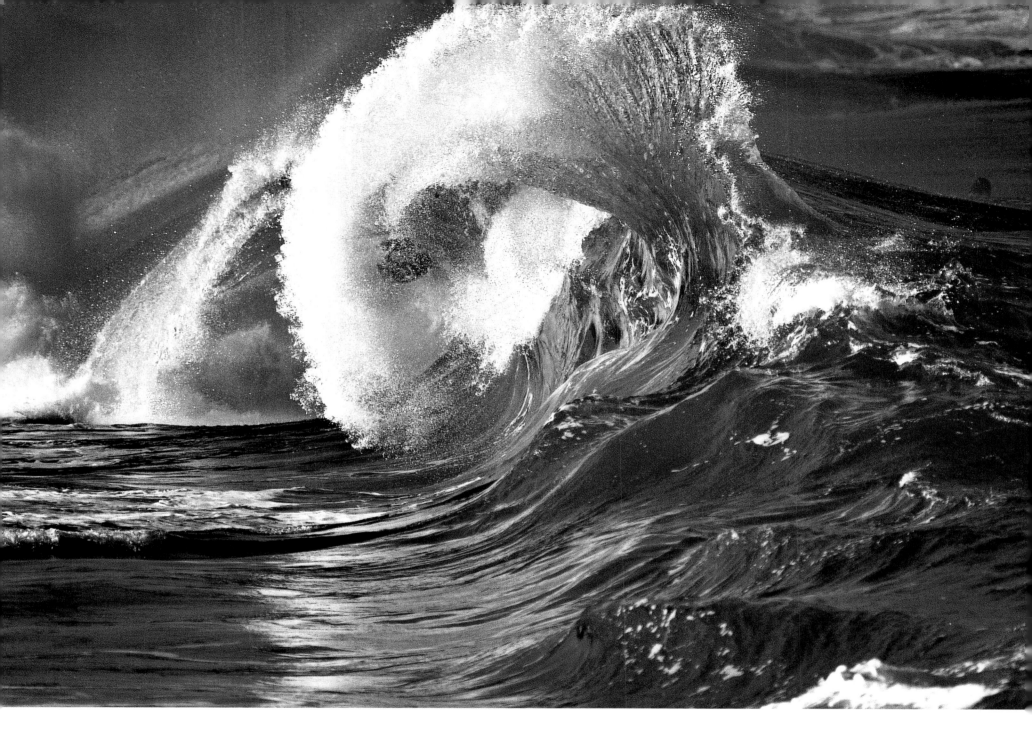

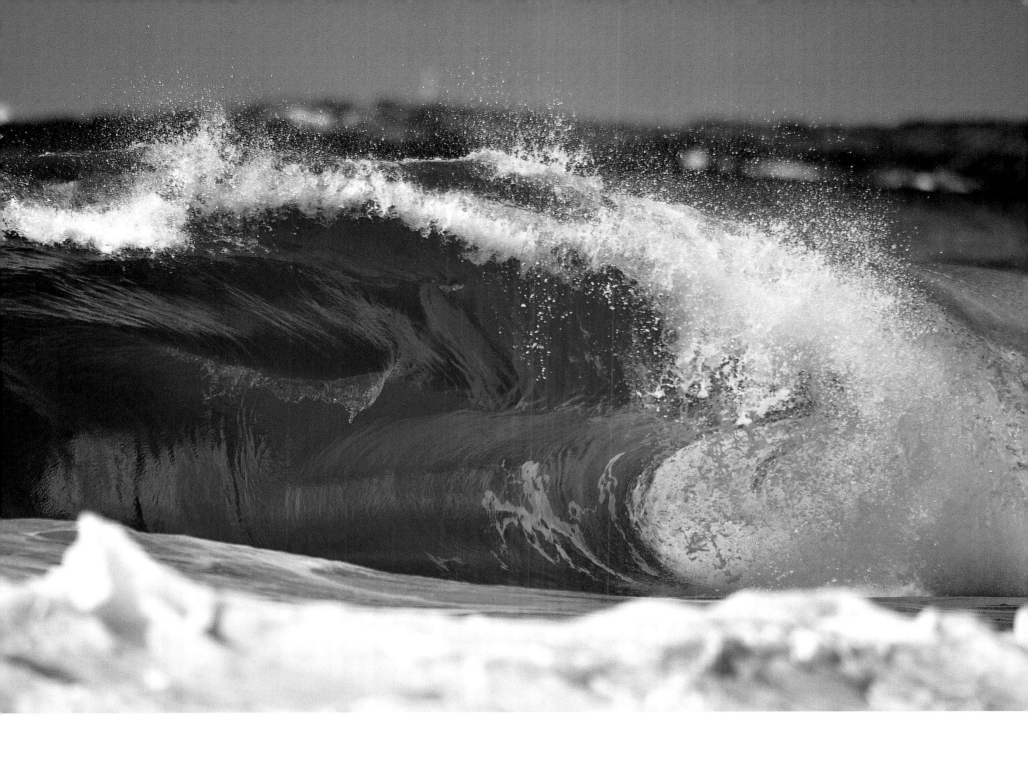

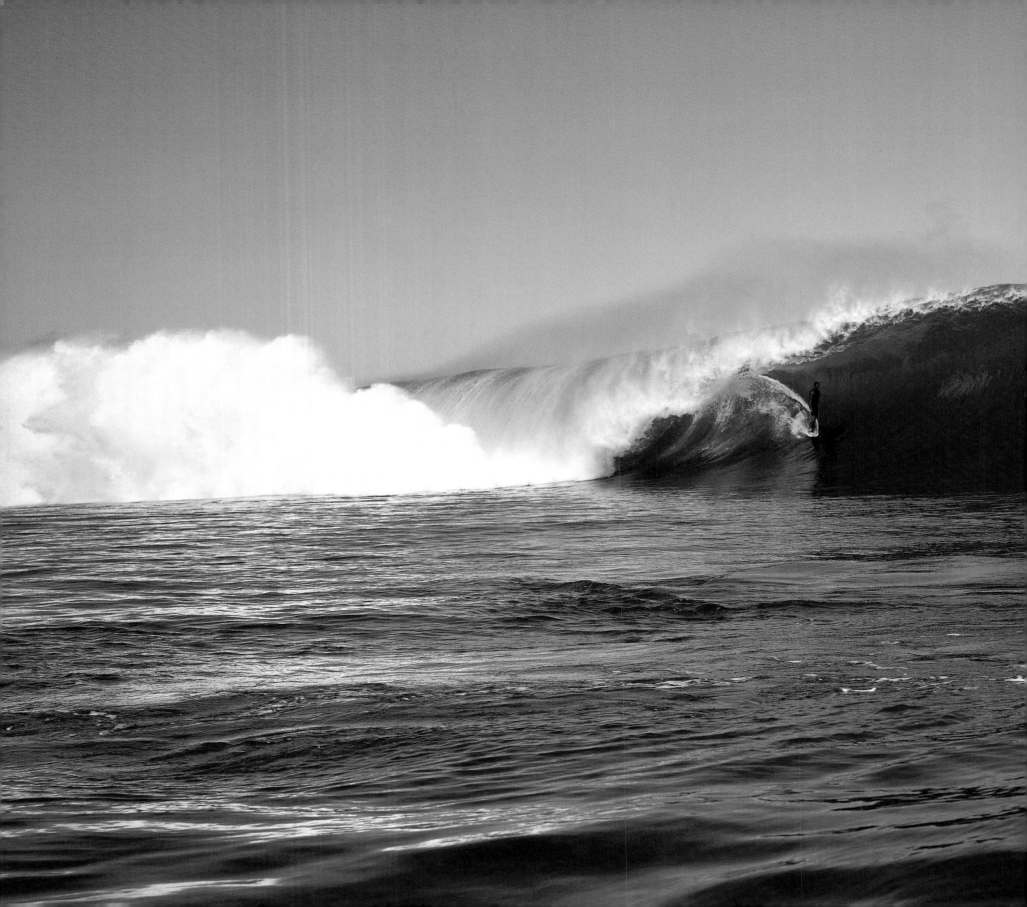

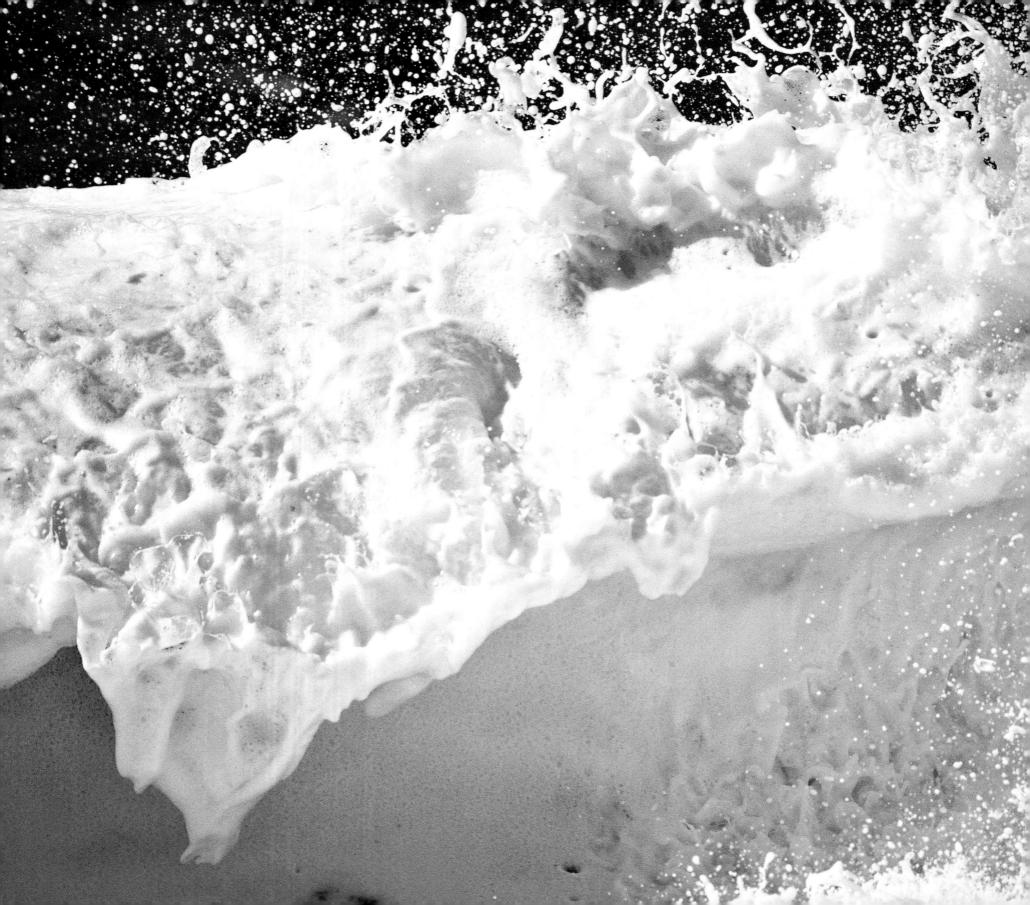

The Complexity of Waves

If painters who chose waves as their subject matter portrayed them in such a disappointing way, it is because they were disarmed by the wave's subtlety. As the most assiduous wave practitioners, surfers naturally inherited the job of creating a typology of waves and giving names to each of the wave's characteristics (the curl, mass, tube, speed, direction it breaks in, etc.), and coining a vocabulary that has been passed on by the oral tradition of surfing. Once this was established, it became possible to talk about waves and to compare them. (Incidentally, the surfer's wave has little in common with the sailor's wave, which is a high-sea wave, as opposed to the surfer's coastal wave.) Finally, note that no two waves are ever alike. It isn't even a matter of waves being different from one ocean, continent, region, tide, or even beach to the other, but of every wave being different from the one behind it, whether they are on the same beach, during the same tide, or on opposite sides of the world. Computer-generated forecasts and satellites are often powerless when it comes to waves. At a certain point, the study of waves reaches a predictable unpredictability.

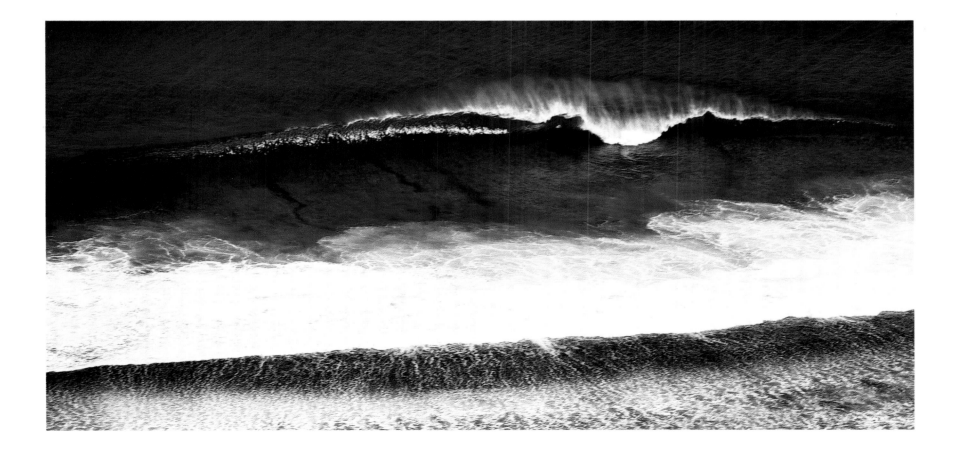

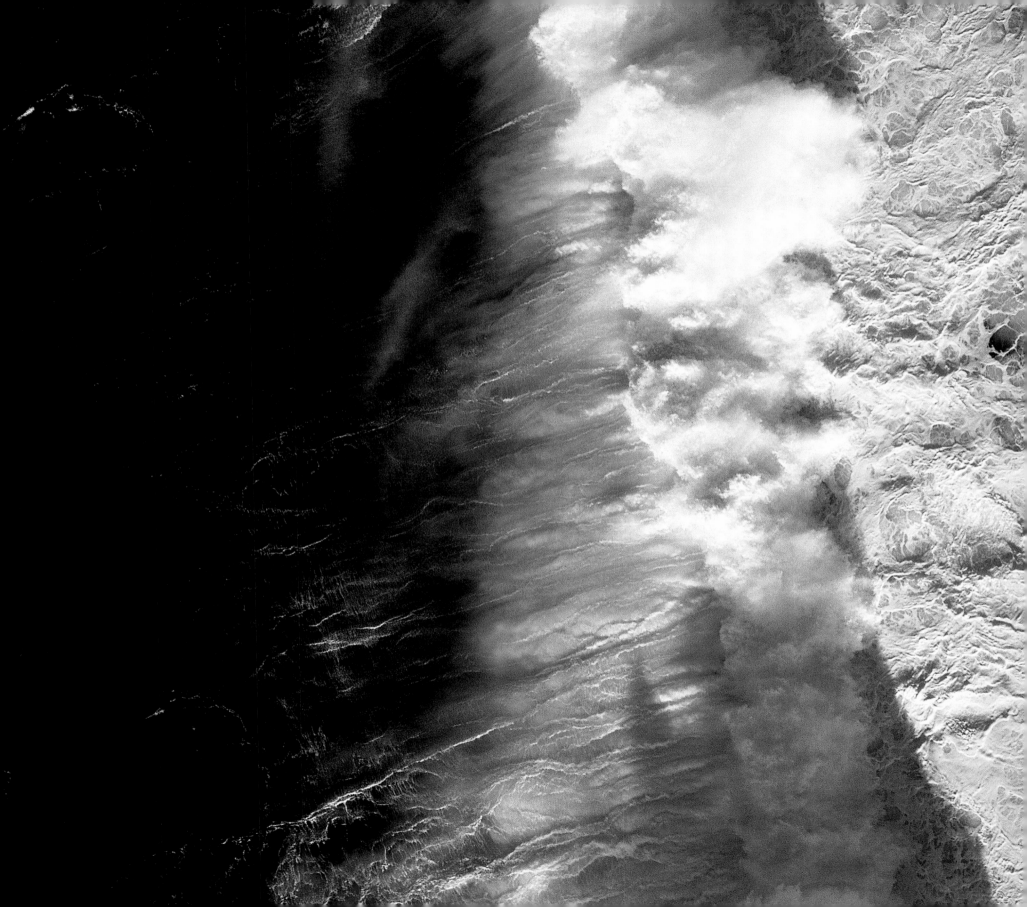

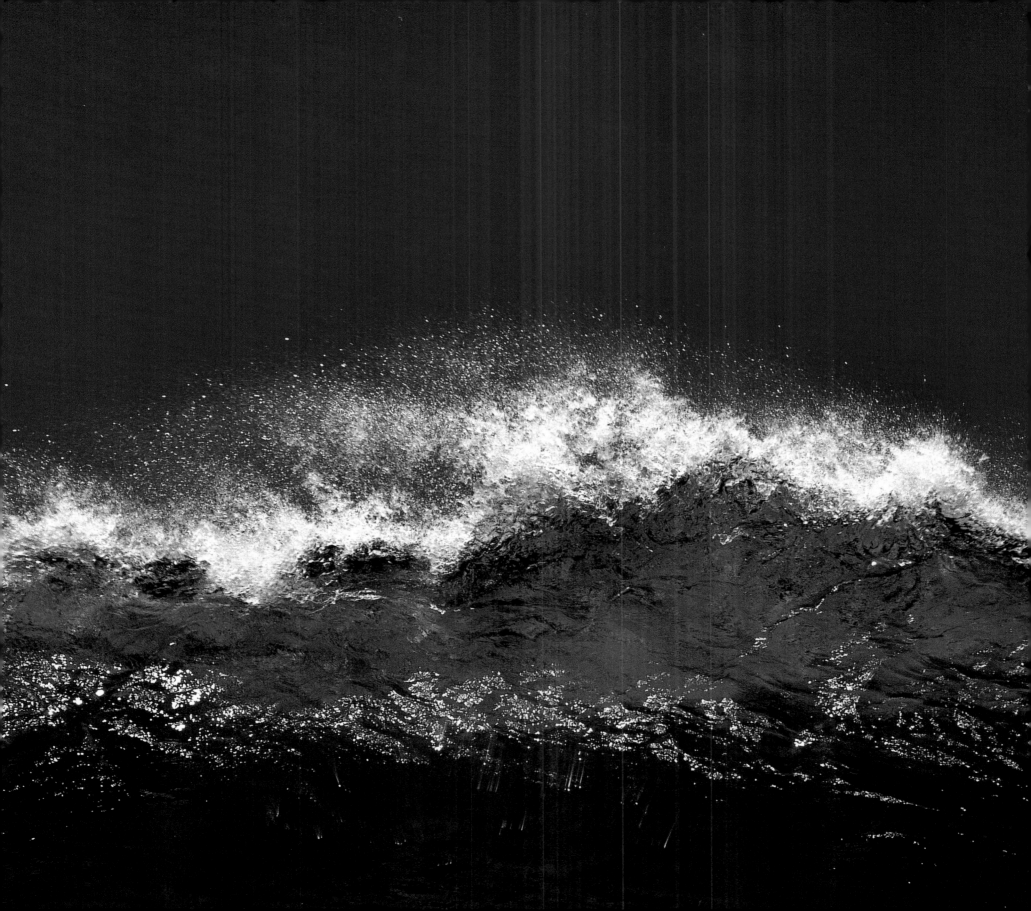

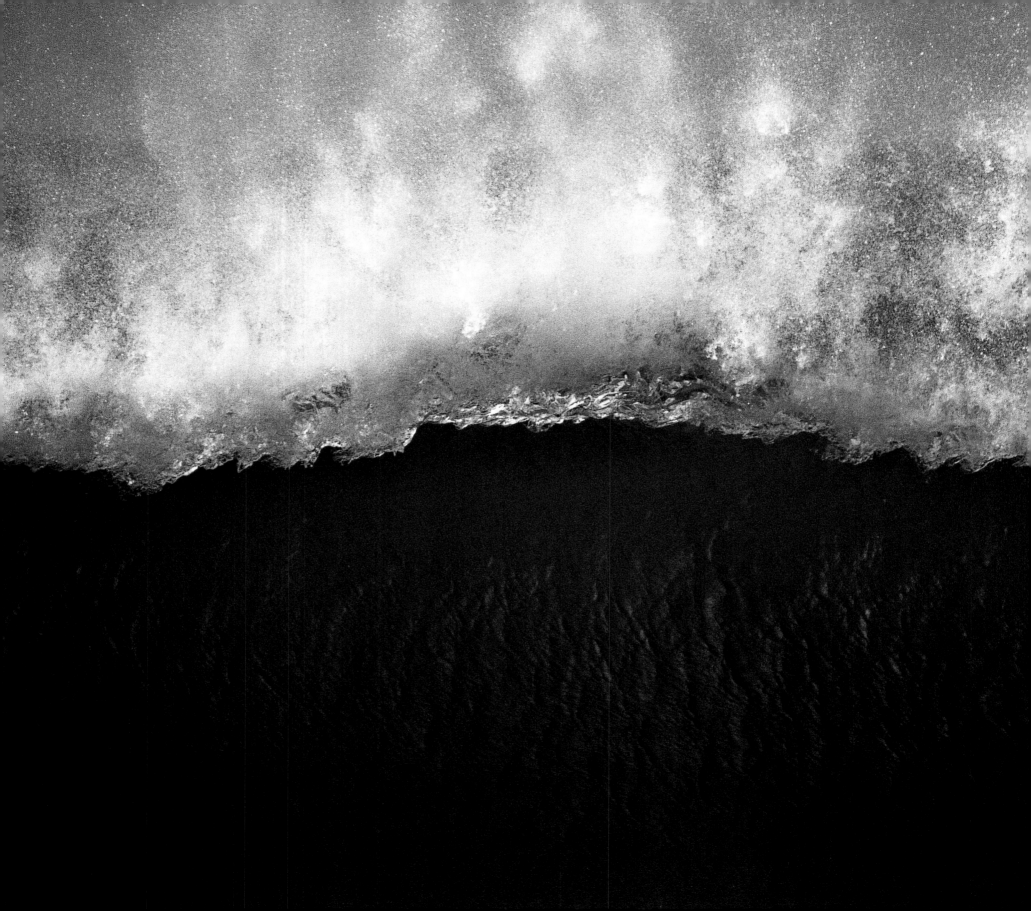

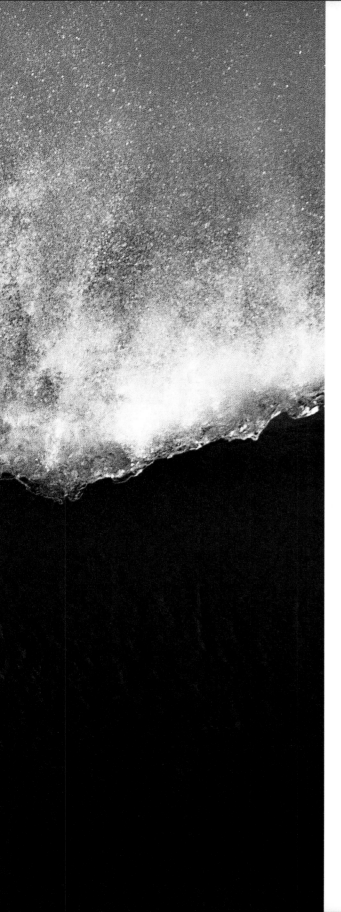

Wave Vocabulary

Once writers and painters had demonstrated their inability to adequately express the complex world of waves, the job fell to those who knew waves best: surfers. Surfers took up the challenge of devising their own vocabulary with the precision of an entomologist, dissecting the wave at the very moment it breaks, or, in other words, at the moment it disappears. Their painstaking work brought a quasi-scientific vocabulary into the language, a vocabulary that proved to be as poetic as it was humorous. Its exclusive reliance on pre-existing words, whose primary meanings had been hijacked by the wave, is full of interesting, and occasionally mystifying, connections.

Intent on expressing the slightest nuance and analyzing every aspect, surfers helped themselves to every word they could think of. The most obvious examples of these surfer deviations are the anthropomorphic expressions, which clearly refer to the human anatomy: "the shoulder," "the lip," and "the face" all fit in this category.

The sources of other terms are more surprising, more ambiguous, and more amusing. Why would surfers have borrowed "the curl" from hair-dressers, or "the Green Room" from the theater?

Terms such as "tube," "barrel," and "pounding" are borrowed from the industrial world. Others are drawn from aeronautics ("takeoff"), seismology ("off the Richter"), the postal system ("it's sending"), cosmetology ("sand facial"), or, when we refer to a wave as a "bomb," from military lingo. The expression used to describe a particularly vicious wipe-out, "getting rag-dolled," refers to a comforting toy. Then there are those expressions, such as "macking" and "gnarlatious," whose origins are as obscure as their meanings.

Mix and match any surfer terms and you're bound to come out with a combination that is totally impenetrable to the average person. Try cracking, "I boosted major air, then a bomb really axed me and I ate a Neptune Cocktail," for instance.

Yet there's one ubiquitous term that cuts across all categories. Whether you're in love or at war, in a factory or at the movies, having your hair done or taking drugs, after the sublime, things are always "epic."

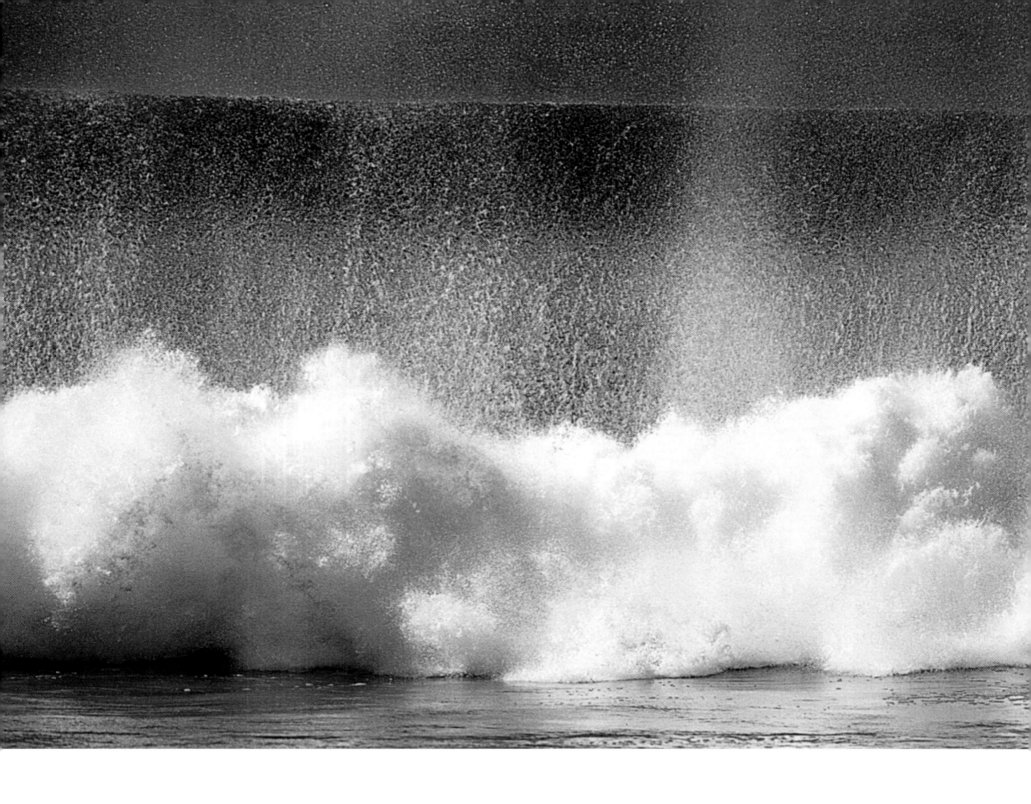

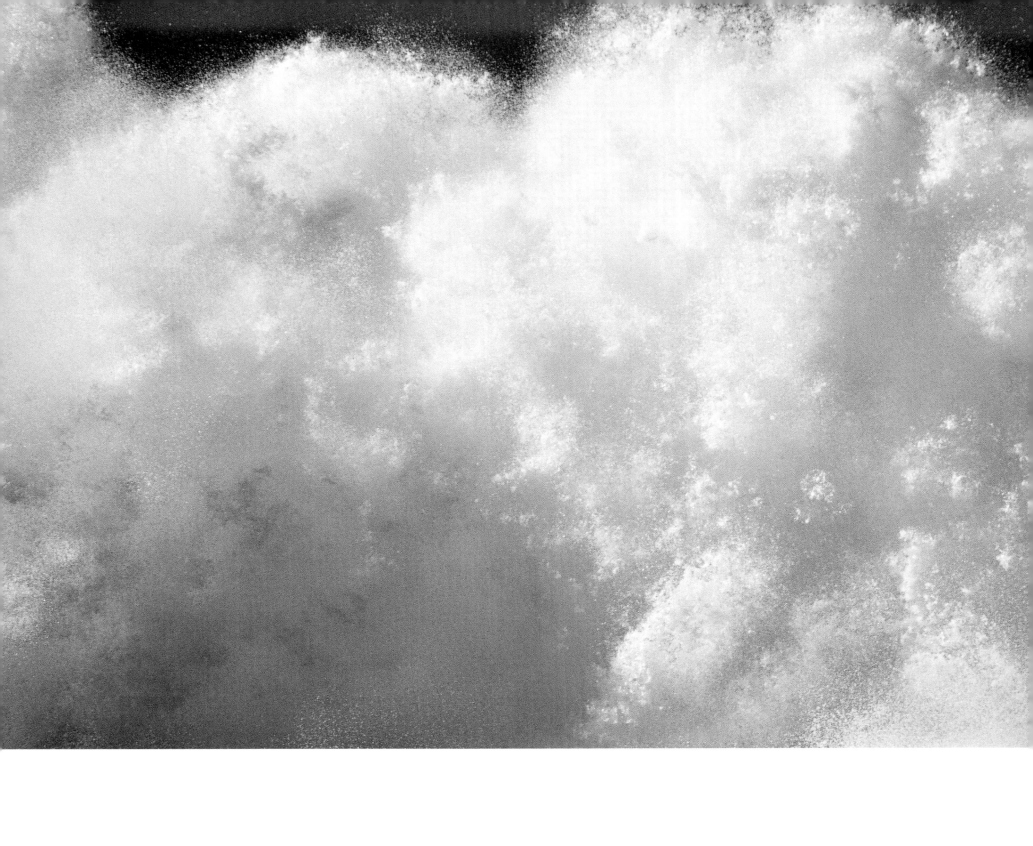

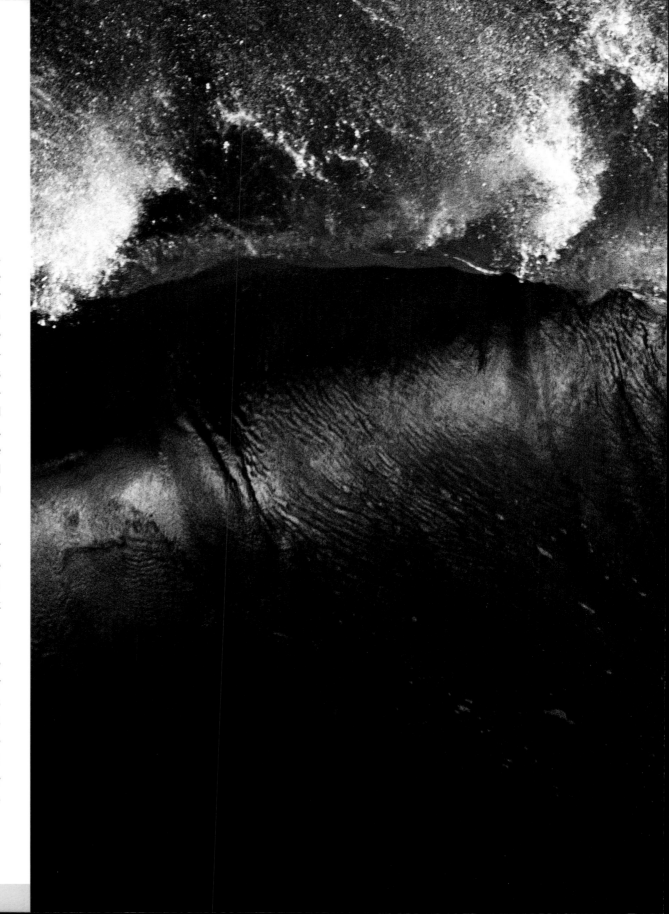

Cold Waves

In winter, the waves are cold. Early in the morning, when everybody else is just heading to work, we run down to the beach. The water stings our hands and faces as we paddle out. Mist rises from the blue sea being split by the distant nose of the board. Though our backs are warmed by the sunlight hitting our black neoprene suits, our hands remain reddened and numb. The waves are tearing into the rock over to the left, wrapping around the promontory, and breaking along the cliff side. Soon the first duck dive of the day will allow the chilly water to slip down the backs of our suits and send a few freezing drops of water creeping along our spines.

The sun rises slowly in the winter sky. Now our taut muscles react quickly—the wetsuits have kept us warm. The sea is saturated with a harsh light that sets the water on fire and bounces back white against the trough of the waves.

Now I'm surfing. The wave is long, I maneuver one curve after another, my sweat mixing with seawater boiled by the sun. My body is burning. The wave's speed doubles as it rips over the rocks, the lip snaps against my back and sends me head first into the rushing translucent foam, deep under. The cold water takes hold of me. As I find myself trapped by the wave, held down by swirling eddies I know the exact duration of, I burst out laughing.

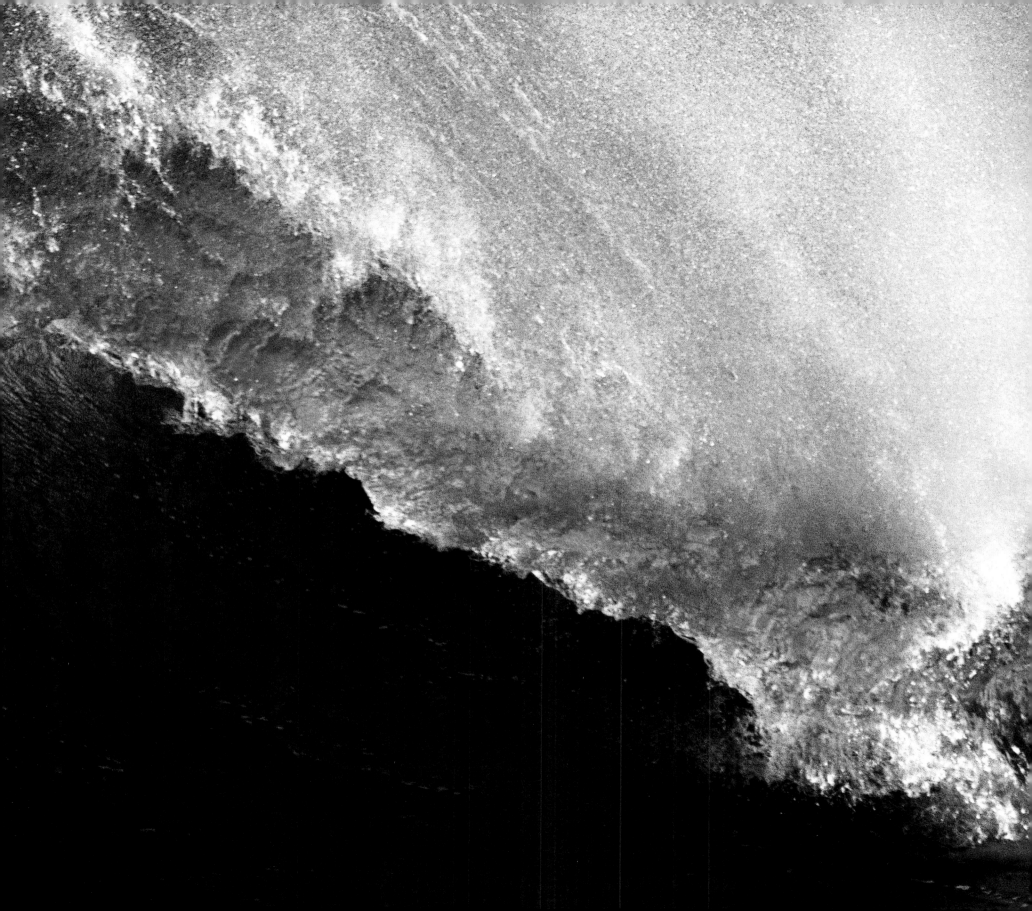

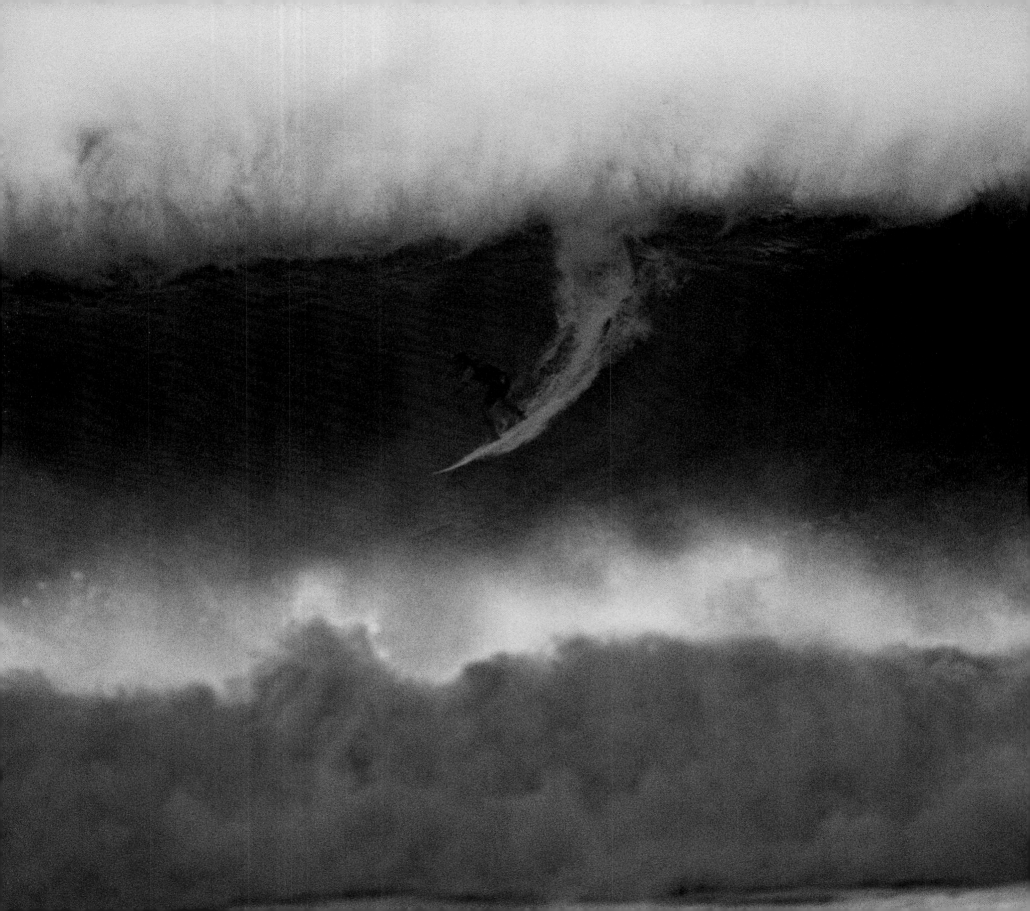

The Structure of Pleasure

Pleasure comes first. It's instantaneous. As soon as surfers set out, pleasure is there, lurking beneath the waves, then triumphantly surging forward and overwhelming them. Kepelino Keauo-ha-lani, a nineteenth-century Hawaiian chronicler, wrote about the pleasure that quickly turns to obsession, leaving surfers *hopupu* (which translates as "a state of euphoria, intense emotion," according to American writer Leonard Lueras). Lueras quotes the following passage:

> When it comes time for the waves, all thoughts of work are abolished, only sport remains. . . All day, there is nothing else but sport. . . Though his woman might be hungry, along with his children and entire household, the head of the family pays no attention. He is entirely absorbed by the sport, it is his only nourishment. Many leave to go surfing at four in the morning—men, women, children. It is a sport which quickly transforms from an innocent pleasure into a diabolical one. So goes life.

What makes the pleasure in surfing so tenacious, so inebriating? Gliding, of course. Gliding over a surface in motion, a surface that glides with you. And fear certainly throws a little spice into the proceedings. But what else?

Could it be the taste of water? Or simply the magic of the seawater, with all the salt from all the minerals and rocks, which make up the ocean's immense basin? Could it be that the ephemeral nature of the waves adds magic to the magic? Is it the brilliance of the water's colors? The profusion of odors? The harmony of the ocean's sounds, comprised of simultaneously rolling and dull music punctuated by the howling impact of waves breaking and of arid noises rising from the heart of the sea? Is pleasure born of speed? Surely, all of the above contribute to making the contemporary surfer as *hopupu* as the ancient Hawaiians were.

Now you might understand why surfers have red eyes and dazed looks when they're outside of the water. It isn't the saltwater that makes their eyes red. It's the proximity to the divine. It isn't the extreme physical commitment that dazes them. It's the personal relationship they've developed with the sublime.

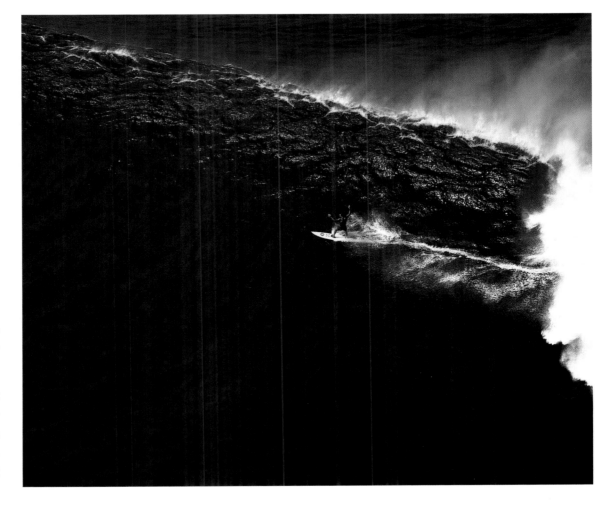

Pleasure and Pain

Pleasure comes first. But pain is never far off. You feel it from the first day, in the tightness of your shoulders and sore neck. Then, little by little, the muscles build up, the body becomes used to it, you become hardened and begin to set your sights a little higher, on tougher waves. Fear and pain are never far apart, for no matter how good you are at surfing, the waves always end up pummeling you.

You might wonder if surfing is a masochistic sport, with the wave clutching a whip. However pleasing this interpretation might appear, it is erroneous, for in surfing, moments of pleasure are distinct from moments of pain. Pain and hardship in the waves do not constitute the pleasures of surfing, they are merely the keys required to access the sport. Those who cannot accept the numb arms of the first session and the memorable wipeouts of the following ones will never find pleasure. We have them to thank for the fact that the waves remain less crowded than they could be.

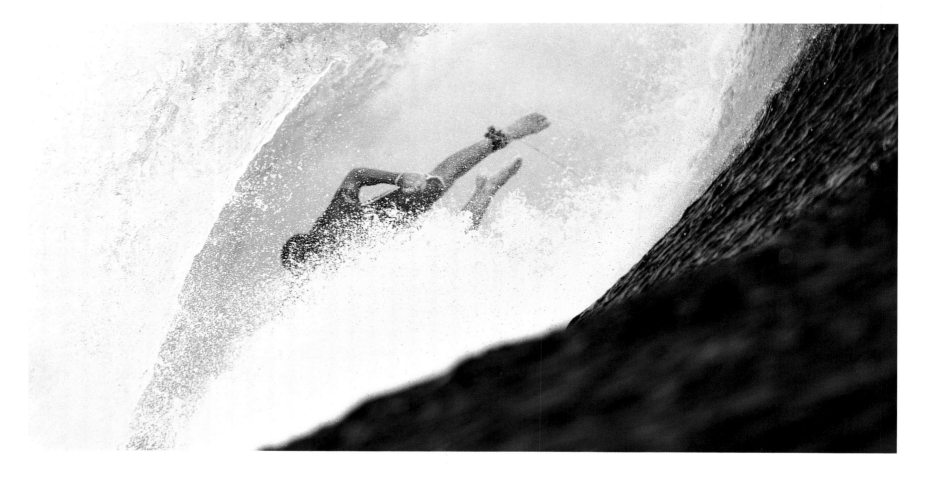

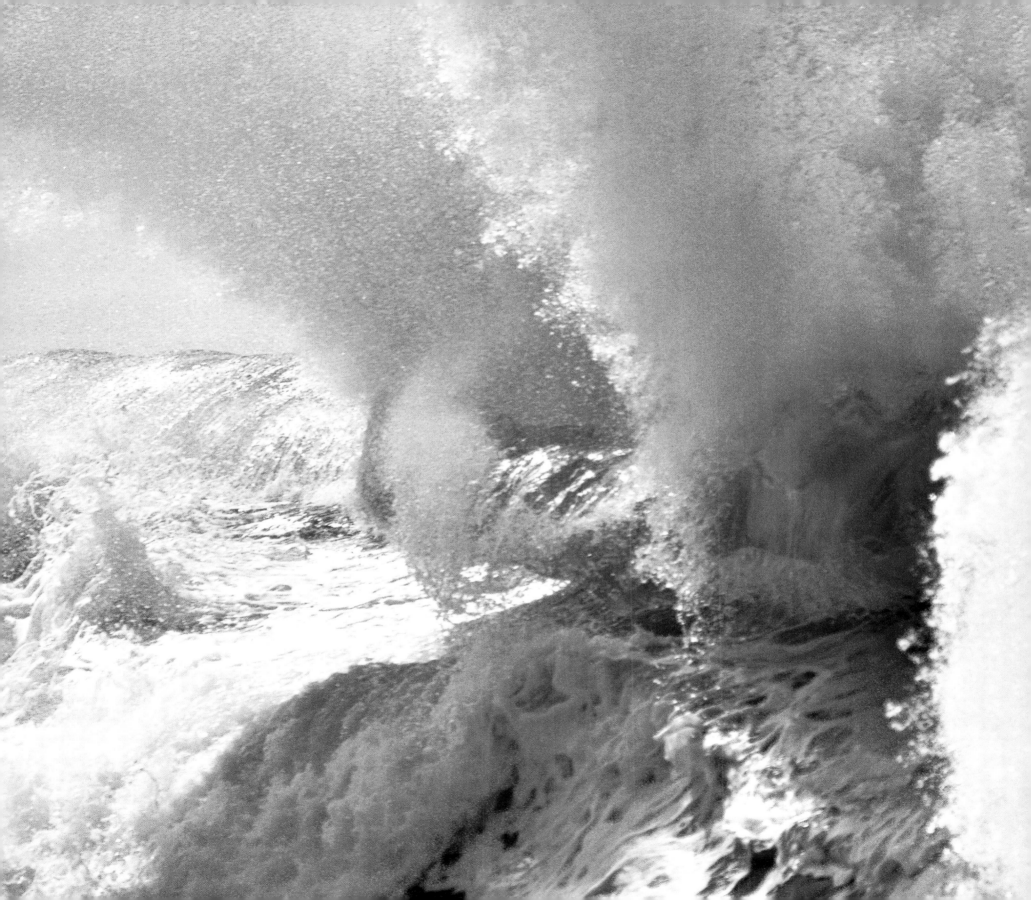

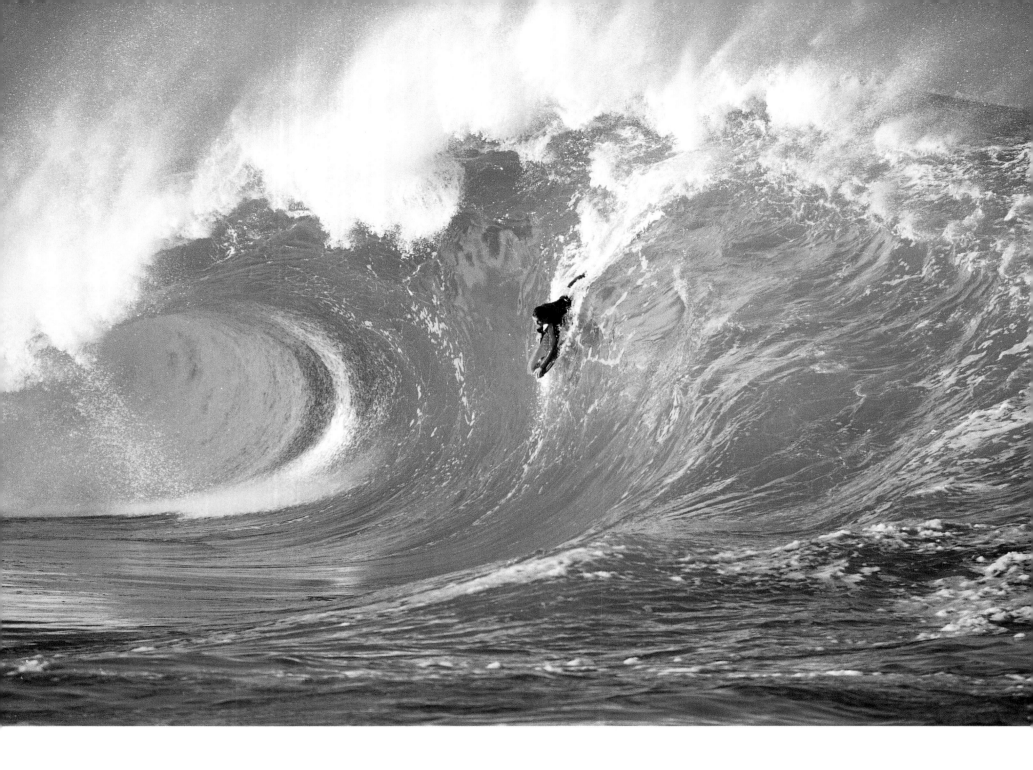

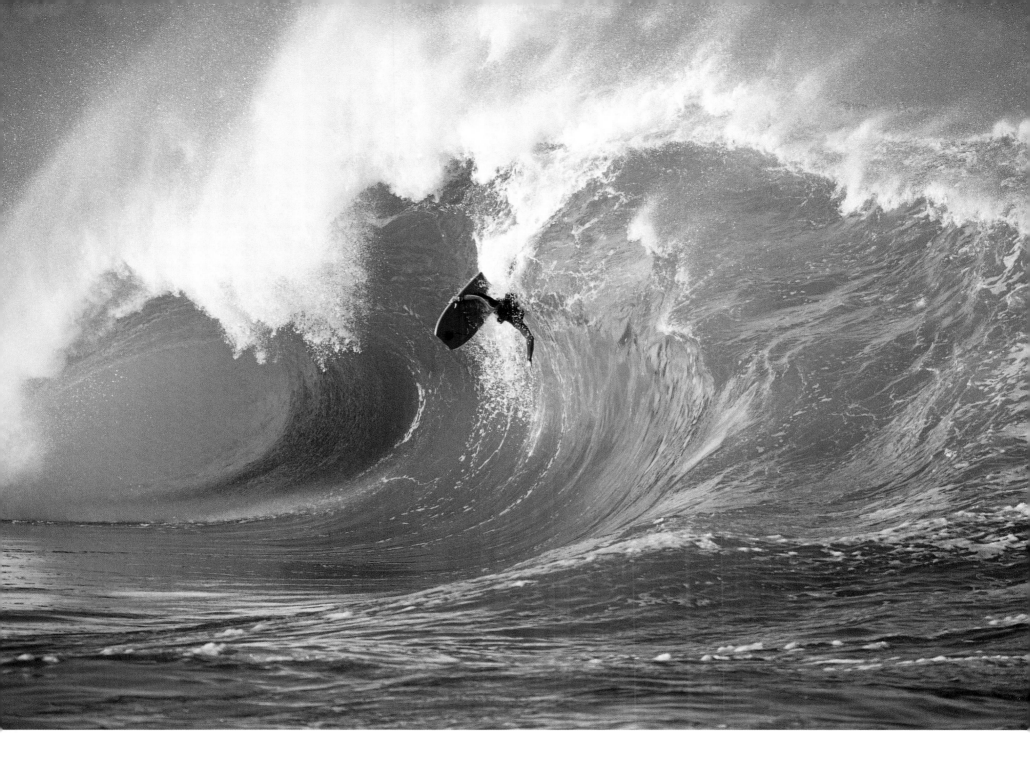

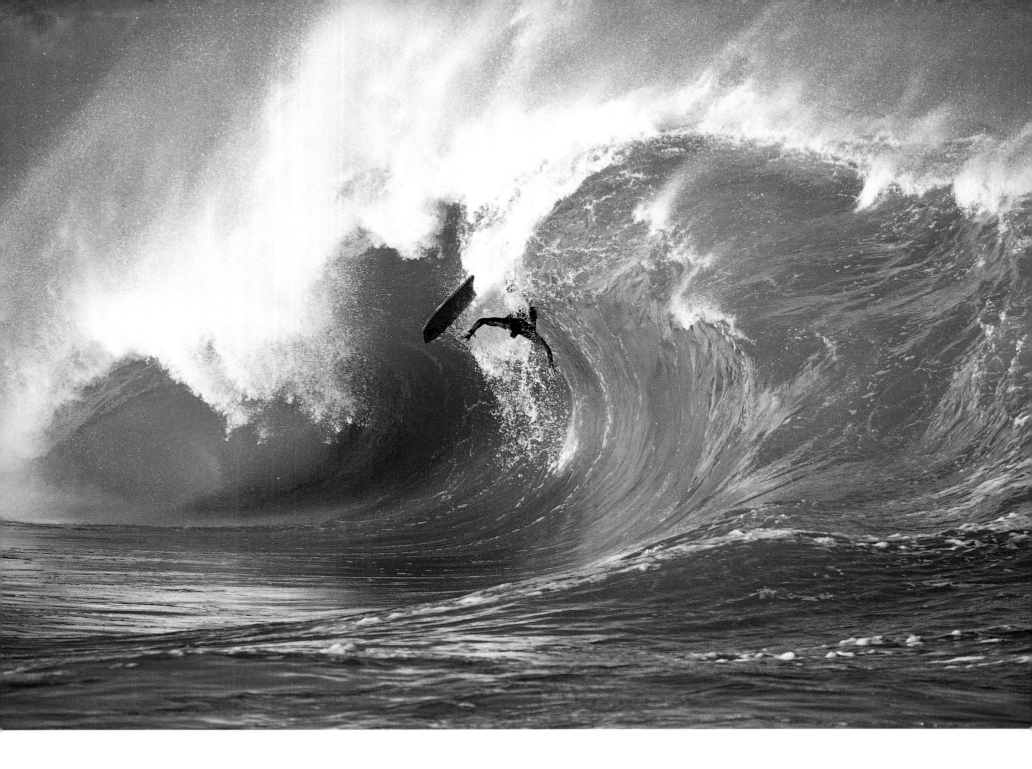

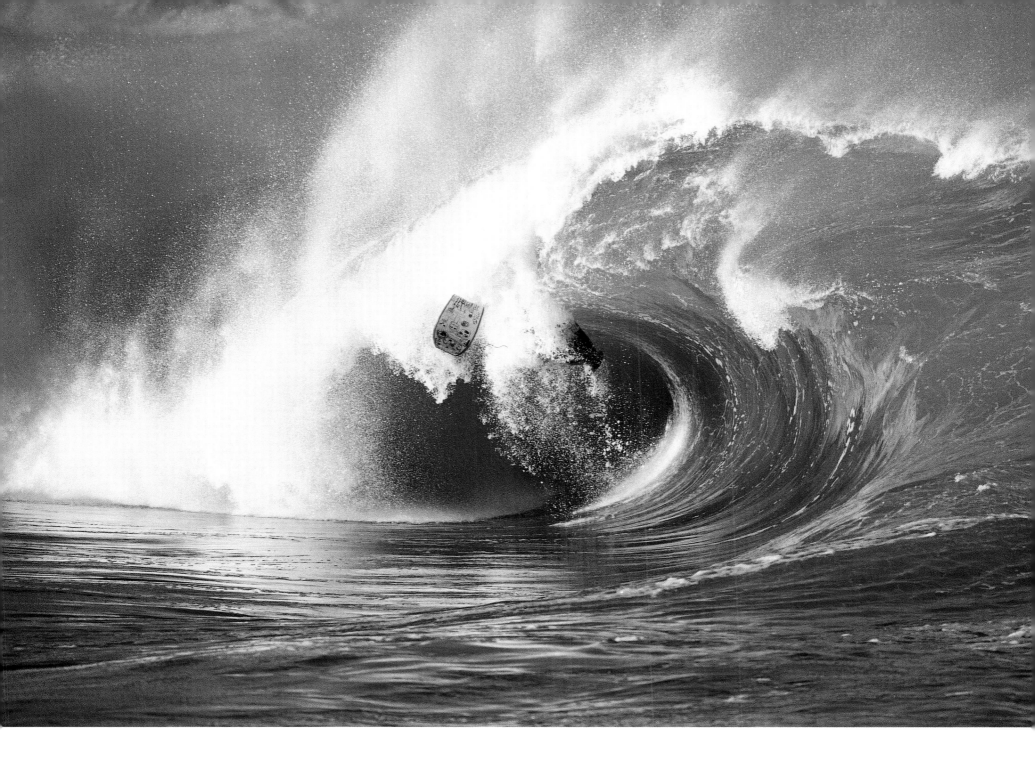

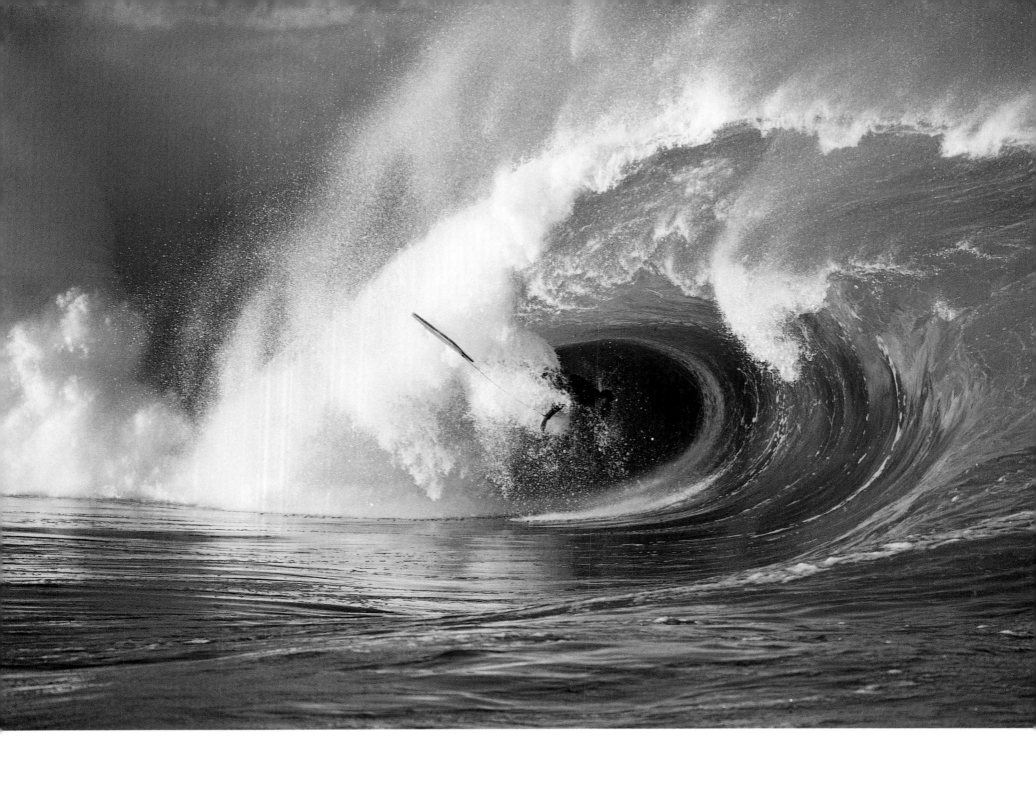

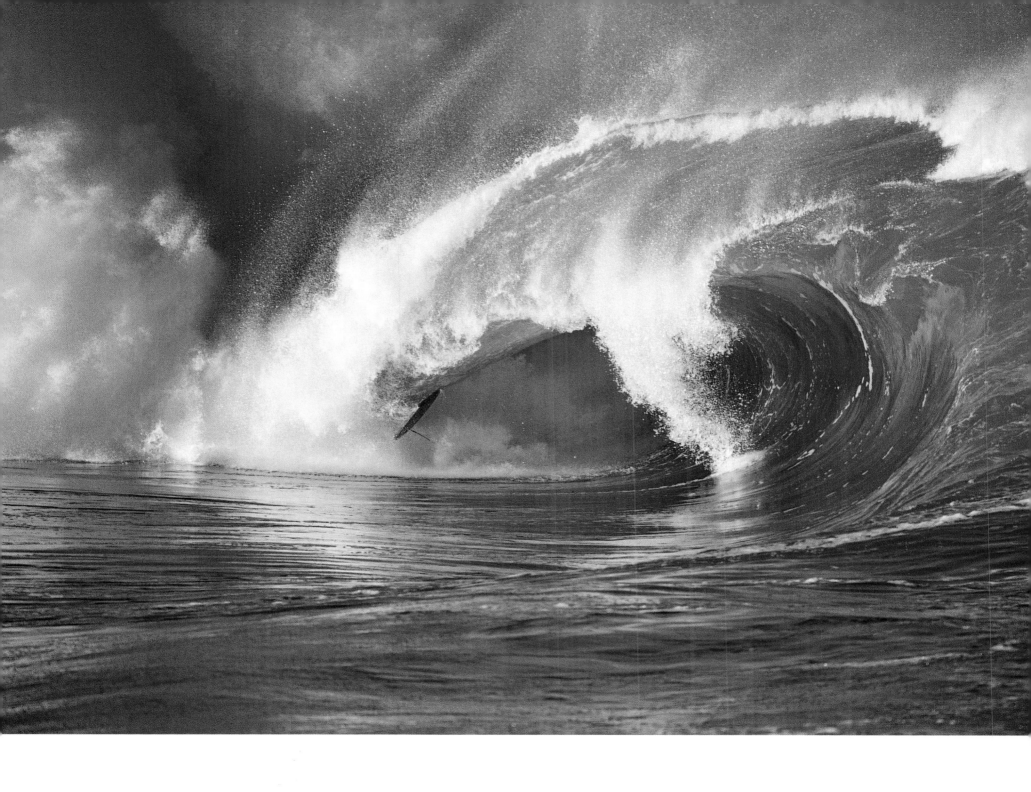

Surfers and Posers

There are summer surfers and winter surfers. For having the courage to face savage swells, winter surfers enjoy deserted beaches and surf sessions restricted to a core of devoted friends. Summer surfers, that is, occasional surfers, include beginners, students, children, and all-around athletes coming to get a taste of the waves. In other words, they include all the landlubbers who take advantage of the summer holidays to toughen up in July to be ready to confront the more serious conditions, which generally start around mid-August. Aside from beginners doing the crab to paddle out, and athletes overwhelmed by the moving tarmac, summer offers up a particularly fascinating type: the surfer who poses with a board. The surfer who poses with a board is a hero. Granted, this surfer is a ridiculous hero, with studiously styled locks, his brand-new, gleaming wetsuit, and a board crafted by an unseen master from an unknown place. This surfer adopts the persona of the old sea wolf, staring out to sea with a wrinkled brow and affected nonchalance. Should this poser chance to venture into the water—oh joy—everyone will see some awe-inspiring basic moves, but the poser will return to land as soon as the swell reaches shoulder height. Turning back to the ocean with the gaze of a conqueror, the surfer loads the board onto the backseat of a dark red convertible. The surfer who poses with a board is a hero, but doesn't know why.

The surfer who poses with a board does open the debate on the issue of showing off, a temptation shared by many surfers. Mastering a difficult art, the surfer often has the poor taste of adopting pretentious poses when looking out to sea. The surfer's clothing is designed to display membership to the surfing caste. But let us take comfort in the fact that the best surfers rarely succumb to these failings. As for the waves, they couldn't care less.

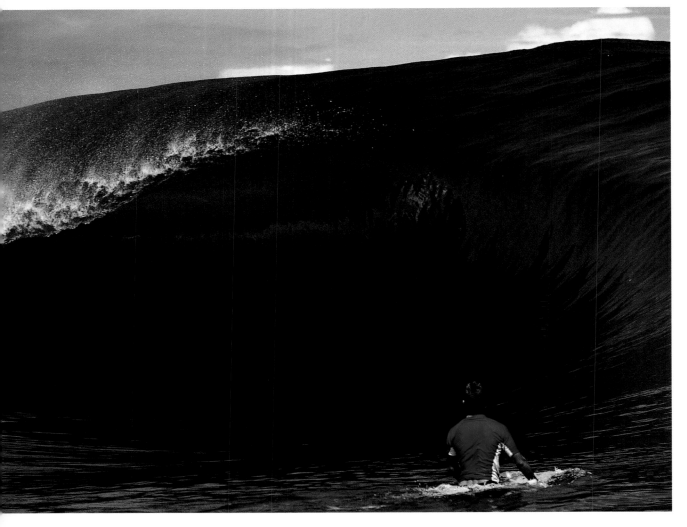

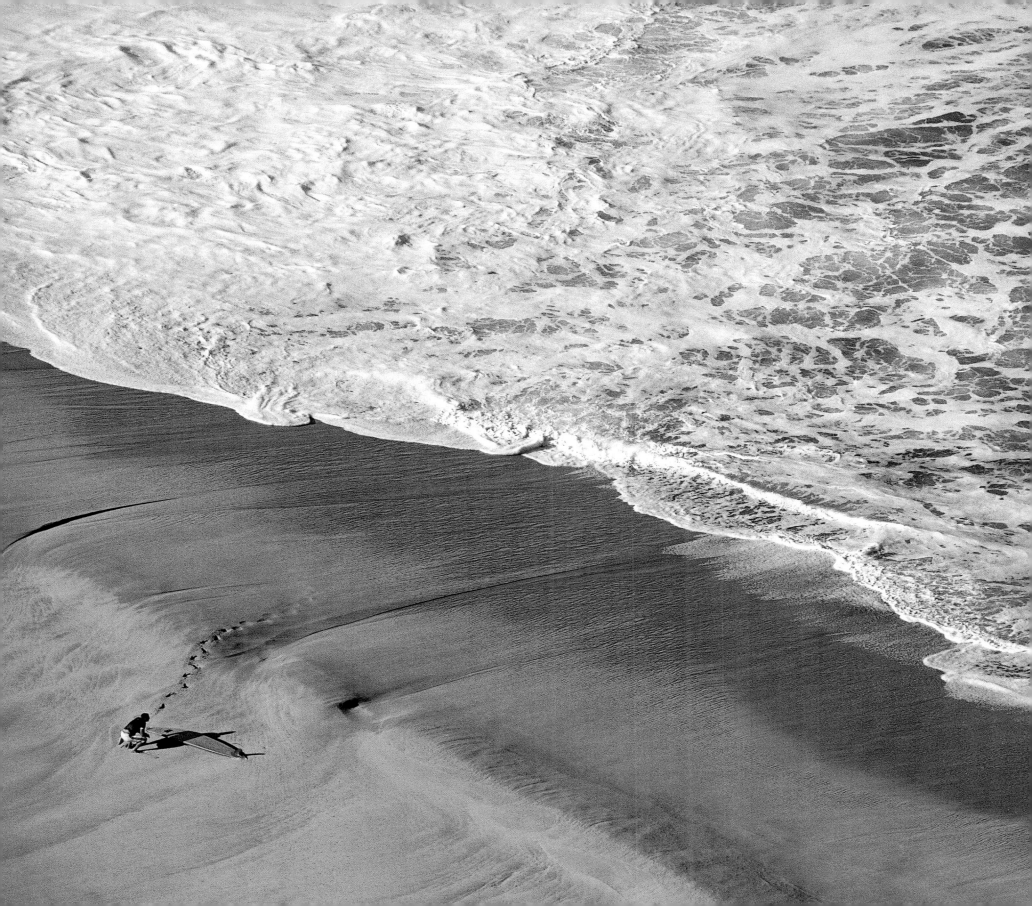

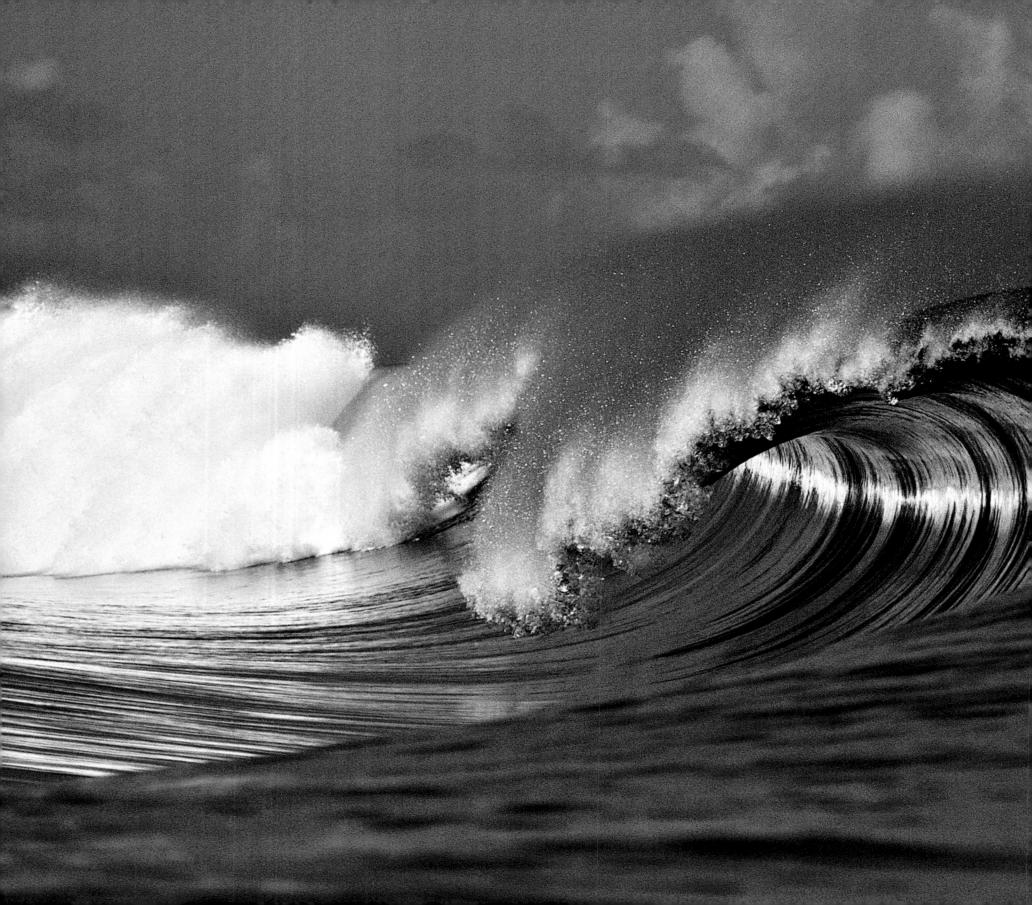

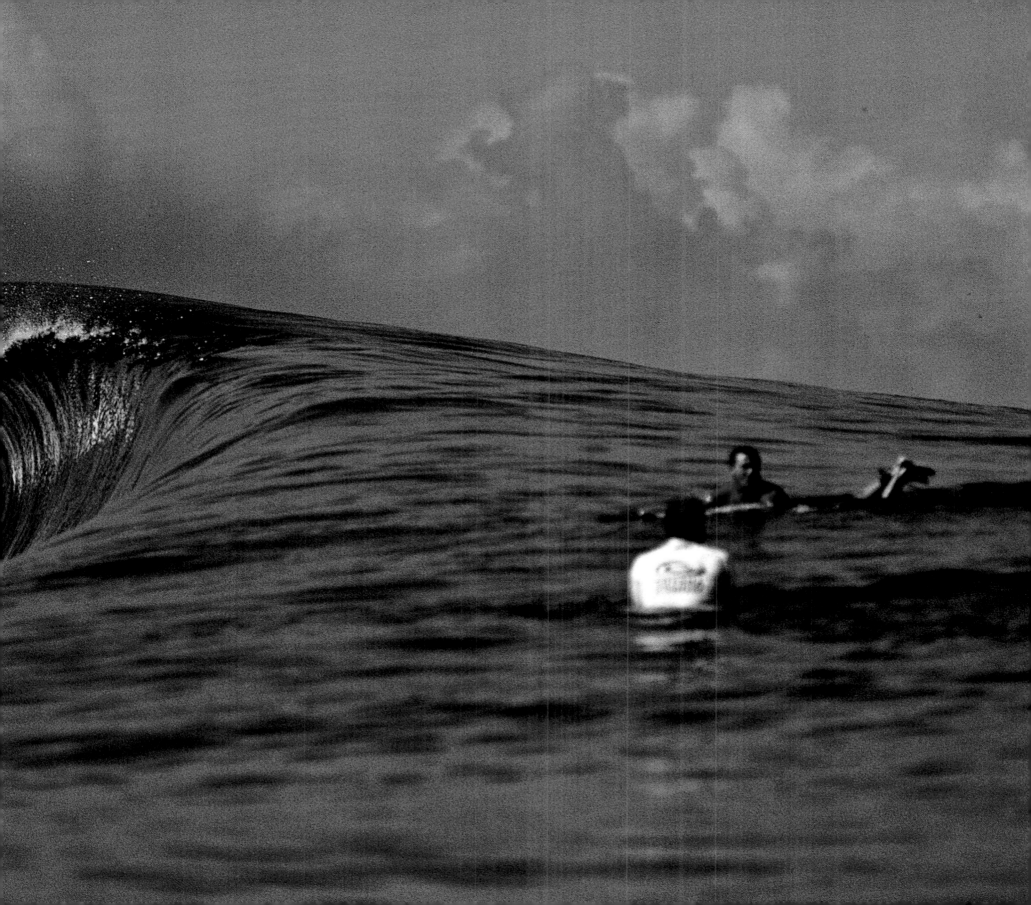

Trajectory of the Cat

The two most significant surfers active in the second half of the twentieth century are Mickey Dora and Laird Hamilton. These two men have little in common other than that they both devoted themselves to a sport and they pushed it to the limit of human experience. But let's look at their differences.

Dora was the most brilliant, charismatic surfer of his generation. Yet when surfing achieved its first international hour of glory, Dora left, and never returned from his "Endless Summer." He never accepted sponsors, participated in competitions, nor sat for photos or interviews. While his fellow wave-chasers were setting up the surf-wear companies—which have since conquered the world's beaches—Mickey Dora, the best of them all, retired to a noble life of absolute solitude and discretion. Dora paid the price by living an impoverished life on the margins. It must be admitted that his media avoidance was far more fascinating than thought provoking. Dora surfed the waves as a soul surfer.

It's a whole other story with Laird Hamilton, the most brilliant, charismatic surfer of *his* generation. With the surf business triumphing in shopping malls and on beaches, Hamilton attracted many generous sponsors, sat for thousands of interviews, and seemed to have his picture published every time he rode a wave, though he does share Dora's aversion to contests. Hamilton is a man on a perpetual quest for the biggest wave, the best surf, the perfect board or tool to master the power of the ocean on any given day. Hamilton wants to dance over the stormy tumult of the ocean with the lightness of a bird. Like Mickey "Da Cat" Dora, Hamilton is a soul surfer.

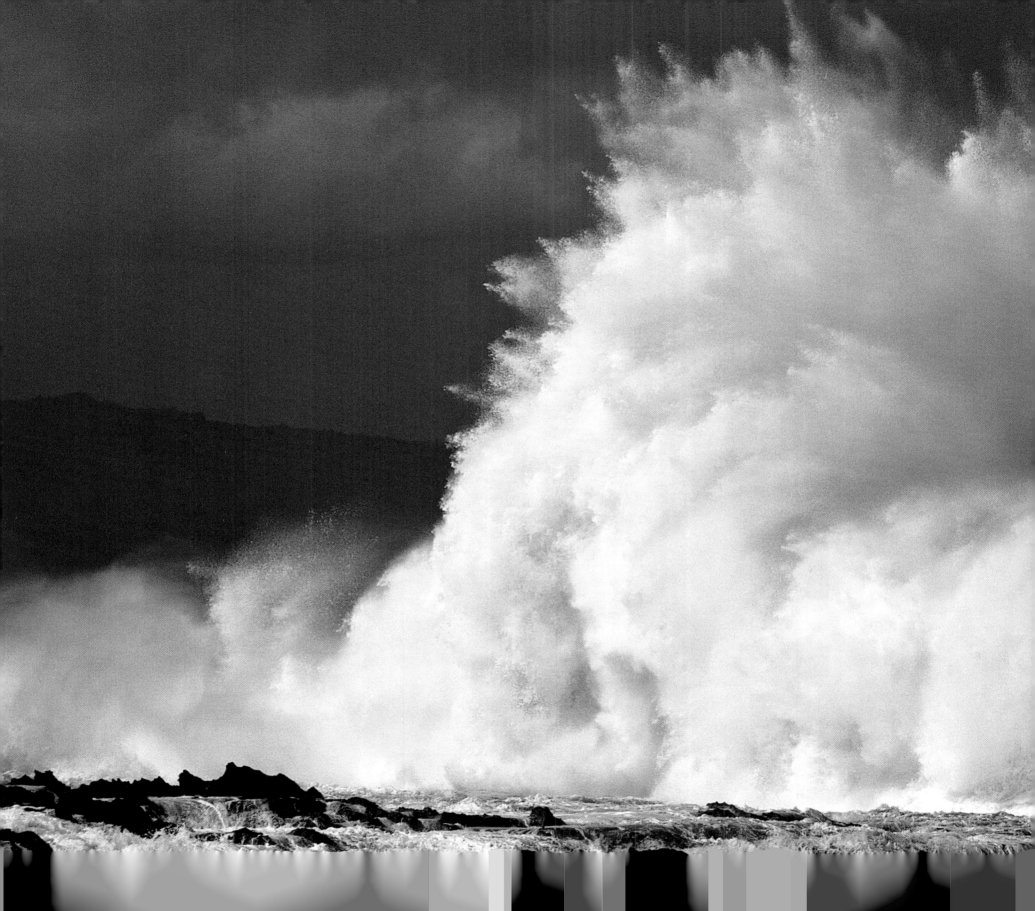

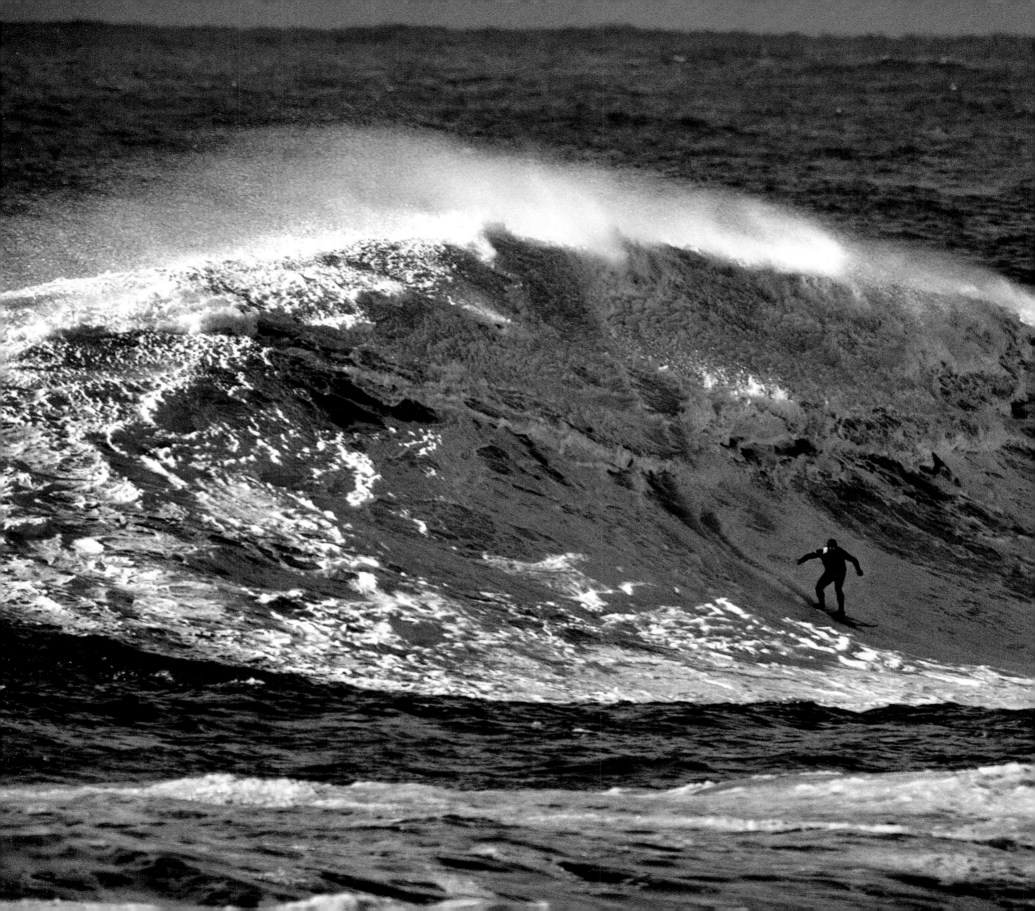

The Exploded Wave

There is an undeniable, fundamental difference between Mickey Dora and Laird Hamilton. There is no guarantee that Dora's asceticism is superior to Hamilton's opportunism. That is a question each one of us must conscientiously evaluate. The real problem with Hamilton, and those who have followed in his wake, is that they have introduced the internal combustion engine into a sport previously limited to the strength of the human arm. A polluting machine has been introduced to the very heart of the sanctuary. We know that the excessive use of motor vehicles endangers our planet, right down to the coral reef. With this in mind, it's hard to avoid thinking of the Hawaiian Genesis, and, particularly, of verses 13, 14, and 15, which describe the birth of life: "Kumulipo was born of the male sex / Po'ele was born of the female sex / The coral polyp was born, coral emerged."

The coral is considered the base from which all life sprang. The litany continues from there, as if life was being unrolled before us like a long carpet: "The larva which digs the earth and builds its mound was born / The starfish was born and gave birth to the little starfish." By altering the coral reef, the internal combustion engine symbolizes an aggressive act, a form of spiritual vandalism. If a wave can't be surfed without damaging the ocean, that's because it's taboo, or, as the Hawaiians put it, *kapu*.

Around the time I was finishing this book, I ran into Fred Basse, one of the surfers who surfs Belharra, a massive Basque Country–wave, which is only approachable with noisy Jet Skis™. The eyes of this responsible man in his fifties glimmer like an excited child's, as if he was still a little *hopupu*. He tells me about the unmatchable experience of riding such beautiful, big waves out in the deep. "It's a marine, human and athletic experience I wish everyone could have," he says. I want to believe him. His pleasure is so communicative that I even want to hug him. I admire Fred. I am tempted to thank him.

Let us reread Kepelino Keauohalani: "It is a sport which quickly transforms from an innocent pleasure into a diabolical one." And he adds: "So goes life."

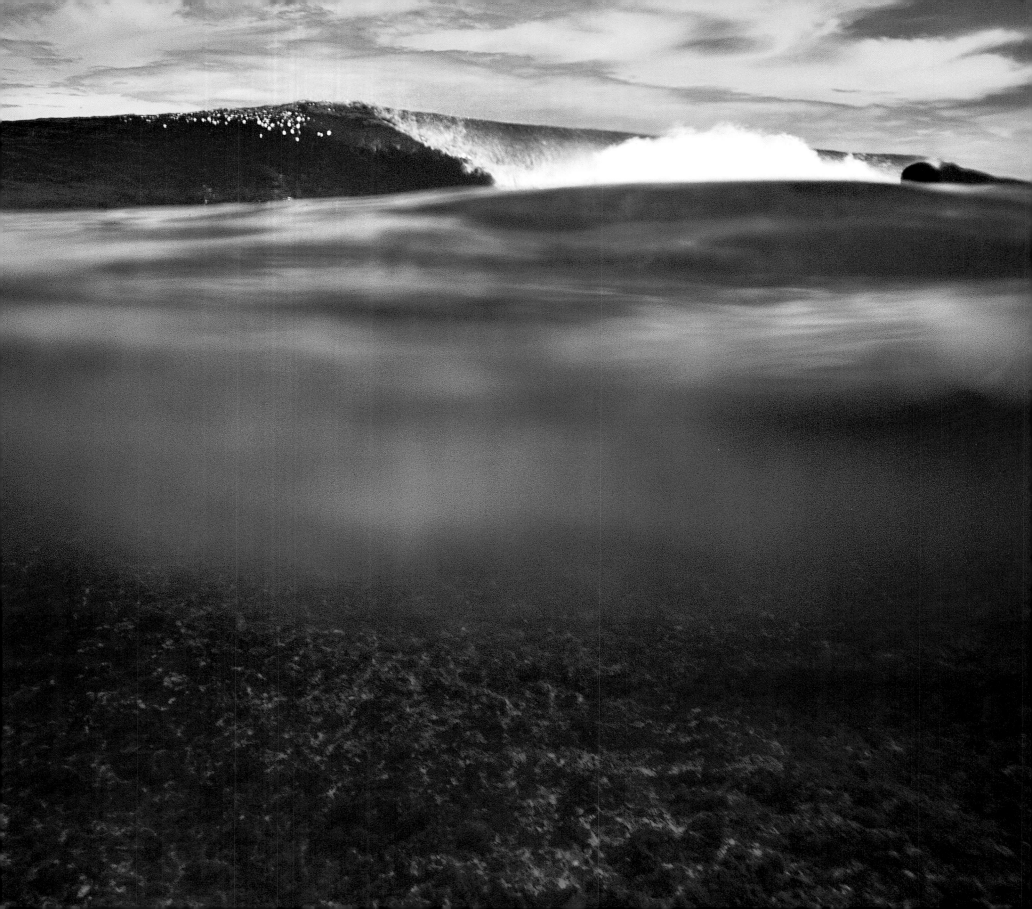

Further Reading about Waves

Books

Butt, Tony and Paul Russel. 2004. *Surf Science*. Penzance: Alison Hodge Publishers.

Chauché, Éric (photographer). 2004. *Kosta*. Biarritz: éditions Surf Session.

Colas, Antony. 2004. *The World Stormrider Guide: 2*. London: Low Pressure Surfing Books.

Dufau, Guillaume. 2004. *Sessions de rêve* (Dream sessions). Biarritz: éditions Surf Session.

Nouqueret, Pierre. 2004. *Vagues et littoral* (Waves and the coast). Biarritz: éditions Surf Session (special environment issue).

Robin, Paul. 1989. *Vagues, l'énergie magnifique* (Waves, the magnificent energy). Marseille: éditions AGEP.

de Soultrait, Gibus and Sylvain Cazenave. 1995. *L'Homme et la vague* (Man and the wave). Guethery: éditions Vent de terre.

Verlomme, Hugo. 2001. *Cent pages de vagues* (One hundred pages of waves). Urrugne: éditions Pimientos.

Verlomme, Hugo and Laurent Masurel. 2003. *Bodysurf*. Biarritz: éditions Atlantica.

Magazines

Surfer's Journal, quarterly, éditions Vent de Terre.

Vagues, annual, éditions Surf Session.

Exhibitions

"Vagues et littoral, l'Expo Surfrider" (Waves and the coast, the Surfrider exhibition), traveling exhibition.

Site: *www.surfrider-foundation.org*

Pierre Nouqueret

Pierre spent his childhood and adolescence among the waves of the Grande Plage in Biarritz. Since then, he has never wavered in his love for the coast and the ocean. A contributor and founder of several surfing publications, he has also served as executive director of Surfrider Foundation Europe (1994–2002), editor-in-chief of *Vagues* magazine (published by éditions Surf Session), and an environmental communication and education advisor. He also curated the pedagogical exhibition *Vagues et littoral* (*Waves and the shore*), which has traveled throughout France.

Guillaume Dufau

Born in Dax, France, Guillaume discovered surfing at the age of twelve on the beaches of the Landes. After studying journalism in Tours, Guillaume returned to his native region to work for *Sud Ouest*, a daily newspaper. In 1997, he joined the editorial staff of *Surf Saga* magazine. A year later, at the age of twenty-four, he was named editor-in-chief. He now heads the editorial staff of *Surf Session*, a Biarritz monthly, a position he has held for five years. He has traveled around the world covering stories for *Surf Session*. His book *Sessions de rêves* (*Dream Sessions*) was published by éditions Surf Session. He collaborated with Alexandre Hurel on the book *Surfeurs de tube* (*Tube Surfers*), which was published by éditions Pimientos.

Alexandre Hurel

After studying history and geography, Alexandre Hurel began his career as a freelance journalist for several Paris publications. He soon succumbed to the call of the sea spray and returned to the Basque coast. After a formative experience as deputy editor for *Surf Session*, he created the stunning *Surf Saga* magazine in 1993. In 1997, he cut out of the surf-press wave to found his own publishing company, éditions Pimientos, which specializes in regionalism, travel literature, and coffee-table volumes. His offices are located in Ciboure, near the port of Saint-Jean-de-Luz.

Sylvain Cazenave

An authentic pioneer of surf and wave photography in France, Sylvain has dug his zoom lens tripod into the sands of every beach on the planet. With his immeasurable passion for surfing, Sylvain has a knack for being around when surf history gets written. A contributor to *Surf Session*, since its inception, as well as to the principal international surf publications, he has published several volumes on surfing and windsurfing. His photos are represented by the major sports photography agencies.

Eric Chauché

After studying film and video, Éric traded in his video camera for a still camera and quickly became an international surfing and sportswear photographer. He created the magazine *Trip Surf*, then founded his own publishing house, Uméa, in Bayonne. A lover of landscapes and beautiful light, Éric follows his quest for authenticity through his travel photography. His work has illustrated numerous volumes dedicated to nature, the ocean, and the Basque mountains.

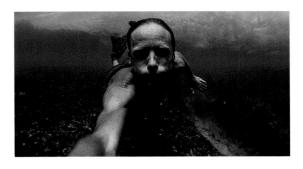

Tim McKenna

Of Australian and Franco-English origin, adventurer Tim McKenna has chosen the fantastic natural studio of Tahiti to set down his board and camera bags, after several round-the-world trips through sands and snow. His passion for surfing has led him to capture the breaking of millions of waves. Tim is currently immortalizing the Polynesian islands' best surfers on the Pacific's finest waves. His photos have been published in many important surf magazines.

Acknowledgments

Thank you to Surfrider Foundation Europe, Stéphane Latxague, Bruno Castelle, and Pascal Dunoyer de Segonzac for their scientific contribution to the mechanism of the wave.
Thank you to Jean Dubertrand and his sons for the picture "The Wave."
Thank you to photographer Olivier Gachen for his portraits of the authors.
Thank you to Bernard Favre, of Cap Sciences, who was responsible for a meeting without which this book might not exist.

To experience the pleasure of riding a wave, you need patience and perseverance; thank you to Laure Lamendin, whose talent allowed us to get going.

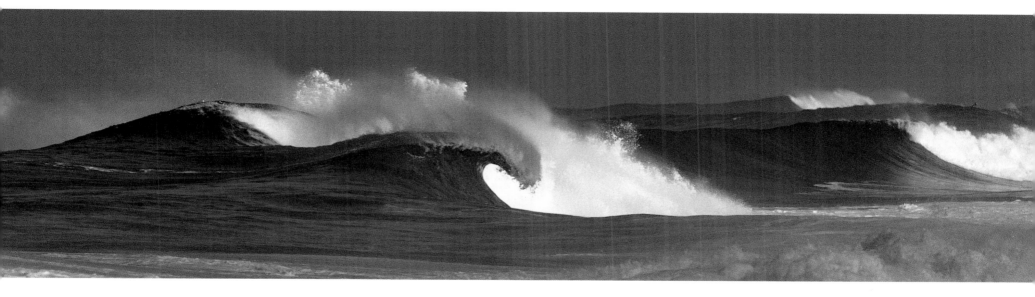

Translated from the French by Nicholas Elliott

Interior design by Elisabeth Ferté
Illustrations by Régis Mac

Project Manager, English-language edition: Magali Veillon
Editor, English-language edition: Sigi Nacson
Design Coordinator, English-language edition: Christine Knorr
Production Manager, English-language edition: Colin Hough-Trapp

Library of Congress Cataloging-in-Publication Data

The Perfect Wave : The Endless Allure of the Ocean / edited by
Pierre Nouqueret ; photography by Sylvain Cazenave, Éric Chauché, and Tim McKenna ;
essays by Guillaume Dufau, Alexandre Hurel, and Pierre Nouqueret.
p. cm.
ISBN 0–8109–5743–4 (hardcover)
1. Ocean waves—Pictorial works. 2. Ocean waves. I. Nouqueret, Pierre.
GC211.2P45 2006
779'.37—dc22
2005030386

Published in 2006 by Abrams, an imprint of Harry N. Abrams, Inc.

Printed and bound in Spain
10 9 8 7 6 5 4 3 2 1

HNA
harry n. abrams, inc.
a subsidiary of La Martinière Groupe

115 West 18th Street
New York, NY 10011
www.hnabooks.com

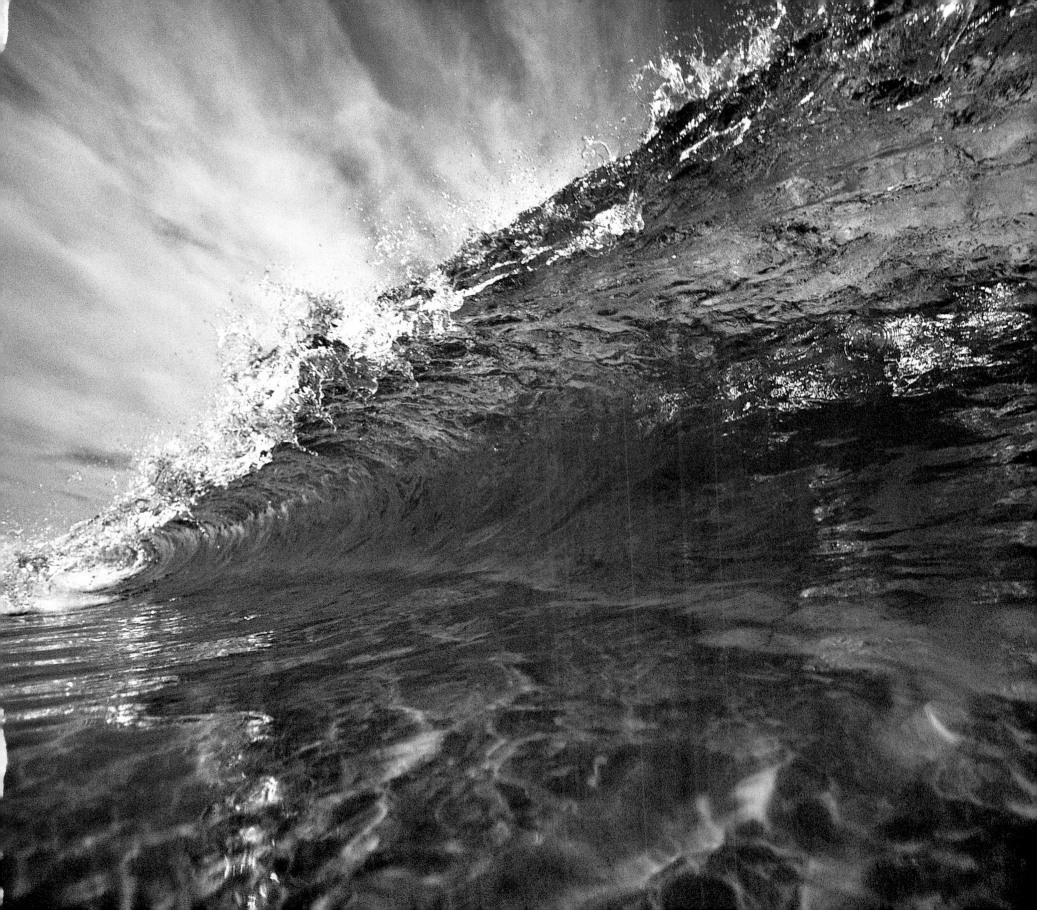

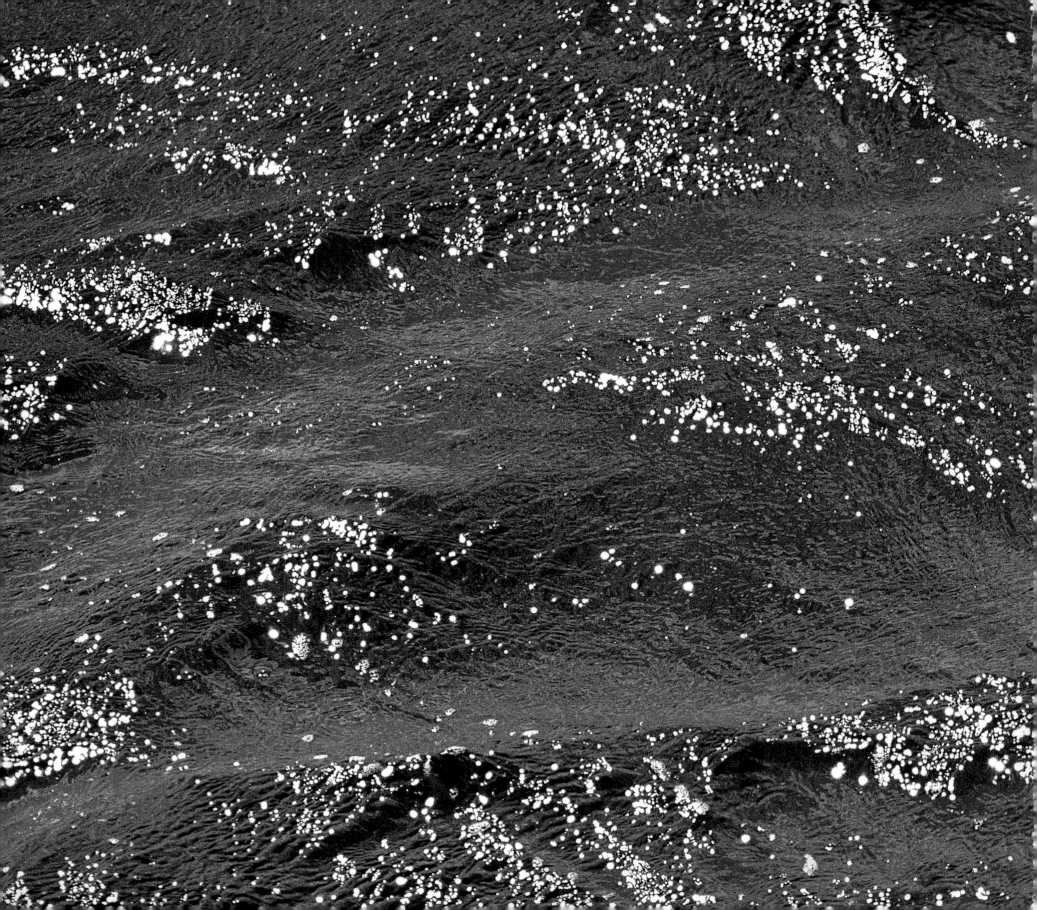